unraveling

ALSO BY PEGGY ORENSTEIN

Boys & Sex: Young Men on Hookups, Love, Porn, Consent, and Navigating the New Masculinity

Don't Call Me Princess: Essays on Girls, Women, Sex, and Life

Girls & Sex: Navigating the Complicated New Landscape

Cinderella Ate My Daughter: Dispatches from the Front Lines of the New Girlie-Girl Culture

Waiting for Daisy: A Tale of Two Continents, Three Religions, Five Infertility Doctors, an Oscar, an Atomic Bomb, a Romantic Night, and One Woman's Quest to Become a Mother

Flux: Women on Sex, Work, Love, Kids, and Life in a Half-Changed World

Schoolgirls: Young Women, Self-Esteem, and the Confidence Gap

unraveling

What I learned about life while

shearing sheep, dyeing wool, and

making the world's ugliest sweater

PEGGY ORENSTEIN

HARPER

An Imprint of HarperCollins*Publishers*

HarperCollins books may be purchased for educational, business, or sales promotional use. For information, please email the Special Markets Department at SPsales@harpercollins.com.

FIRST EDITION

Designed by Bonni Leon-Berman

Illustrations by Daisy Okazaki

Library of Congress Cataloging-in-Publication Data has been applied for.

ISBN 978-0-06-308172-7

23 24 25 26 27 LBC 5 4 3 2 1

In Memory of Beatsy Orenstein: ILFMM

and

In Memory of Mel Orenstein, because I also LFMD

It may be that when we no longer know what
to do we have come to our real work.

—*Wendell Berry*

contents

from sheep to sweater

SHEEP DON'T LOOK LIKE THEY'D BE slippery. It turns out, though, that they secrete a waxy substance called lanolin that weatherproofs their fleece—it's the same stuff that's in a lot of cosmetics, moisturizers, lip balms, and in the ointment nursing moms slather on cracked nipples. That means that when you try to hang on to one, it slides. The ewe currently wedged belly-up against my legs is no exception: weighing in at around one hundred forty pounds, she is wriggling like a greased-up toddler. A greased-up toddler with hooves. Did I mention that I'm holding a rapidly whirring electric clipper in my

right hand? Its blades, which have no safety guard, are sharp enough to sever my finger, or, maybe worse, slice open a major artery on the animal. My arms are glistening with sweat from wrestling the sheep into position, my back already aches, and my Covid mask is stifling me. Learning to shear sheep during the pandemic seemed like a bit of a lark—a way to tap into the romance and resilience of an earlier age; to connect with something enduring when life had become so precarious; to better understand, as a lifelong knitter, where my fiber came from; to get out of my house. *Why the hell couldn't I have stuck to sourdough?* I think to myself as I look down at the giant ball of wool beneath me, raise my hand, grit my teeth, and prepare to plunge in.

THIS WAS CERTAINLY NOT where I imagined myself at the beginning of 2020. In early January I published a book on boys, masculinity, and sexuality, a follow-up to one I'd written about girls. I was on a national tour in a different city every day, doing media spots, meeting hundreds of people at book signings, lining up a roster of speaking engagements for the upcoming spring and fall. The pace was exhausting, exhilarating: I'd worked for decades to get here, to have this platform, this reach, to feel like my ideas were making an impact. In the midst of it all, a friend back in California texted me an emoji, the one that looks like the face in Edvard Munch's *The Scream,* along with the words "Covid-19!"

I had no idea what she was referring to.

A couple of months later, things had changed. On March 9, a Monday, I dropped my sixteen-year-old daughter, Daisy, off at high school

in Berkeley, then headed to the airport: I was supposed to give three talks in Los Angeles over the next couple of days—at a preschool, a high school, and a college—then fly to New York for a network TV appearance. Ever the modern working mom, I had organized the trip to be home in time for Daisy's swim meet on Friday. But I was growing increasingly uneasy, thinking about all the people who would have touched the airplane's seats, tray tables, and armrests (this was when we still believed Covid was transmitted through physical contact). I thought about the myriad surfaces in the hotel rooms; the restaurants where cooks and servers would touch my food, plates, cups, flatware, the pen they'd give me to sign the check. I thought about everyone who'd want to shake my hand at the events, or hug, or ask me to autograph a book they'd been holding with their bare fingers.

All of these things—things I normally wouldn't have noticed, some that I actively enjoyed—made my breath come short and my chest tighten. Even as I tried to convince myself that it was fine, that I was being ridiculous, I pulled off the freeway to turn around. My plane was leaving in less than two hours. I would not be on it. "But we'll have hand sanitizer at the event!" one host wailed when I phoned in my apologies.

We all know what happened next. Within forty-eight hours, the students at the college I was booked at were sent home. By Thursday, Daisy's swim meet was called off, as was that weekend's SAT (it would be canceled six more times in the coming months; she never did use those number two pencils). Within a week, the high school had shut down; it wasn't clear how or whether classes for its thirty-four hundred students—many of whom had no computer at home and some of whom did not have a home at all—would continue. It felt like we were falling backward in slow motion, arms and legs flailing for purchase.

What did you do when life came to a terrifying, screeching halt? Me, I read the news incessantly, then avoided reading the news entirely: rinse and repeat for weeks, then months. I fixated on the *New York Times* Spelling Bee, discovering the hidden, secret designation of "Queen Bee" for those who get all the possible words. I scrolled and kibitzed on social media. I told dear friends, in soulful Zoom sessions, that I loved them (often while accidentally on mute), feeling simultaneously deeply connected and deeply disconnected. I made a list of Great Books for Daisy to read in case school never resumed (she balked). I gave it up and lifted all restrictions on her device use, the ones that were supposed to keep her from becoming a slave to the algorithm. I let her become a slave to the algorithm. *I* became a slave to the algorithm.

I washed groceries, sealed mail in Ziplocs, nagged everyone to scrub their hands—*yes, again!*—sanitized my own red and raw. I refused to buy extra toilet paper; I bought extra toilet paper; I felt ashamed for buying extra toilet paper. I made myself cry picturing my husband, Steven, dying of Covid: he is over sixty-five and was not as scrupulously careful as I would have liked if he would only have let me be in total control. I drew up a list of all my passwords and wishes in case *I* died of Covid. I recalled a self-defense skills class I'd taken with Daisy when she was in kindergarten in which both the kids and the parents were encouraged to "stay safe in your imagination"; I did not stay safe in my imagination. I don't know anyone who was able to stay safe in their imaginations, except maybe Steven, who always says there is no point fretting over something that might never happen.

There was another layer of worry—more of existential angst—that had been building for me before the pandemic, but my perpetual motion and the vagaries of daily life had allowed me to avoid dwelling

on it. I was getting older, a lot closer to sixty than fifty (okay, okay, I was fifty-eight). Steven, a documentary filmmaker, was talking about retirement—*retirement!*—or only taking on work that genuinely excited him, which amounted to the same thing. Daisy would be leaving for college in a year, ending the most intensive time of parenting and taking a chunk of my identity with her. Who would I be once she was gone? Watching from the kitchen as she sat at the dining room table doing research on colleges, I remembered the three-year-old in red sneakers, her hair in two spouts on top of her head, who would peek around the doorway wanting to play pretend. "Look at this, a little child!" I was supposed to say in mock surprise. "Are you all alone? Can I be your mama?" It was a bit she wanted me to repeat over and over until I was exasperated—and why was I so exasperated, why didn't I play as long as she would want?

I wasn't ready. Not for any of it. There are libraries of books for women on balancing work and motherhood—I wrote one myself!—as if that is the entirety of our existence. This next phase? It's like dropping off a cliff. Yet another cliff. We are not a culture, to say the least, that venerates older women—the sheer amount of age-forfending plastic surgery we engage in (not blaming, just noting) is testament to that. When someone wrote in the *New York Times* that while she was turning sixty, she still felt twenty, I thought, *Yes. . . .* and *no.* Turning sixty, I feel sixty. Like even though I can—*flex!*—still do a handstand in yoga class, that doesn't take away from the amount of sand at the bottom of my personal hourglass. Now, suddenly, in lockdown, I had a lot of time to ruminate about how I got here, what I might have done differently, how I might spend the precious productive years that remained, how few they were starting to seem in number. Writing felt impossible, but that didn't matter—my work

had evaporated anyway, leading to yet another source of panic. Just when I'd gotten my life together, it seemed to be unraveling.

I confided my feelings all day, every day, to my mom. She never answered back. That's because she's been dead since 2016, a month shy of her eighty-sixth birthday. In the four years prior to that, she'd struggled with advancing Parkinson's disease, a heart valve replacement, a long-overdue cochlear implant, and, finally, terminal pancreatic cancer. She spent her last eleven days in a hospital bed in the living room of the apartment she'd shared with my dad at an independent living facility, unable to eat, drinking only tiny sips of water from a dropper. My dad, her children, her grandchildren, all wandered in and out, mixing our mourning with the mundane: we would be eating pizza or take-out Chinese at the dining room table; Mom would be on the other side of the room, dying. It was intense and it was difficult, but it was not *bad*. That ushering out felt like part of life, natural. We could all be there for her and for one another in a way we'd be denied were it happening now—a loss within that greater loss that I can't even fathom.

My mom was the one who'd first taught me to knit when I was around eleven. This would prove so ubiquitous among women I met while writing this book that I began abbreviating it in my notes as SLFHM, *she learned from her mom*. No surprise there: craft has always been the province of women. Lessons on food or thread weave us together across the warp of time, the weft of space. For my mom and me, knitting bridged the generation gap, created reliably neutral ground where we could meet. When things were fraught between us—when I bristled at her, fairly or not, for being intrusive or narrow-minded or lacking all boundaries, when I resented that as a housewife of her era she could not be the guide to contemporary womanhood I needed—we

could still bond over a trip to the yarn store, picking out our patterns, comparing colors, fondling the merch. She was a far better knitter than I, too, so although I dismissed her advice on nearly everything else, I would eagerly seek it out on a complicated sweater.

I never did ask how *she* learned to knit—her own mother, an immigrant from the nebulous region of Eastern Europe known only as "the Old Country," did not, to my knowledge—so the answer disappeared at my mom's death, along with those to so many other questions that, in the self-absorbed ways of daughters, it never occurred to me to ask. Mom, were you happy? Did you have regrets? Were you ever lonely? Who did you talk to when things got hard? How did you survive parenting a teenage girl? And how, as that girl prepared to leave home, did you ever let her go? I don't know, at any rate, that I would've wanted to hear the answers, that I would've listened. I may have griped to my friends that my mother didn't *see* me, not the *real me,* but did I ever truly see her? Did I even try?

What I really wish for now is something impossible, in defiance of both physics' and nature's laws: not to talk to her as she was at the end of her life (or as she would be were she still alive today, at ninety) physically frail, psychologically shaky—but to have a conversation with her at my age, and for me to be this age as well. Instead, I talk to her in my head, taking on both our roles, while knitting my thoughts, feelings, and fears into multicolored blankets and warm winter hats, just as she taught me.

In the pandemic's early days, the rhythm of my hands, of the needles, as I sat on the couch watching TV (whether the news or anything but the news) was the only thing that calmed me, kept me still and patient. I couldn't control what was happening in the world but I could control this: the tossing of the yarn, the tugging of the loop,

the counting of the stitches, the accrual of the rows. Knitters are fond of pointing out that the repetitive action of needlework, like meditation or yoga, induces a relaxation response. It can lower blood pressure, heart rate, stress hormones. As a bonus, you get the primal joy of transforming raw material into something useful and, hopefully, beautiful. No wonder during this time everyone who could—everyone safe and stable within a certain social class, all of us "worried well"—embraced old-timey, domestic crafts. We yearned for the tangible even as we flocked to the virtual, reverted to bygone comforts even as the present (and the future) were yanked from beneath us. We turned skills that were once—but are no longer—crucial to survival into 'grammable symbols of self-sufficiency and indomitability.

I was especially primed for such behavior, and not only because my mom was a knitter. Her father's family had homesteaded in North Dakota, sponsored by a German-Jewish industrialist who had dedicated his fortune to rescuing his Eastern European compatriots from pogroms and persecution. Initially, his charity paid my great-grandparents' passage from Minsk to Moisés Ville, an agricultural settlement in Argentina that some envisioned as an alternative to a homeland in Palestine. They hated it, and subsequently, through the same organization, made their way north and west.

As an adult, I would recognize the true cost of their good fortune: the homestead was just up from the Standing Rock Sioux reservation where the Lakota and Dakota people had been corralled to make room for those white settlers. As a girl, though, I loved my grandpa's stories about picking chokecherries and blackberries, about clearing fields, raising barns, breaking wild horses. I even liked hearing about how his older brother, who'd moved to Montana, shimmied up a drainpipe during the 1918 flu pandemic for a clandestine visit to his

wife who was quarantined in the hospital; she recovered, he got sick and died. It seemed so . . . *romantic.*

Maybe that's why, scrolling by all those loaves of bread, tie-dyed sweat suits, and DIY knockoffs of Harry Styles's cardigan, I began to think, *Why stop there?* This enforced pause in life could be my one chance to connect not only with my mom but with my ancestors, to act out my fantasies of going full-on *Little House*—setting aside the fact that Laura Ingalls, whom I also adored as a child, was, frankly, racist, and, in her post-frontier life, believed the New Deal was a socialist plot. I'd long dreamed, for reasons that, much as my editor would like me to, I can't fully explain, of making a garment from scratch: shearing a sheep (though I did draw the line at raising one, or at least the city zoning laws drew that line for me), processing fleece, spinning and dyeing yarn, then knitting up the result.

Now, with an indefinitely empty calendar, nothing was stopping me from trying—at the very least, it would take my mind off the state of the world, give me something to do besides sit here and stew. What I didn't expect was all I'd discover about how clothing has shaped civilization, class, culture, power, or its pivotal role in our environmental future. I didn't imagine how these ancient skills would deepen my awareness of women's work or challenge my sense of place and home. I didn't anticipate that this quirky little project would reflect the social justice reckonings of the moment, or that making yarn would help me untangle the knots of my own life. All I knew was that while everyone else was stress-baking and doomscrolling, I felt an inexplicable, unquenchable urge to confront a large animal while wielding a razor-sharp, juddering clipper; shear off its fleece; and figure out how to make it into a sweater.

unraveling

1

you do ewe

IT'S NOT AS SIMPLE AS YOU might think to find a sheep to shear. For
one thing, they don't produce fleece on demand. Shearing is seasonal
work, and that season varies somewhat with geography and climate.
In Northern California, where I live, it runs January to June. Any
other month, you will be largely out of luck. Also, may I remind you,
I was attempting this project during the height of the pandemic. It
would have been challenging to find another person willing to stand
six feet apart from me for an afternoon of *any* activity, let alone one
involving a huge amount of sweat and heavy breathing.

Even under ordinary circumstances, learning to shear is tricky. There is only one annual five-day course offered in the entire state: in Mendocino County, a few hours north of my home in Berkeley. I'd tried to sign up for it before, but either it was offered when I was going to be out of town (because in the Before Times I was seemingly always going to be out of town), or the online registration closed too quickly. In 2019, the class filled within two minutes. I don't know why all these people are so intent on stripping down a sheep; since there continues to be a critical shortage of professional shearers, I presume that most, like me, are crafters in it primarily for the experience.

Maybe that was another reason sheep shearing appealed to me: it is a job drifting toward extinction. As a writer of books—a trade that, in the modern world, seems to be going the way of the blacksmith, the lamplighter, the gandy dancer (the what, you say? *Exactly*)—I have a fascination with defunct jobs of bygone eras. In the U.S. there are fewer than five hundred professional shearers left for over five million sheep. The larger, commercial endeavors bring in crews from Central and South America or Australasia, but in those regions, too, the trade is in decline. Australia has only twenty-eight hundred shearers for roughly seventy-three million animals; there are apparently too many other ways to make a living that don't require bending over for eight hours a day while an ungulate kicks you in the face. During the pandemic, when travel was restricted, the shearer shortage hit a crisis. In Spain, farmers became so desperate that they petitioned the king to intervene with the government on their behalf, allowing them to charter a plane for shearers from Uruguay.

Given all that, automation would seem inevitable, even desirable, but so far all attempts to mechanize shearing have been a bust. A much-ballyhooed effort in the 1980s, the "shear magic," required an operator to stretch out a sheep's legs as if it were being rotisseried and

strap it to a rack before two clippers dropped down from above, like scrubbers in a car wash, to shave it clean. The process not only looked traumatic for the animal, it took twice as long as hand shearing. Plus, the machine wasn't portable, so it couldn't be carried from ranch to ranch.

A decade or so later, something called "biological wool harvesting" also had a moment: ranchers would cover their sheep with what looked like giant hairnets, then inject them with a protein that would cause the fleece to break at the skin. After a month, they removed the net and, voilà! The wool fell right off. It sounded good, but the nets were fiddly things, and anyway, they only worked on smaller animals, so interest quickly faded. Most recently, in 2019, an Australian tech company unveiled a pair of disembodied, robotic arms that eerily mimic a human shearer's movements. They've so far only been tested on life-sized 3D-printed sheep (designed, also eerily, to replicate the shape and contours of the real thing, except without faces or legs), but since the arms become "smarter" with each shearing, they may someday hold promise; certainly the plastic sheep seemed unfazed by the experience.

At any rate, the Mendocino class, like everything else, was canceled during the pandemic. There were a few courses still running in other parts of the country, but they were in places where too many people for my comfort did not believe Covid was real; besides, I wasn't eager to get on an airplane. To add to the difficulty, I was determined to learn from a woman. Thirty-some years ago, when I moved from Manhattan to the Bay Area, I briefly took up windsurfing: it fit my Hollywood-inflected vision of What One Does in Sunny California. I did not fully comprehend that San Francisco was in the chilly, *northern* part of the state, nor that the water in the bay typically hovers around fifty-four degrees. My first time out, buffered by a neoprene wetsuit that made me feel like the Michelin man, I tried

repeatedly to heave the sail out of the water. No luck. Female surfers don't have the upper-body strength to muscle the mast like guys can. But my teacher, also a woman, said she saw that as an advantage. We had to learn sooner to surf correctly, through balance and counterweight. Ultimately, she felt that made us progress faster. I suspected the same principle might hold true in shearing.

It turns out that while the number of women in the profession has grown over the past several decades, 95 percent of shearers are still male. In part, that's because the work is, indeed, so physically grueling: shearers are fond of saying that theirs is considered "the hardest job in the world," and that they burn five thousand calories daily. Running a marathon, by comparison, burns a piddling twenty-six hundred. Although I'm duly impressed by that information, the message clearly doesn't sink in, since I persist in believing that, as a woman on the south side of middle age, I will easily be able to do this thing. *No problem, sign me up!*

The job may also skew male because it's migratory work—small-flock shearers have to go to where the sheep are, driving thousands of miles a season, sleeping in cheap motels or the cabs of their pickup trucks. Shearers have the rugged, rambling reputation, if not quite the mystique, of cowboys. That lifestyle doesn't necessarily appeal to many women, let alone mesh with potential family obligations. Really, though, the biggest reason for the gender disparity is that age-old combo of tradition and misogyny. Shearing is one of the many vocations (like seafaring or stock trading) that, for generations, hung an invisible "no girls allowed" sign outside its clubhouse, convinced that the presence of a coworker with a vulva was an existential threat to a precious way of life. Historically, in Australia, when a woman approached the shearing shed, whichever man spied her first would

shout, "Ducks on the pond!" indicating that the other dudes should stop their presumably incessant cursing and spitting and, I don't know, comb their hair or pull their pants up to cover their ass cracks or hide their porn or some such.

Eventually, through numerous inquiries at local yarn shops and fiber studios, I found Lora Kinkade. A tall, broad-shouldered twenty-nine-year-old, with strawberry-blond hair cut in a chin-length bob, she has been a professional small-flock shearer for four years. She also manages an organic produce farm near Mendocino. Lora knew a ranch in Sonoma County raising some longer-haired sheep breeds that could stand a midseason trim. She would be pleased, she said, to give me a lesson.

BELLY, CRUTCH, UNDERMINE, TOP KNOT, NECK, CHEEK, FIRST SHOULDER, SHORT BLOWS, LONG BLOWS, LAST SIDE.

BELLY, CRUTCH, UNDERMINE, TOP KNOT, NECK, CHEEK, FIRST SHOULDER, SHORT BLOWS, LONG BLOWS, LAST SIDE.

There are many ways to shear a sheep, but today's most used approach globally was pioneered in the 1950s by a Kiwi named Godfrey Bowen—referred to as "the Nureyev of shearing"—along with his brother, Ivan, who may have resented that he was not. The Bowen method does, indeed, unfold like a ballet. There are nine positions and forty-eight cuts (or "blows"), starting with the belly, then the "crutch" (under the tail and between the legs), the "undermine" (left

flank and lower back), and so on—all repeated, along with intricately choreographed footwork, in the same order each and every time. The sheep's body, too, is guided into a series of precise postures in relationship to the shearer, a semicircle that ends with the animal ideally situated to stand up and walk away. The technique is efficient and ergonomic for both humans and sheep, combining the speediest possible shearing with the least potential for injury to all. It also yields the highest-quality fleece. A charismatic public speaker, Godfrey traveled and taught throughout the world. He received an MBE (member of the Order of the British Empire) in 1960 for his exceptional contribution to the realm, the same honor later bestowed on the likes of Ed Sheeran and Adele. A few years later, Nikita Khrushchev conferred the Star of Lenin on him for his work with Soviet shearers (the actual Nureyev had by then defected). Godfrey, who promoted the idea of competitive shearing, was also among the first people inducted into the New Zealand Sports Hall of Fame. He died in 1994, at the age of seventy-two, but I think he'd be chuffed to know that a YouTube video of his work has been viewed over three million times.

Also on YouTube: some gruesome videos shot by animal rights activists of sheep being maimed, cut, and even left to die by shearers. Anytime humans interact with animals—whether for food, fiber, or as pets—abuses happen, and they are inexcusable; I don't want to dismiss that. There may be aspects of large-scale shearing that unwittingly encourage inhumane treatment—the machismo; the fact that payment is often based on the number of sheep sheared; the ways that shearers are pitted against one another, assigned to their spots based on their previous day's count. Some ranches also engage in mulesing, a controversial practice in which strips of skin are painfully sliced from around the animals' tails to reduce the threat of a fatal maggot infestation. Still, mistreatment is not the norm, most certainly not

among smaller flock shearers. The truth is, when performed properly, shearing does not harm the sheep. Quite the opposite. In the instructional videos I watch—of Godfrey Bowen and many others—the process is quick and the sheep docile, flopping about like rag dolls. "I'm not saying they love it," Lora tells me when we speak on the phone, "but it doesn't hurt them, and it's necessary."

She's right about that. To find a time before sheep required shearing you'd have to go back to the Stone Age. More hairy than woolly, that ancient progenitor of today's animal—the mouflon, a name I think they should've stuck with—was one of the first to be domesticated by humans, right after dogs, primarily as a source of milk and meat. Somewhere along the line, some clever soul discovered that twirling together strands of the mouflon's coat created strong, sturdy cord. It was part of what Elizabeth Wayland Barber, a linguist and textile archaeologist, calls "the String Revolution," a technological leap as influential as, if less celebrated than, the harnessing of steam during the Industrial Revolution. In her history of ancient women's work, she writes that string (first derived from plants 120,000 or so years ago) not only resulted in the literal fabrication of fabric, it also allowed humans to tie things together, which meant carrying more. It allowed us to bind, to tether, to develop next-level tools, such as snares to catch animals or nets to catch fish. Barber goes so far as to speculate that—move over, fire—the humble string was "the unseen weapon that allowed the human race to conquer the earth."

Initially, to harvest fleece, people wandered hither and thither looking for bits that the animals had shed or that had gotten snagged on branches: hence, the aimless, dreamy state we refer to as "gathering wool." Over the next several thousand years or so, the whole idea of breeding sheep for fiber emerged. The early, primitive varieties had double coats—longer and coarser on top, finer underneath. Women

were tasked with plucking the seasonally loose wool directly from the sheep's bodies, which they did reputedly while rocking and singing to calm the animal, perhaps a precursor to our own counting sheep to fall asleep. Some ancient breeds that remain, such as the Icelandic and Shetland, still drop their heavy winter coat, so are "rooed," their wool pulled off by hand, each spring.

Sheep continued to co-evolve with people, their cultivation spreading across Europe, Asia, and Africa. Today there are over a thousand breeds of domestic sheep—well over a billion animals worldwide. Some have external ears, some don't. Some have horns, some don't. Some produce wool that is plush against the skin, others coarse fiber suitable for high-traffic rugs. Some "hair sheep" don't produce much fleece at all and are raised primarily for meat, though most contemporary sheep are still woolly.

Since sheep fiber decomposes (beneficial environmentally, if not archaeologically), it's difficult to pinpoint when, exactly, the transformation of wool into fabric became common. Safe to say it's been a minute. The oldest examples we've got were found on "bog bodies" in Northern Europe: human corpses that had been naturally mummified by peat swamps. Based on their still-visible, preserved wounds, the bog bodies seem mostly to have been pitched into the muck after having met with a violent end: murder, execution, ritual sacrifice. Peat is acidic, so it can dissolve bone but tans protein—skin, hair, nails, internal organs, as well as leather and wool—leaving it so perfectly intact that turf cutters who have inadvertently dug up Iron Age bog bodies have assumed they were freshly killed and called the police.

Some of the earliest surviving wool garments were found in 1835 folded neatly atop the body of "Haraldskær Woman," a lady around my own age who died in fifth-century BCE Denmark. Forty-four

years later, not far away, "Huldremose Woman," a second female bog body of similar vintage, was found still dressed in a checked wool skirt, a wool scarf, sheepskin capes, and linen underwear. The peat had turned her ensemble brown, but color analysis showed the skirt was once blue and the scarf red, colors that would signify wealth.

During antiquity (and beyond), fortunes rose and fell on sheep. There is a reason that Jason and his Argonauts sought a golden fleece in Greek mythology rather than a golden cowhide. In Italy, the Medici family's financial empire—whose political, economic, and cultural legacy can be felt to this day—was made possible by their earlier success as wool merchants. In Spain, the wool trade financed the journeys of Columbus and the conquistadors; until well into the eighteenth century, anyone caught exporting sheep from that country without permission was put to death. Under Henry VIII, wool comprised 90 percent of England's exports, the most valuable commodity of his domain.

After millennia of selective breeding for the fluffiest animals possible, most sheep have lost their ability to shed or otherwise regulate their fiber growth. You could argue that our voracious needs created a monster. Unshorn, modern sheep can die in the summer heat (imagine walking around wearing the equivalent of ten sweaters in ninety-degree temperatures) or lose their balance, tip onto their backs, and slowly suffocate. They become infested with flies, lice, and maggots; they can't run or see a predator's approach; they have difficulty grazing; and lambs are unable to reach their mothers' teats to nurse.

In February 2021, construction workers found a rogue sheep, christened Baarack (get it?), wandering the Australian bush. Struggling and blind beneath years of accumulated wool, he resembled an

enormous, grungy cotton ball, but with hooves and a snout. When he was shorn (an event that garnered 18.5 million views on TikTok), his fleece weighed seventy-eight pounds, about ten times that of an average, well-tended sheep. That's enough for over sixty sweaters or nearly five hundred pairs of socks. Underneath it all, poor Baarack was actually underweight, starving from being unable to get his mouth past all that wool to reach a food source.

Baarack was still short of the record: that is held by Chris, a wayward merino ram rescued in New South Wales in 2015. Chris, who was named after a sheep from a British sitcom, was carrying ninety pounds of fleece; the shorn result is on display at the National Museum of Australia, where it is a highly popular exhibit. The animal sanctuary that sheltered Chris until his death four years later from natural causes commented, "This is no title to covet, as it amounts to being the most neglected sheep in the world."

The idea, then, that sheep shearing is inherently cruel is woefully ill-informed, and yet it persists. In 2019, the actress and PETA activist Alicia Silverstone appeared nude on a Times Square billboard, the phrase "Leave Wool Behind" scrawled across her rear. How clueless! Lucky Brand clothing, meanwhile, promoted its polyester "shearless fleece" sweaters with tags that read, "The world needs more fat sheep," illustrated by a photograph of Shrek, an escaped wether (castrated ram) who was found in the mountains of New Zealand lugging a perilous sixty pounds of unshorn wool. Neither he nor the world "needed" that. After being "educated" by the American Sheep Industry Association as well as avid yarn crafters, Lucky apologized in a tepid "we did not intend to offend anyone" sort of way on social media.

BELLY, CRUTCH, UNDERMINE, TOP KNOT, NECK, CHEEK, FIRST
SHOULDER, SHORT BLOWS, LONG BLOWS, LAST SIDE.

BELLY, CRUTCH, UNDERMINE, TOP KNOT, NECK, CHEEK, FIRST
SHOULDER, SHORT BLOWS, LONG BLOWS, LAST SIDE.

You can't wear just any shoes in a sheep-shearing pen. The wood floors
get slick with lanolin. If you wear hiking boots, sneakers, or anything
else with a conventional tread, your feet will slide out from under you,
landing you smack on your butt. Or worse. Sheep-shearing shoes (say
that three times fast) are suede, like moccasins. Over time, the soles
build up a patina of lanolin, which helps them stick to whatever
is on the floor. When mine arrive in the mail, I pop them on, de-
lighted. They are black with bright red laces threaded around the top
edge that I cinch into pleats to create a custom fit. If I wasn't about
to get them completely covered in sheep yuck, I'd consider keeping
them as indoor slippers. As it is, I strut around the house for the rest
of the afternoon, periodically holding up a foot to admire it.

Daisy emerges from her bedroom lair, where she's been largely
holed up since Covid closed the high school, glances down at my feet,
and freezes. "What are those?" she asks, with the edge of disdain that
only a teenage girl can muster.

"My new shoes!" I say. "Do you like them? I'm going to wear them
everywhere!"

She shakes her head, her expression a mixture of alarm and dis-
gust. "Mom, you can't wear those."

I laugh and tell her what they're really for.

"So, you're only going to use them *once*?" she says. I nod and she
looks first relieved, then suspicious. "What did they cost?" I attempt,

unsuccessfully, to take advantage of the teachable moment to explain to her about tax write-offs.

I've also bought a singlet—a sleeveless undershirt that reaches nearly to my knees—that will keep my rear well covered as I work. The company insignia of its maker, Horner Shearing, is emblazoned on the back: a drawing of a longhorn ram's head—or it could be a diagram of a human woman's reproductive system, but, given the context, I'm fairly confident of my interpretation. I pull it on over my jeans, simultaneously feeling badass and dorky. Again, my daughter opts for the latter.

"Mom," she repeats, "you can't wear that."

"I *can*, actually," I counter. "In fact, I think over a pair of leggings it would make a fetching summer dress!"

She looks appalled. I pause for a moment to consider: as someone who writes about the touchy issues of girls, body image, and slut-shaming, I frequently advise mothers to stay mum about their teen girls' more egregious fashion or makeup choices; I know I've exhibited near-superhuman restraint myself at times. She, however, feels utterly free to act as my personal fashion police—much of the time, I admit, I'm grateful to her for it. I let that thought go, as all mothers must, as I'm sure my own mother did when I criticized how she applied blusher as I swanned around in my tube top and Candie's, reeking of Love's Baby Soft. Steven, meanwhile, who has sauntered in from the kitchen and witnessed our conversation, gives me a quick once-over and says, "Sure, Peg." It does not sound like he is agreeing with me.

To complete my 'fit, I need a pair of heavy work pants. I decide that I've spent enough and can get away with repurposing a pair of red jeans that I never wear but keep around out of guilt and because, you never know, in some distant future they might come back into style. Or come into style in the first place. They definitely do not spark

joy. But—take *that*, Marie Kondo—they're sure useful now because I won't have to wear my actual joy-jeans in the shearing shed, potentially ruining them forever.

BELLY, CRUTCH, UNDERMINE, TOP KNOT, NECK, CHEEK, FIRST SHOULDER, SHORT BLOWS, LONG BLOWS, LAST SIDE.

BELLY, CRUTCH, UNDERMINE, TOP KNOT, NECK, CHEEK, FIRST SHOULDER, SHORT BLOWS, LONG BLOWS, LAST SIDE.

I repeat the words of the shearing pattern to myself as I do laundry, as I make lunch, as I shower. I watch videos that Lora sends me of burly men with Australian accents who seem to de-fleece sheep in seconds. I pretend I'm holding clippers—called a handpiece—and practice the blows along with those men on my daughter's stuffed Snoopy, the one she got at age two from Children's Hospital when she had to have her leg x-rayed. Next, I try it on my labradoodle, Ginger, turning her this way and that, sliding the imaginary blades along her belly, up her haunch, across her neck. She endures the game without complaint, but it isn't all that helpful. *There is no way I will remember this,* I think, when faced with a slithery animal that both outweighs me and doesn't want to be there.

Lora emails links to strengthening exercises for my legs and back. "The work is uniquely physical," she writes, in what will turn out to be a massive understatement. She also sends a release form absolving her of all responsibility should I be injured. Sheep's hooves are sharp and

they kick when they are unhappy. Along with the overall physicality of the work, I've chosen to ignore that fact. I further agree that should I lethally injure any animal I'm shearing—something that neither Lora nor any of her students has ever done—I will compensate the ranch two hundred dollars in damages. I sign my name with diminishing certainty and the sincere hope that I will still have all my teeth by the end of the day—and that the sheep I shear will still have all of theirs.

BELLY, CRUTCH, UNDERMINE, TOP KNOT, NECK, CHEEK, FIRST SHOULDER, SHORT BLOWS, LONG BLOWS, LAST SIDE.

BELLY, CRUTCH, UNDERMINE, TOP KNOT, NECK, CHEEK, FIRST SHOULDER, SHORT BLOWS, LONG BLOWS, LAST SIDE.

AT AROUND SIX ON a Saturday morning, I pack a lunch, fill a couple of water bottles, and throw on my singlet and red jeans (I'll put on my shearing shoes when I get to the ranch). My phone buzzes. It's a message from the Alameda County emergency notification system, warning about elevated fire danger in my neighborhood. I downloaded the app for the first time earlier in the summer. We live along a ridge at the top of Berkeley, just below a street picturesquely named Grizzly Peak and only two blocks from the largest urban wilderness in the country: a string of seventy-three thickly forested parks shot through with over a thousand miles of hiking trails. On my daily walks, I've seen foxes and deer, opossums and raccoons, owls and red-tailed hawks; occasionally, I've bumped into rattlesnakes and

mountain lions (I would prefer not to). All less than ten minutes from the town's urban center.

Although I have long fretted over the potential for earthquakes in California—refusing to hang pictures over the beds, bolting the house to its foundation, and, well, I've always *meant* to secure the bookcases to the wall in the living room—until recently, I didn't worry much about fire. True, five years before we purchased our home an inferno whipped through the neighboring Oakland Hills, destroying nearly thirty-five hundred houses and killing twenty-five people. Steven and I, still only dating, watched from the roof of his apartment building across town as homes went up like matchsticks and oily eucalyptus trees exploded, spreading the flames. Ash rained down and the sky turned dark, but we were never in any real danger. Although that fire was shocking, it seemed . . . a fluke.

Twelve years later, the Rim Fire burned over 257,000 acres in the Stanislaus forest, in and around Yosemite, where Daisy and I had for six years attended Berkeley's "family camp." Built in the 1920s as an escape from summer fog and rapid urbanization, the rustic assemblage of wood-floored tents, more than anything else, had represented her childhood to me: a week a year with neither screens nor cell service and the freedom kids used to have to roam around at will. We'd returned home from our annual visit just days before the blaze erupted. I watched on a real-time online map as the fire moved toward, then away from, then toward, then away from the riverbank where the camp stood. Then, one morning when I looked, the area was engulfed by a giant blob of red. Gone. I wept as if I'd lost a relative. Still, that fire was started by an illegal camper, so while tragic, it, too, seemed . . . a fluke.

There were others, increasing over the years, but, always, there seemed a *reason:* mismanagement of equipment by PG & E, our local

utility company, for example, caused over fifteen hundred fires in six years, including the 2018 Camp Fire, which was, at the time, the most expensive, destructive natural disaster in the state's history. Then came 2020, the year California began to burn in earnest. In August, the state's first "gigafire" (a word coined specially for the occasion) would incinerate over a million acres in the north, an area larger than Rhode Island. Four more blazes, sparked within weeks of one another, would destroy nearly another combined 1.5 million acres. California's oldest state park, Big Basin, where we used to hike among redwoods that were fifty feet around and as tall as the Statue of Liberty, would all but disappear. Already locked down in our house because of Covid, we shut our windows tight against the smoke. Few homes in this area have air-conditioning. It's sort of a point of pride. We don't need it: we have "Karl the fog," nature's own cooling system. There may be a handful of oppressive days each year, but they don't last. Locals tend to say if you don't like the weather, wait a few minutes, it'll change. Not this time. Our house sweltered. The air choked us. I scrambled to find purifiers online for every room (at newly inflated prices).

Climate change had combined with misguided fire-suppression policies to shift our home into an official high-risk fire zone. My phone pinged with "red flag warnings," instructing us to be ready to evacuate at a moment's notice should a blaze ignite nearby. PG & E cut off our power, sometimes for days, mostly, it seemed, to avoid being sued for touching off yet another firestorm. We set "go-bags" by the front door; mapped all possible escape routes; moved our passports, birth certificates, photo albums, and other valuable or treasured items to Steven's office across town. I obsessively scanned the real estate listings, thinking we should move, but couldn't hope to compete with the young technorati who, since the pandemic, had

been decamping here from San Francisco for more space and a yard, driving the already astronomical housing prices even higher and paying their way in cash. Now, on those walks in the woods, I looked at the fallen branches, twigs, and detritus lining the paths, the record number of dead and dying trees with their browning leaves, and all I could see was tinder. Steven, as always, was less concerned, shrugging when I informed him that a fire could engulf the 1.5 miles between our house and the bottom of the hill in less than a half hour.

So we stay, uneasily, unsure of what else to do. I text my still-sleeping husband about the latest warning, hope for the best, and head out the door.

ACROSS THE RICHMOND–SAN RAFAEL Bridge, the unsung span that connects Berkeley to the North Bay, the air is foggy and damp, the way it should be at this time of year. I drive northwest past grazing cows, silent farm equipment, faded whitewashed barns (one with a hand-painted sign that reads, CELEBRATE KINDNESS, because we are still in Northern California). This is Sonoma, wine country, so there are also discreet signs for luxury spas where those aforementioned tech types unwind. The ranch I'm visiting is outside the town of Bodega, which, along with the adjacent fishing village, Bodega Bay, is famous as the setting for Alfred Hitchcock's *The Birds*. Gulls still circle the docks behind the Tides Wharf & Restaurant, where the first avenging avian dive-bombs into Tippi Hedren's head, although these days the risk there is less being pecked to death than experiencing disappointment over the decidedly mediocre clam chowder.

Hitch, I'm sure, would find no shortage of cinematic symbolism to illustrate today's horrors. Sonoma has been hit hard by rising temperatures, reduced rainfall, and wildfire. The year's grape harvest will likely be devastating, the flavor of the fruit ruined by smoke. Wells are running dry, and produce farmers can no longer water their crops. Some of the best-known, pioneering organic growers in the region are on the precipice of collapse. With less grass, a shorter season, and soaring costs for supplemental hay, ranchers struggle to feed their livestock; even those using recycled wastewater no longer have enough for their animals to drink. Local sanctuaries are flooded with calls, sometimes from people in tears who have lived on this land for decades, generations, but don't know what to do: they're no longer able to maintain their cattle, sheep, or horses, and no one wants to buy them. Hundreds of animals have been "dumped": snuck onto a neighbor's property or abandoned on a back road with the hopes that somebody, somewhere, will take care of them.

A wooden sign for Bodega Pastures, topped by a hand-whittled ewe, directs me onto a dirt road. The ranch is a thousand acres, with about two hundred sheep; it has so far been safe from calamity. I wind my way past a chalkboard with a to-do list scrawled on it; a few houses; picnic tables; a building that, before the pandemic, housed a preschool. During the day, animals wander freely here (at night they are penned to keep them safe from coyotes); several eye me from the side of the road, and I'm suddenly keenly aware of how large sheep are. Spotting Lora's pickup truck in the dirt yard of a weathered wooden barn, I take a deep breath.

"You can do this!" I tell myself, and drive through the gate.

shear madness, shear delight

LORA IS CHATTING WITH JAY SLIWA, a rancher in his early thirties with a shy smile and, coincidentally, the same unusual strawberry-blond hair as hers, but tied into a braid that hangs midway down his back. He's spending the day fixing a door and some gates, but first, he says, he'll start an electric generator for us—the power is out on the ranch today: that pesky NorCal grid again.

Bodega Pastures has existed, in one form or another, since the gold rush, about as long as anything in this part of the country. For over a

century, it was a family-run dairy farm. "That was when people could make a living on ten cows and a hundred gallons of milk a day," Jay explains. In the late 1960s it was reconstituted as one of those groovy back-to-the-land utopias that attracted young idealists from the Woodstock generation—if I were fifteen years older, I might've been one of them—most of whom would bail after a few months when the reality of manual labor set in. Still, a few hung on, some for the rest of their lives. The ranch, which raises sheep for both wool and meat, continues to be run by consensus without a formal leader. There are fifteen households here and forty residents—the oldest (and official owner) is in her eighties; the youngest is five. No one pays rent, but they do kick in annual dues for insurance, property taxes, and infrastructure.

Jay moved here at age twelve, when his mom became romantically involved with a resident. During his twenties, he says, "I wandered the world plenty," but he always came back, landing on this land, and thinks he probably always will. "I value the sustainability of raising sheep," he says. Most residents take on outside jobs to make ends meet, but Jay says, "We do raise enough here to eat and to clothe ourselves and those are real things." He pauses, then adds, "When the shit hits the fan, we're okay. People will be coming to us for food and supplies." Lately, that survivalist rhetoric doesn't sound so extreme. A few days earlier, when I told a friend what I was up to, she joked, "Now you'll have a skill that will get you into the last remaining safe community during the zombie apocalypse; be sure to throw some food over the wall for the rest of us." At least I think she was joking.

Speaking of the apocalypse, although sheep farming, especially on an industrial level, can wreak havoc on the environment, Lora chose Bodega Pastures purposely, to show me something different.

The ranch engages in what's called "regenerative" agriculture: land management that one-ups "sustainability" because, at this point, simply maintaining the status quo—that is, not making things worse or dubiously "offsetting" one's carbon emissions to avoid changing damaging practices—is no longer enough. Rather than "zero-waste" or "zero-emissions," "regenerative" systems (which have been likened to "yoga, but for farmland") *improve* the air, earth, and water, leaving them better off than before.

I'm no expert on either agriculture or environmentalism—I'm just a girl who likes to knit—so a lot of what Jay tells me goes zooming over my head, but the gist is this: things like planting cover crops and windbreaks, deep composting, and strategic use of manure all yank deadly carbon out of the atmosphere and drive it into the soil, where it's needed. It's not cheap to make such enhancements, and Bodega Pastures has been the beneficiary of several regional grants to do such things as buy extra compost for their hay fields (the sheep themselves don't produce enough waste to cover it), but if brought to scale, regenerative ag would, all on its own, mitigate the impact of climate change. It would also improve crop yields, revive grasslands, and increase soil resilience, making it compelling even to those un-convinced we are in crisis.

Sheep are especially suited to regenerative ranching, both because their fiber is renewable and because their grazing can be targeted to enhance pasture health. Since they enjoy noshing on dry brush, they can also be deployed to naturally reduce wildfire risk; on a day like today, when I keep glancing nervously at my phone to see whether my house is burning down, that makes me an instant con-vert. Eco-conscious brands like Allbirds, the North Face, and Pa-tagonia have lately become all about regenerative farming. So, as it

happens, has Kering, the parent company of Gucci, because, really, what could be more "gucci" than saving the planet?

Inside the barn, Jay leads us through a labyrinth of hay bales, the gaps between the boards, the knotholes, and the unfinished windows letting in a flat, gray light. A table with a chicken-wire top sits a few steps above a shearing pen—that's for skirting fleece, separating out the dag (shearer lingo for "wool matted with poop," though the word also means "nerd" in Australia) and other undesirable bits. Bodega's mixed-breed flock produces between eight hundred and a thousand pounds of fiber a year. Some is sold for quilt batting or building insulation (wool is naturally flame resistant); the ranch also sells cleaned, ready-to-spin fleece and yarn directly to consumers, as well as raw fleece to DIY people like me (those who don't want to go quite so far as to shear it themselves). Nearby I notice a small stack of books: *The Essential Chomsky*, a treatise on biblical archeology, a children's story about lambs.

Jay has rounded up a dozen sheep for us, which seems daunting. Lora told me that on her first-ever day of shearing, she tallied (completed) exactly one sheep. My goal is a comparatively ambitious three, with the hope that the fiber from one will prove usable. I take in the potentials, who are bunched together on the darkest, far side of the pen. Sheep are prey animals—"Pretty much the definition of prey animals," Lora comments—so they tend to rush away from whatever approaches, crowding together for protection. That may be why they've developed a rep for being—there's no other way to put it: Stupid. Mindless. Also helpless and defenseless. Like lambs to the slaughter and all that. In reality, sheep are one of nature's more intelligent creatures, able to navigate complex mazes and to recognize as many as fifty human faces after over two years, which might be

better than I can do. They can differentiate among our expressions, too, preferring a smiling person to a frowning one. Among their own kind, they make little sheep-y friends whom they commune with and watch out for—rams will have a weaker buddy's back in a fight. If you pay attention, you'll discover that sheep can be angry, despairing, bored, elated. As an aside, their weird horizontal-slit pupils allow them to see behind themselves without turning their heads, which, I will tell you, does not advantage a person trying to haul them out of a pen.

Lora, who has nearly three inches on me and is enviably muscular, strips down to her shearing outfit: black jeans and a tank top that wouldn't look out of place in a trendy restaurant. She tucks her hair behind her ears and unrolls a leather pouch from New Zealand. It contains the handpiece for her clippers, which looks like something a barber might use for a buzz cut. She screws on two different blades: a comb, which always stays stationary, holding the wool steady, and the cutter, which sits on top of the comb, zipping side to side, slicing away. Both are sharp. *Very* sharp. To ensure they stay that way, the combs are swapped out hourly and the cutter every fifteen minutes, after which each needs to be cleaned and reground before it can be used again. Accordingly, shearers carry dozens of each blade; Lora's are strung on circles of wire, like *Game of Thrones* torture necklaces. She also sets out a couple of curved needles and dental floss, just in case, to sew up any sheep wounds, though she assures me she has rarely had a shearing accident.

She hangs an electric motor from a hook, connecting the hand-piece to a long metal drive shaft, then, in blue chalk, draws a circle next to a diagonal line on the wood floor. The entire shearing process should take place within that circle, she says; in first position, the

sheep's flank should be parallel to the line. Lora flicks the clippers on and off. They roar like a lawn mower. She will run the motor while I shear—it's too much for a beginner to manage both—and suggests we establish a safe word so she can cut power when I get in trouble.

"How about 'off'?" she says.

I think I can remember that.

Then she warns me: if (if!) the sheep struggles, my instinct may be to throw down the handpiece—which, obviously, since it is a hot, whirring blade. But that will break the comb, so every time I do it, Lora will charge me twenty dollars for a new one. It can add up fast. "So avoid it," she says. "Instead, just let the sheep go." She also mentions a guy she knows who severed a tendon in his arm by not being suitably cautious with the handpiece. Again, it's a hot, whirring blade. I gulp.

Hazel Flett stops by to introduce herself. An elfin seventy-two-year-old in a homemade sheepskin vest with long, gray-brown hair and twinkling blue eyes, she was described to me as "the backbone of Bodega Pastures." She dismisses the label with a wave of her hand. "That's just because I've been here so long," she says. It's true: in the early 1970s, as a sociology grad student from London, she flew to DC with friends for a little adventure and bought a Greyhound ticket to the West Coast. Someone knew someone here in Sonoma, so they made a phone call, rustled up a ride, and came to check it out. Hazel recalls getting out of the car, looking around at the golden hills, the achingly blue sky, the circling hawks, and thinking, This is where I'm going to die.

"The beauty was just mind-boggling for this English girl," she says. "It was like being in your own national park, but without the signs

telling you what you're supposed to think." When her friends took off for Vancouver, Hazel stayed behind; she's been here ever since. She knows each of the ranch's two hundred sheep on sight—as she did their parents, grandparents, and great-grandparents—recognizing their faces, recalling details of their personalities, remembering how many lambs they've birthed, the quality of their shorn fleece. She also spins and dyes yarn, and has been a knitter since age six (SLFHM).

Hazel introduces me to her husband, Joe, whom she met on the ranch—he was one of the first residents, having followed his brother west from New Jersey. A big man with a Santa Claus beard, he authored several respected books on Northern California marine mammals; these days, he wears the expectant, slightly confused expression a person develops with Alzheimer's disease. I chat with him for a moment about our mutual love of strong coffee, then he ambles outside to sit in the yard and look at the hills. Hazel, who plans to spend the day near the skirting table working on a project for a local artisan, checks on him every few minutes, love and worry etched in the lines of her face. At one point, she's gone for quite a while—Joe wandered off and she had to track him down.

Caregiving has gotten her thinking about her own aging, she tells me. "I never thought about getting older, what I'd do. But I know I'm not going to stop with the sheep. Maybe I should so that the young people can feel like they're in charge. So they can do things their own way. That might be good. But then I look out here and I see the sheep who are the descendants of our original flock. So much of my energy is on the hoof. I see them wandering around and it's so beautiful . . ." She smiles and lets the sentence hang.

I feel for Hazel. It is hard to imagine letting go of a lifetime of professional commitment and knowledge, letting it fade into irrelevance.

More than that, a generation younger than she, I realize I am be-ginning a shift in my perspective from thinking about old age as a daughter—grieving my mother's, and more recently my father's, declines—to reckoning with it for myself. Steven and I talk more often about the logistics of aging in place, options for long-term care that would alleviate the burden on Daisy. He discusses ways to end things should he fail cognitively or physically, if his quality of life threatens to sink below a threshold he finds acceptable. I used to summarily shut those conversations down; I don't anymore, though I still don't like them. My own concerns are, debatably, more trivial: I obsess over who will properly style my curly hair. "You will have to figure my products out," I warn him sternly. I guess we all have our things.

Lora crosses the dirt floor of the pen, wading into the huddled flock to show me how to catch a sheep. "They can be fearful," she warns as they edge away from her. "So I don't single them out in a formal way; I never look directly at the one I'm choosing. And I don't give them 'mean' eyes. I believe first impressions make a difference—maybe they do, maybe they don't, but I think so. So, I use soft eyes. I try not to give off predator energy. I talk to them." She slowly closes in on her chosen ewe, reaching under the jaw with one hand, catch-ing the wool at its flank with the other. Lora guides it backward out of the pen and I latch the low gate behind them to keep the rest from following. She walks the sheep a few more feet, then gently turns its head toward its shoulder blade while pressing its hip toward her. "This is kind of a ninja move," she explains as the animal reflexively sits down and flips onto its back. "You're not picking them up, you're just sort of . . . rolling them and stepping out of the way."

She drags the ewe by its forelegs the last few feet into the circle—that may sound disturbing, but it is the most ergonomic way to move

them—and sets it up in first position, its back pillowed against her legs, its rump resting on top of her feet.

"Getting the sheep into position is the hardest part for a lot of people," she says. "You want the weight on its right leg, not on the tailbone—that will hurt the animal."

She maneuvers the right front hoof through her own legs and behind her butt. "You want to really wedge it in tight," she instructs. She holds the other foreleg out of the way with her left hand and prepares for the first belly blow. "You want to start up high, that way the neck blows will be easier later."

Lora turns on the shears, sliding them down the animal's chest, the fleece peeling off as easily as a tangerine's skin. When the sheep starts to kick, she stops and rocks it side to side. "You're okay, mama," she says calmly. "You're okay." The sheep settles. Lora finishes the belly, continuing to narrate as she moves through the other eight positions, shearing the legs, the undermine, the head, the neck, the long blows up the back. It is indeed like a ballet, but also like watching a skilled magician share her secrets—I may now know how the tricks are done, but I doubt I can pull them off myself without the rabbit hopping away or the cards spilling from my sleeves.

Within three minutes, the sheep is clean, pink-skinned. She stands up and scampers away none the worse for wear, though I suspect she may wonder what that was all about. Lora shakes out the fleece, which unfurls—*ta-da!*—in one sheep-shaped piece. Typically, she can tally as many as 150 sheep a day this way, but she made it nearly to 220 in 2019 when she trained for a couple of months in New Zealand. "I consider myself pretty advanced in the States," she says, "but in New Zealand you have to be able to shear more than two hundred fifty sheep a day to get beyond 'learner' status." That

works out to over thirty sheep an hour, or a sheep in less than two minutes.

The world record for shearing a single sheep, incidentally, verified by Guinness, is 37.9 seconds, held by a thirty-five-year-old man from Donegal, Ireland. While not (yet) an Olympic event, competitive shearing is a popular sport—primarily among guys. The contests tend to appeal less to women, for much the same reasons as the profession itself. "You can feel the men wanting to beat you just because of your gender," says Lora, who has, nonetheless, entered the occasional contest. "That's a really unattractive feeling—unless I'm winning, then it's really satisfying. But giving them the satisfaction of being able to reaffirm their egos by shearing faster than me?" She shrugs. "It's not my favorite."

THE TROUBLE IS, WHAT to do with all the wool? California only has the mill capacity to process ten thousand pounds annually, yet the state produces three million—about a quarter of the country's total production. In Texas, still the largest U.S. wool producer, the fleece of ten million sheep were once so integral to the economy that for twenty years, starting in 1952, the state hosted an annual, nationally televised Miss Wool of America pageant. Hosted by Art Linkletter and featuring such megawatt celebrities as actress June Allyson and *Beach Blanket Bingo* star Frankie Avalon—the Zac Efron of his day— the highlight of the event was the modeling by contestants of the upcoming season's wool fashions.

Back then, the Lone Star State was home to twenty-eight mills

that processed local wool; today there are two. The infrastructure collapsed under offshore competition and reduced demand, and the sheep population has followed suit: there are about 90 percent fewer sheep in the U.S. than there were at their peak in the 1940s, much of that decline happening over the last thirty years. "People don't realize that most of our wool is processed in the developing world or China," Hazel says from her perch near the skirting table. "It happened without anyone noticing, because all we see is the finished clothing in the store." Or at least we used to, before the pandemic and the supply chain gummed up the globalization works.

Shipping raw fleece from the U.S. to Asia is prohibitively expensive, and anyway, in part because of that international competition, the market value is so low that the sale price barely covers the cost of shearing. The sheep that remain in this country are now largely raised for meat or lanolin; wool has become a useless byproduct, so much so that some ranchers are transitioning to those handful of "hair" breeds that require fewer shearings. "So many people I shear for— people with eighty, a hundred, a hundred and twenty sheep—throw their wool into the garbage or incinerate it because they don't know what else to do with it," Lora tells me. "I shear for this gentleman who told me that his grandfather used to be able to buy a brand-new truck every year with the money he made from selling wool. Now? He throws it away. He'd lose money on it otherwise. That's such a radical and devastating shift in a few short decades."

Most of the wool for our garments is grown, harvested, and produced far away, where we don't witness its environmental impact or human cost. Since the 1960s, we've also worn progressively less wool, along with less cotton and other natural fibers. I had brought my trusty, eco-friendly "fleece" hoodie—made from recycled water

bottles!—with me to the ranch. I didn't realize that was the fiber-world equivalent of brandishing a ham and cheese sandwich (on white bread) at a Bar Mitzvah. That I even thought of that polyester fluff as "fleece" was a triumph of Orwellian marketing: the simultaneous invocation and supplanting of associations with natural fibers convinced me to pull the synthetic wool over my own eyes. Such doublespeak is intentional. Consider: just weeks after Lucky Brand's Shrek blunder, a Lands' End catalog promoted a faux-fleece "sherpa" jacket with the tagline "Lambs wish they had a coat this soft." Meanwhile, author Clara Parkes, known as knitting's "wool whisperer" (SLFHGrandma), called out Duluth Trading Company for claiming its "fleece-infused" shirt was superior to the real thing: "No smelly animal fur here," an advertisement bragged, "just soft, furnace-warm 200-gram polyester fleece." That was especially galling since the store also sells 100 percent wool hats, socks, and sweaters.

Both companies also apologized. They had to. Because that "soft, furnace-warm," putatively sweeter-smelling polyester is not just an affront to sheep ranchers: unlike the real deal, once you toss out that hoodie, even if it was spun from recycled plastic bottles, it will take more than two hundred years to decompose. Same goes for your high-end yoga pants, those pricey jeans that cling just right to your curves, your swimsuit, your bra, your favorite dress, your socks, your underwear, your "breathable" Covid mask—you get the idea. Doesn't matter whether it's cheap tat or luxury lines, over 60 percent of the garments worn on this planet are now either partly or entirely made up of petroleum-derived synthetics—polyester, viscose, nylon, rayon, Dacron, acetate, Lycra, spandex, Gore-Tex—and that, my friends, is just a fancy way of saying plastic.

Synthetics have some phenomenal qualities: they've allowed humans to survive in space; protected first responders from bullets without weighing them down; helped treat deep-vein thrombosis. They're easy to care for, too. Before synthetics, a woman (it was nearly always a woman) spent hours each week on ironing. Among the middle class, "wash-and-wear" fibers liberated them from laundry, abetting their entry into the workforce. Synthetics also democratized fashion, uncoupling style from social status. These days, any teen with a pocketful of babysitting money can afford to kit herself out like her favorite celeb in cheap runway knockoffs. And for the eco-conscious, it may indeed be preferable to buy clothing made from recycled plastic than so-called "virgin" materials. But it's not exactly a "green" choice; more . . . yellowish brown, like a half-dead lawn. Even if those fabrics could be fully and endlessly recycled through zero-waste, "closed-loop production" (a hot buzzword in the fashion industry that refers to reusing the same materials over and over to make new items), they would still, in everyday use, let loose trillions of teeny-tiny plastic threads called microfibers.

That "fleece" you wear to the farmers' market? It is the outerwear version of a Labrador retriever, shedding nondegradable plastic filaments—thinner than a human hair, often invisible to the naked eye—all over the organic produce. Every time it's washed, as many as 250,000 more threads get rinsed down the drain and, too small to be filtered out at wastewater treatment facilities, go straight into the waterways; the equivalent of fifty billion plastic bottles a year floods into the oceans alone through microfibers.

When I was growing up in the Minneapolis Jewish community, we used to symbolically cast our sins each Rosh Hashanah into what was then named Lake Calhoun, after the pro-slavery vice president

who has a lot of his own misdeeds to answer for (it is now, as it was traditionally, Bde Maka Ska, which means "White Earth Lake" in the Dakota language). I imagined our transgressions building up in the depths over the years, an ever-expanding, tarry mass. Microfibers are a little like that, but real. Those microscopic synthetic nasties have been called "the biggest environmental problem you've never heard of" and are now the most significant threat to the ocean. France recently became the first country to mandate that by 2025 all new washing machines sold there must have microfiber filters. Such measures would help, if broadly adopted; so would reducing dependence on plastic textiles. "That's why I'm so interested in having commercial shearing continue," Lora says. "I don't want the wool industry to die or be on that downward trend. Because natural fibers are actually doing a lot of work toward climate justice. This animal can do so much for us if raised correctly. We have spent thousands of years evolving them to produce what we need."

FINALLY, IT'S MY TURN. I sidle up to the smallest ewe in the pen and, after several tries, catch her by the jaw and flank and attempt to walk her backward. She does not want to walk backward. "Hold her closer to your hip," Lora coaches. That doesn't work. Instead, the sheep breaks free and dashes to the back corner of the pen, burrowing between two larger flockmates. I take a breath and give it another go. As I move among the sheep, I pat each one gingerly on the head while thinking, *Not a predator, not a predator, not predator.* Then I recall that touching a sheep's head can trigger its bucking instinct, so I quickly

shift to stroking their sides instead. They look at me gimlet-eyed, not so easily fooled.

My chosen sheep slips my grasp twice more before Lora jumps into the pen to pitch in. We grab her again, this time successfully, and back her through the gate and into the shearing pen, where I try that elegant ninja flip. It's not that different, really, from how I get my dog on her back to brush her belly—just an extra hundred or so pounds of animal. I actually do it, all by myself. Heartened, I grab her forelegs to pull her the final few feet, but she is a deadweight. "Use your legs," Lora calls out helpfully, then, "Bow her toward me!" I think: *What does "bow" mean? What does "toward" mean? Does it mean the tail should be closer to Lora or farther away? What about the head?*

After what seems like forever, I get the ewe more or less along the diagonal line, leaning her on my thighs as if I'm a human Barcalounger. I twist her right hoof this way and that, trying to figure out how to get it between my legs and behind my rear. "Keep your right leg straight and walk the left one back until the hoof goes under," Lora says. This does not really happen, but somehow, the hoof finds its mark and I get her into a credible first position. Wool and skin form a big pot at the base of her belly, so when I look down I can't see the bottom of it. This is the moment, and my main instinct is to drop the shears and bolt. Instead, I raise the handpiece; yell, "On!"; and plunge into the "brisket," a word that makes me think of meat, which seems a bit rude under the circumstances. (Among the various words for a sheep's anatomy, my favorite is "pizzle," which is the genitals of a male wether. You have to be careful, clearly, not to cut the pizzle, but it makes me giggle every time someone says so.)

Beneath the dirty, matted surface, the sheep's fleece is clean and

snowy white, her skin rosy. Lanolin accumulates thickly on the blades and I'm terrified of making a "skin cut," which is exactly what it sounds like. Instead my tentative blows strike too shallow, so I have to do each twice. That's a "second cut," and it's a major no-no since the resulting fibers will be too short to spin. Luckily, belly wool is useless anyway—too full of muck and dung. On the other hand, the area is home to some very delicate equipment: on a ewe, that means the teats and vulva. As I approach those areas, I get increasingly jumpy—maybe I over-identify. Sensing my hesitance, the sheep kicks, hard. Lora told me that accidents are most likely to occur when the power dynamic between human and animal becomes murky, which it most definitely has. I unthinkingly start to fling the clippers in order to have both hands free to steady her, then I remember that twenty dollars. "Off!" I yell instead, and momentarily release the sheep.

Back in position, I pull up the skin of her belly with my left hand to get a better view. Still terrified of hurting her, I don't notice that my index finger has slid into the blade's path, and I slice off a bit of the top. Out of pride, I refuse to react, but the sheep's wool quickly starts to resemble a crime scene. "Off!" I yell, and drop her to the ground again so I can staunch the bleeding and tape it up.

Whoosh! I get through the belly. Next comes the "crutch"—the wet, dag-caked place along the inside of the legs and under the tail. Also dicey work. I muddle through and then finish the left leg and flank. Next, I buzz across the top of the head, ear to ear. Hazel watches from her worktable with what is either amusement or concern, I'm unsure which.

"The neck is prime real estate," she calls out, encouragingly (I think). It's also another scary blow. I can't tell how thick the wool

is and I don't want to hit a carotid artery. To avoid that, the Bowen method has me tip the animal's jaw straight up with my left hand, smoothing out both the wool and the wrinkles in the skin. I need to call "off" and "on" every few seconds, but, again, I make it through. My reward is that it's time for the "long blows" up the back and along the spine; those are the fun part, like the autobahn of shearing. I know I'm supposed to hold the blade flush with the animal's skin, but I still can't quite see where I'm going, so I keep lifting the tip toward me, making second—and third, and fourth—cuts, ruining the best of the fleece. "Blade down! Blade down!" Lora repeats from the sidelines. As if commenting on my technique, the sheep lets loose a gigantic mound of poop pellets. Perfect.

Lora talks me through the footwork. A little shuffle with the right, toes out on the left. And then, the big move: a ballroom-style dip, where the shearer takes a tiny step back with the right foot, swings the sheep's hip around to switch the curve of its spine, and lays it on the ground to clip the final side. That is exactly as confusing as it sounds. I feel like a gymnast with the twisties, unsure of where I am in space. Left and right cease to have meaning, as do up and down, and I can't tell whether I'm looking at the sheep's shoulder or its rump. The head seems to have disappeared entirely.

Lora steps in to help and somehow, thankfully, I finish. The sheep jumps up, looking patchy, like a preschooler who's cut her own hair with blunt-edged scissors. Lora sprays the number one on the ewe's side in Blue-Kote, an antiseptic for livestock wound dressing that doubles as nontoxic graffiti paint, and snaps our picture. Given that shearers, as I mentioned, generally get paid by the sheep, photographing the number this way helps them keep track. The sheep trots outside and I glance at my phone; it has taken me over an hour to

shear this animal. I am pouring sweat, my back feels like it's going to buckle, and my pants legs are coated with grease.

There are ten more sheep in that pen.

UNTIL I BEGAN THIS project, I didn't much think about where my clothes came from or where they went. I certainly didn't think about clothing the way I do food: trying to buy locally, organically, ever conscious of environmental ramifications, of the treatment in its production of both humans and animals. I had read *Fast Food Nation* and *The Omnivore's Dilemma*. I'd watched *Super Size Me*. I had personally profiled Alice Waters for the *New York Times Magazine*. I knew how the industrial diet affected human and planetary health. Although I had a vague sense that it was "bad," though, I was far less educated about the impact of fashion, especially so-called fast fashion.

Those synthetic fabrics, combined with draconian labor and environmental practices in the developing nations where our clothing is produced, have paved the way for lightning turnarounds and rock-bottom prices. So, whereas back in ancient times—say, the 1990s—brands released new lines at most four times a year, companies such as Zara and H&M began adding hundreds of dirt-cheap, instantly obsolete, shoddily made plastic-fabric styles to their racks each week. Ultrafast youth brands, such as ASOS, Shein, and Boohoo, now add thousands of new styles a *day*. Americans buy 60 percent more clothing annually than we did when H&M debuted in this country in 2000—that's roughly a garment every five days—spending less for it

and keeping each piece for half as long. The amount we throw out has doubled in that time to eighty pounds a year per person; a garbage truck of textiles (that's 5,787 pounds) is now either dumped or burned *every second*. Read that again. And once more.

Overall, it's fair to say, the fashion industry is an ecological fiasco, responsible for more greenhouse gases than all international flights and maritime shipping combined. Nor can we donate our way out of our overconsumption. Nearly half of what we give to Goodwill and the like ends up as someone else's problem. Americans alone are responsible for over 1.58 billion pounds of secondhand clothing that is dumped on countries such as Pakistan, Kenya, Angola, and Ghana (where it's referred to as "dead white man's clothes"). There, it undermines local textile industries, costing livelihoods, or ends up as landfill: mountains and mountains of plastic cloth.

Despite the fact that all we've worn since lockdown is soft pants, the pandemic, by consigning us to our screens, has accelerated those trends. Ultrafast fashion retailers don't even bother with brick-and-mortar stores. Instead, they have influencers. By early 2021, #haul videos, in which young (mostly) women gleefully unbox dozens of "You won't believe how cheap this was!" garments, had racked up over fifteen billion views on TikTok. Still, there are other teen girls, including most that I know, who have turned hard in the other direction, who would never dream of shopping at the likes of Brandy Melville or Forever 21—let alone PrettyLittleThing—preferring the online resale site Depop or, when they can afford it (or their parents are paying), ethically produced brands. "If no one ever bought another item of new clothing again, everyone would still have enough to wear," my daughter often declares, and that is likely true. Before any purchase, she and her friends consult sites like Good On You,

the online bible for brand ratings and the latest info on lower impact fashion. Sustainability—long associated with shapeless, earth-toned schmattes—has become the new sexy: one ad for planet-friendly cashmere sneakers depicts a woman's lower face, her tongue naughtily extended, with the tagline "We have a new fetish."

Youth-oriented companies, aware that environmental indifference is not a good look, have begun touting their own limited "eco" collections or secondhand marketplaces. But with no agreed-upon definition of "sustainable," greenwashing is rampant. The Higg Index, for instance, a highly touted self-assessment tool that allows manufacturers to display environmental "sustainability profiles" alongside select garments, is championed by a consortium that includes multibillion-dollar brands with a vested interest in portraying polyester as environmentally friendly. That's a little like Philip Morris's funding of anti-smoking initiatives. Or the signs in my neighborhood grocery store promoting local, organically grown produce that hang over shelves upon shelves of fruit packed in plastic clamshells. Higg-related marketing faces a potential ban in Norway, but in this country it has been rapidly normalized, including as part of a New York State law attempting to hold large apparel companies responsible for their role in climate change.

Maybe something is better than nothing, but there would seem an inherent contradiction, or at least substantial limits, in grafting a climate justice agenda onto a business model that depends on ever-expanding production. True change will have to be more systemic, and probably more painful. As with the food movement, the only path that makes sense to me involves a kind of "slowing," or what fashion industry critics have begun calling "degrowth": in this case, making far fewer clothing purchases, for which we will likely have to pay significantly more, and keeping them for a much longer time, as

we once did. That's going to be a tough sell not only to consumers but to retailers.

Part of me wishes I'd never found out about any of this, because I can never un-know it and I was already trying to be so conscious of recycling and composting and avoiding single-use plastic and buying organic produce and driving a hybrid car and shunning chemical sunscreen and never using straws in my drinks and not flushing the toilet if it's only pee. Plus, I'm confronted daily with the ways that those individual changes aren't stopping the rising heat, fires, hurricanes, floods, tornadoes, polar vortices, or droughts. Can't I just buy a danged pair of pants?

I know that it's better to be aware, that it's important, that it's right, but still: shopping was once a source of pleasure, or escape, or a reliable mother-daughter bonding activity. Now I find it difficult, when I walk into a store (or, these days, browse online), not to see future landfill. When I do indulge, I spend hours going down internet sinkholes, trying to parse the effect of each purchase on the planet, on the labor force, on animals. Are the eucalyptus trees used to make greener Tencel fabric becoming a mono-crop (bad!) or grown at the expense of the rain forest? Was there plastic in the finishing chemicals secretly sprayed on my all-natural merino base layers to keep them from shrinking? What constitutes a living wage in Myanmar? How much water was used to produce that organic cotton, anyway, and where did it come from? Sometimes the whole situation can make me want to take to my (eco-certified) bed.

Still. If I care about the ethics of what I put into my body, I have no choice but to care equally about what I put onto it. It is hard to imagine what it would mean to create something more radical: how to dismantle the global fashion behemoth, shifting to a local, organic model of clothing production. But then again, why not? Thirty

years ago, someone nattering on about organic produce, free-range chicken, or farmers' markets would have been considered fringy at best. The rest of us were happily buying snap peas from Tasmania in the dead of winter. It's not like factory farming has gone away, but the alternative market—local, grass fed, pesticide free, organic, sustainable—has become mainstream, and it's growing.

There has been no movement yet with similar reach in the clothing world, though many are trying and both the desire and the will are increasingly there. Since 2007, companies that have been certified as "B Corps," including a handful of apparel manufacturers, have met rigorous standards for environmental and social impact. On a more local scale, Bodega Pastures is a member of Fibershed, a Northern California–based nonprofit working toward regional textile production systems—similar to those organic produce networks—that take both the environment and workers' needs into account: reviving infrastructure, educating on "climate beneficial" growing practices, connecting farmers and ranchers with millers, spinners, dyers, designers, textile artists. Deepening our sense of place. The organization is small and the task mammoth. But it's a start.

LORA AND I BREAK for lunch in the barnyard. I sit on a folding chair leaning against a wall and remove my Covid mask; she stretches out a social distance away on the bed of her Tacoma pickup. Milly, her brindle dog, is curled at her feet (she was, Lora tells me, named for the e. e. cummings poem "maggie and milly and molly and may," which, some say, is about the disparate selves we inhabit over the arc of time; that feels almost embarrassingly on the nose of my life). It's

cool and overcast, and the sweat chills on my back. Sheep shamble by without so much as a glance our way.

"You're a fast learner," Lora says approvingly, and, while I doubt that's true, I nearly burst with satisfaction. "It *is* true," she insists. "Most people are angry or in tears by now. You're not."

Maybe I can thank twenty years of yoga for my equanimity, or a natural affinity—possibly due to all those homesteading stories—that I've always felt for domestic animals. I'm also in my late fifties. I've been through two rounds of breast cancer, six years of infertility treatments, childbirth (via C-section!), the death of my mother, and all the other inevitable trials of circling the sun this many times as a woman on our planet. That in itself takes grit, and I'm no longer easily fussed. Still, there were several moments during the past hour when I felt like crying or cursing, when I wanted to fling the sheep to the ground, hurl aside the handpiece—twenty dollars be damned—and stalk off in a fit of pique. And I might have, if it weren't for this: did I really want to look at the sweater I expected to make and think, *I gave up on shearing, so this is really Lora's work*? No. I did not. I set myself this task and I was going to see it through. So I held it together and persevered.

I ask Lora how she became a shearer—it doesn't seem an obvious trade for the daughter of two schoolteachers. Then again, she is from Petaluma, about half an hour southeast of here, a town that has been designated "the chicken capital of the world" (it's also been called "the arm-wrestling capital of the world," but that's another story). Growing up, she never felt much connection to the local ag kids: she left after high school to study poetry at UC Santa Cruz, coming into her own during college as queer and feminist. It was there that, like so many environmentally minded young people of her generation— especially those from Northern California—she was also drawn to

the food movement, to its promise of tangible, progressive change that was unlike the farming she'd known.

After graduation, she volunteered in rural France, then came home to work on, and ultimately manage, organic, sustainably grown produce farms locally. As with Jay, the vocation felt like something "real" and "solid" to pursue in the face of increasing instability. "I was told that if I got a college degree I could do anything I wanted," she says, munching her sandwich. "But I feel like I was prepared for a world that no longer exists. Because no matter how much education I got, no matter where I went to school, this state would still be on fire and the well on the property where I live would still be running dry. So I made the conscious decision to go from a life that was primarily intellectual to one that was skills-oriented, to making sure I knew how to do things with my hands and understood the processes that affect my life the most."

From food, it was a short leap to textiles. Lora has knit since she was a child (SLFHM) and learned to spin from the woman whose farm she worked on in France. One weekend, while attending a fiber festival back in Northern California, she happened upon a shearing demonstration. "This guy made that sweeping statement about how it's one of the most difficult jobs in the world," she recalls. Like me, she can't really describe what happened next, doesn't fully understand the "why" of it, but she felt a compulsion to sign up for the class in Mendocino, the one I couldn't get into. Two years later, she was teaching it. "Most people who can afford to are already eating organic kale," Lora says, "or eating kale at all, and agree that it's better for the planet. So that can feel like an echo chamber. But how many vegans do you know who wear plastic 'leather' microfibers on their skin? The clothing movement feels like a place I can still make

a difference. I wish people would wake up and reinvest in the infrastructure, change their mindsets, get excited about it."

Despite that passion, Lora isn't sure how much longer she can tolerate the demands of her job. Each shearing season, she clocks over eleven thousand miles on her truck; those ten-hour days of driving (time for which she's not paid) are starting to wear her down. Also, she's turning thirty next year. The first of her friends just had a baby. That's gotten her wondering what she wants to accomplish before she has children herself, what, in this land of flame and drought, she can really hope for. I think about Hazel, pondering her future; I think about Lora, considering how to construct an ethical adulthood, to combine work and family in an uncertain time; I think about myself, poised between them, anticipating the uncharted changes of an empty nest. We are, years apart, all women in transition, each navigating the new whether we want to or not.

"Honestly," Lora admits, "I've been considering leaving California. I don't know if I have the temperament to have a go-bag packed every summer or to farm in my respirator three months a year. But then again, I don't necessarily want to be the person who literally heads to greener pastures, either. Sonoma County is my home. Is it a betrayal of your relationship to a place that cared for you to leave it, to run away?" I understand her dilemma; as California burns, I also contemplate whether it is time to go, when it would be time to go, where I could go, even as this work I'm doing links me more granularly to the local. We look over the sere hills in silence. "I don't know," Lora finally says. "But I do think we all have a role to play."

THE SECOND SHEEP SEEMS to quickly grok that I am a newbie, and once she does, it's all over. As soon as I get her into position, she writhes and kicks, and either I drop her or she slides through my hands. After the first few blows, I can't seem to steady her for another, so Lora finishes the job as I watch from the sidelines, relieved and a little ashamed. The sheep does not dare try its tricks with her. Lora fetches a third, more docile ewe and shears it to the point I'd reached when I quit, so I can continue along as if it's the same animal. No question, I'm getting fatigued. My arms are rubbery, the tendons in my neck tight; I have been bent double at the waist for too much of the day. Still, I tally this one a few minutes faster than the first, a small victory.

Now that I've had some practice, I move on to the main event: the sheep whose fleece I'm hoping to take home. We settle on one of the few ewes among the flock who, Hazel tells us, has a name: Martha. She is the sole offspring of a Wensleydale ram—which sounds to me like a piece of cheese but is actually a breed originating in nineteenth-century Yorkshire, England. Full-blooded Wensleydales look like lead singers in an ovine reggae band. Their long, curly wool, resembling dreadlocks, hangs over their eyes and noses, cascades down their bodies nearly to the ground. Improbably, their faces and ears (which jut out horizontally) are blue. Wensleydales produce some of the world's most lustrous wool. Unfortunately, Jay tells me, the ram they bought "wasn't that interested in the ladies," so Martha is his only progeny. Lora perks up at that, and we mull the possibility of a queer ram. "Why not?" Lora asks. (Later I look it up, and in fact, sexuality might indeed have been the issue: as many as one in ten rams shows a lifelong preference for same-gender partners; one in five is bisexual).

I'm still spooked from the sheep I couldn't shear, and while I start out strong with Martha, I choke on the lower belly blows. "On!" I yell, then "Off!" Then "On!" again, but I can't regain my mojo. In the end, I ask Lora to do that part. She says it's not really cheating: in New Zealand sheep are generally "crutched"—the unusable wool snipped off around their genitals, near their teats, under their tail, and sometimes on part of the belly and legs—in advance of the official shearing. Besides, it's getting late, and Lora has a long drive ahead to yet another job.

Suddenly, I'm up against the clock. I aim to finish Martha in twenty minutes and, okay, it takes thirty, but I have more than halved my original shearing time. When I'm through, my legs are quaking, I'm pretty sure I've pulled something in my glutes, and I am a little nauseous from the exertion. I don't think I can lift my noodly right arm for even one more blow. I'm also deliriously happy. This may be the closest I ever get to a Cheryl-Strayed-at-the-Bridge-of-the-Gods moment, albeit without quite the literary resonance. Lora sprays MARTHA! on the sheep's side in Blu-Kote next to the number three. In the photograph she then snaps of us, my arms gleam, the muscles still taut, and my eyes above my mask are euphoric. Martha looks distinctly less enthused—even slightly depressed—but then again, she is unaware that she's posing for posterity, and, besides, everyone has bad angles. I let her go with a pat on the rump, and she trots outside to graze, tail swishing.

The fleece I've shorn is not going to unfurl in one impressive sheep-shaped whole as Lora's did. It's in little heaps on the floor, full of second (and probably third and possibly fourth) cuts. Still, some of the pieces seem promising, and beneath the grimy tips, I can see the fiber has a silvery, pearlescent sheen.

"Do you think it's enough for a sweater?" I ask Lora nervously.

"I think so," she says, furrowing her brow. "It should be."

Her response is not quite reassuring—I begin to wonder whether I will need to downgrade to a vest—but for now, I push those concerns aside. I stuff a trash bag with Martha's fleece—I do not know how that famed "baa baa black sheep" could have fully filled three—breathing in its smell of earth and barn. Tomorrow, muscles in my legs and back that I never knew existed will ache. My hamstrings will scream and bruises will bloom up and down my calves. One of my fingers will feel yanked from its socket, and I'll have to wrap up three others that are bloody with nicks from the shears. But right now, today, at this moment? All I know is, *I did it*. And as I drive back along the gray-shrouded coast toward the heat and smoke and wind of Berkeley, brimming with confidence and pride, I kind of, sort of, want to do it again.

3

the stuff of us

SOMEWHERE OUT THERE, THREE SISTERS ARE hard at work. Women everywhere are always working hard, so that is not unusual, but these particular three (who are, in point of fact, goddesses) serve a special function: they determine our destiny—yours, mine, all of ours—portioning out each life from birth to death. They are the Fates, or, in their native Greek, the Moirai. I say they are "somewhere" because it is not clear where, exactly, the Fates of myth reside. Some say that they live with their father, Zeus, on Mount Olympus, laboring in holy brightness. Others, that they are relegated to the underworld,

where they toil in the gloaming of the dead. The disagreement may reflect a larger ambivalence over how the sisters' power (like that of so many women) is perceived: Is it light or dark, great or terrible, merciful or malevolent? Should we revere them, fear them, or both? And from what, by the way, do the sisters fashion our existence? Fiber, of course. Within three days of birth, the sisters pay all babies a visit. The first, Clotho, a maiden, spins the filament of the child's life; Lachesis, who appears as a matron, measures out its span; Atropos, presenting as a crone, snips it off with her scissors, determining the instant that newborn will die.

Ancient Greeks believed in predestination. We may snarl our strands, tangle or frazzle them along the way, but their length is immutable, unchangeable by human or god. That makes the sisters, arguably, the mightiest deities in the pantheon, though they are not generally viewed as such. At this point in my own life's thread, I am especially taken by Atropos. A "crone" is said to be any woman over fifty (*what?!*) and, as such, is usually portrayed as haglike: disagreeable, malicious, frightening. Yet, crones are also symbols of wisdom and justice. There is no male equivalent, perhaps because aging men do not threaten the social order the way women do if we stop giving a fuck and embrace the power in our release from the confines (whether enforced or chosen) of conventional femininity.

The ancient Greeks are not the only culture to equate spinning thread with creation. The Romans have their counterpart for the Fates, named the Parcae. In Norse mythology, three female Norns produce and control the strings of destiny; they were also called the "Wyrd" Sisters, a word that meant "fate" for centuries before it evolved into the oddness of "weird" or became immortalized in Shakespeare's *Macbeth*. The goddess Frigg, meanwhile, who is married to Odin, is said to spin the strands of time and to know the fate of all (though

she never reveals it). Unlike the Greeks, Scandinavians could potentially alter their future by consulting itinerant female shamans termed "völvur," or "wand-bearers," which sounds like it comes from a word for genitalia but is a reference to the distaffs they carried—sticks holding raw fiber for spinning.

Neith, the ancient Egyptian goddess, while not a spinner per se, was believed by some to have woven the world. Far across the ocean, Navajo and Hopi tribes of the American Southwest spoke of Spider Grandmother—a spinner of silk, a weaver of webs—who was essential to creation stories. As if perpetuating terrestrial life weren't enough, many of these spinners of myth were also tasked with keeping the universe whirling: Plato wrote that "the Spindle of Necessity," also tended to by the three Fates, rotated the celestial bodies—the stars, planets, and sun—around the Earth (the sisters, like so many women, must be adept multitaskers if they can do that job while also meting out the lives of everyone on the planet). In Scandinavia, the heavens spin around "Frigg's Distaff," the constellation that we call Orion's Belt.

Spinning is the stuff of us, woven (yes, woven) into our legends, metaphors, language. If, like me, your hair was pale blond as a child, you may have been called towheaded, which I once thought was spelled t-o-e (and was therefore an insult) but actually refers to the coarse, shorter fibers separated from flax during its processing for spinning. Or maybe you are tall and lean, considered "spindly." As a writer, my job is to spin a good yarn, and early in my career I learned that reporting was all about successfully "gathering string." Political campaign managers and PR agents are deft at spinning failure or scandal into its opposite. You might appreciate a spin-off of your favorite television series—like *Better Call Saul* after *Breaking Bad*. Even in the disembodied ether of modern technology, we refer to the un-

spooling of responses in texts (a word derived from the same root as "textile"), emails, social media, and web comments as "threads." And what fabric, what meaning, do we create from those techno-communications? I often have no clue, which is the modern spelling of "clew," a ball of twine, but has evolved into something that helps us find answers. It was a "clew" that Ariadne gave to Theseus before he was sent into the Minotaur's labyrinth, allowing him to find his way back after he slayed the beast, yet his thanks was to then betray her. *Get a clue, Ariadne.* We hang by threads, we lose the thread, we pick up the thread, we have common threads, we thread through crowds, our reasoning is threadbare—and that is not even starting on metaphors involving sheep, wool, fabric, weaving, sewing, knitting. Textile analogies loom large in our world.

It makes sense to me that the designers of life would be female rather than male, as in the Judeo-Christian tradition, and it seems especially appropriate that those goddesses would spin. Making something from nothing is the quintessential magic of women, whether turning fiber to thread or flour to bread or engaging in the ultimate creative act: conjuring new humans from nowhere at all. What could be more elemental, more mystical, more divine, than that? No wonder, on a spinning wheel, you feed your newly spun yarn onto the ever-swelling bobbin through "the orifice": a hole in a wooden piece that is called "the maiden," which itself rests atop "the mother of all."

ONCE HUMANS STRUCK UPON the idea of twisting fiber into cord with their fingers, the next stage was to tie the fiber to either a rock

or a stick in order to weigh it down and make the twirling and winding more efficient. Eventually, like those old TV ads where a person eating a chocolate bar accidentally crashes into someone holding a jar of peanut butter and creates a candy revolution, those two pieces came together, forming a spindle: a flat, weighted disc (or "whorl") attached to a dowel-like shaft. Hand spindles found at archaeological sites dating back to 6000 BCE are not much different from those in use today. They look a bit like a child's top, but with a foot-long stem. Contemporary artisans make their spindles out of all sorts of things: excavators in the future may unearth DIY versions from the 1990s with whorls crafted from compact discs (remember those?).

Techniques for using spindles have not changed much over time, either, though I have yet to meet anyone who carries a distaff. Instead, you drape a length of unspun fiber across one arm or wrap it into a loose bracelet on your wrist. You tease out a few strands and twist them so they attach to a "leader" (a piece of scrap yarn you've knotted onto the shaft), then thread that through a hook on the end of the spindle. Next, you roll the shaft against your leg to build up the tension ("charging" it) and—*boom!*—you let it drop or otherwise set it spinning. As it rotates, you pinch out, or "draft," lengths of fiber, which the motion tightens into thread. Before the spindle hits the ground or loses its charge and begins to turn in the wrong direction, you stop, wind your fresh-spun yarn onto the shaft, and begin the process again. Once you've filled a spindle, you can re-spin or "ply" the thread in the opposite direction with a strand from a second spindle so it will be stronger and more functional. If you examine a bit of yarn (even unwinding it a smidge), you can see how that works. Yarn might have two plies, three, or even four, which is how many spindles you'd need to fill and re-spin together to create it.

Some crafters prefer spindles to wheels, and not only because they are, at a minimum, hundreds of dollars cheaper: they believe that the direct, physical connection to the materials gives a person more control over the outcome. Also, spindles are wonderfully portable, weighing only a couple of ounces. You can tuck one into your bag and grab it instead of an iPhone when you're bored. The truly proficient, which would not include me, can even spin while walking.

Imagine that all thread for households and industry was once produced this way: the scope, the need, the time, the value of women's spinning, then, was tremendous. Women from all walks of life—queens, noblewomen, peasants, slaves—spun constantly; Elizabeth Wayland Barber, the archaeologist and linguist, speculates that the position of the Venus de Milo's shoulders, head, and body are such that she may have been depicted as spinning before she lost her arms. Journalist Kassia St. Clair has noted that while we laud the Vikings' maritime achievements (not to mention their goofy horned helmets), those men could never have taken to the seas unless women had hand-spun an almost unfathomable amount of thread with which to make their sails. A woman of great dexterity, St. Clair says, might produce thirty-two to fifty-five yards of thread an hour. That's about the length, at the upper end, of half a football field. Yet, even at that rate, a single large sail would require the equivalent of two and a half years of labor. Then there would be the clothing and bedding to make; outfitting an ordinary Viking ship stem to stern, she calculates, required an estimated 114 pounds of wool—that's about 1,140 miles of yarn—and about ten woman-years of work.

Spinning so defined our foremothers' lives that even now genealogists refer to the female line of a family as the "distaff" side; entertainment industry slang uses "distaff" to signify the feminine, as in

"the distaff-helmed movie" or "a distaff *Ghostbusters*"; in the sports world there is "distaff" horse racing and "distaff" wrestling. I wonder how many fans are aware of the word's provenance. It was not until 2005 that "spinster" was phased out as a legal term in England, and it is still the only option for single women to check when applying for a visa to enter Hong Kong. I think they should do so proudly: without the burden of a husband or children, single women were free to spend even more time at the vital and economically crucial task of making thread. Before the Industrial Revolution, according to St. Clair, a third of the income in a poorer English household might have come from spinning. "Spinsters," who could produce over twice as much fiber per week as married women, were respected contributors.

MARTHA'S FLEECE IS TOO precious to learn on: there's not nearly enough to spare. Besides, it has a long way to go before it's ready for the spindle. Raw fleece needs to be "processed"—cleaned (or "scoured") and carded into a cloudlike fluff—before it can be spun. That, for a beginner like me, involves weeks of work, which, since Martha's fleece is (no offense to her) filthy, must be done outside. The trouble is, the air is still clotted with particulate from the fires. A few minutes in the backyard leaves my throat raw, my lungs aching. As I retreat indoors, it occurs to me that so much of 2020 has been about breath. Covid blocks patients' airways, potentially lethally, and respirators have been in short supply; George Floyd died gasping, "I can't breathe"; the smoke from the wildfires chokes us. Everywhere, we step back from strangers, friends, family (why is that distance called

"social"?), avoiding others' airborne expulsions; we huff uncomfortably through our masks. I also feel like I am holding my breath until November—when I hope it will rain, when I hope we will have a new president. I wonder if we will ever breathe freely again.

When breath is threatened, it's breath that calms. I have begun meditating every morning, counting each inhale and exhale up to ten, then starting again. I never had the patience to do this before, and it takes all my concentration now. My body breathes me, whether I will it to or no. When I lose focus, which I do every few seconds, I try to label my distraction "thinking" or "feeling," but I'm not clear on the difference. Thoughts, I'm told, give oxygen to emotions, fueling unease—or maybe it is the reverse, I'm not sure. Regardless, I return again and again to my breath; I can't say whether it helps, whether it much reduces the anxiety crushing my chest.

Every few hours, I peek at PurpleAir, an app I hadn't heard of before this year: it's based on a network of sensors, bought and installed by "citizen scientists," that churn out hyperlocal, real-time info on air quality. My neighbor has one, so I can pinpoint (if a little compulsively) exactly what's happening on my block. Good air is green, moderate is yellow. Orange means breathing outside is unhealthy for sensitive adults as well as children; red is bad for all. My neighbor's sensor, lately, is often purple. *Purple.*

Crafters who clean fleece regularly have a whole setup—a backyard sink, dedicated pots, hot plates on which to warm the water, five-gallon tubs. I have none of these. So when a sunny, moderate-air day arrives, I set several quarts of water on my kitchen stove to heat, which I will then pour into buckets and haul outside. While I wait for the water to warm, I dump Martha's fleece in an odiferous mass onto a tarp on my back deck. There are those who "spin in the grease"

without scouring their fleece—Lora, for one, told me she prefers it. There is less prep work involved. Also, the yarn will be more water resistant, as it is on the sheep itself, and, as a side benefit, the lanolin makes the spinner's hands baby soft. Spinning in the grease works best for fleece that is not, in actuality, too greasy to begin with (shorn from a breed with a lower lanolin content) and won't be dyed, since lanolin may make the color take unevenly. Also, the fleece has to be relatively clean, and Martha's has too much "swarf," a satisfyingly onomatopoeic word that refers to all the nasty bits: straw, dead bugs, burrs, pee, manure, flakes of dry sweat (known, also satisfyingly, as "suint"). This is why you may, on a joyride through the countryside, see some sheep wearing cunning little jackets. It's not to keep them warm, it's to keep them clean, minimizing the swarf and raising the market value of their fleece. Anyhow, I want to do my spinning inside the house, so I need to clean this mess up.

I grab a few clumps, maybe a little under a half pound; pull apart the curly locks; and arrange them neatly in three mesh lingerie bags. Despite its durability, fleece can be finicky. Like all animal fiber, sheep's wool is covered in microscopic, overlapping scales that trap air and are part of what makes wool warm (you can feel the scales on your own hair by running your fingers backward up a strand). They also can make the fibers lock together, or "felt"—matting into an unspinnable wad—if you plunge the fleece into water that's too hot, or shock it by transferring it too quickly from hot to cold (or the reverse). Felting can be a good thing if you're making slippers or a peacoat or cute little stuffed animal ornaments for a Christmas tree. Or if you're an elf. But for my purposes, it's death. Felting cannot be undone. Since sheep are generally not exposed to 180-degree liquid when the fleece is still on their bodies, it's not something they have

to contend with, but if you've ever ruined your favorite sweater by washing it in hot water or accidentally throwing it in the dryer, you know exactly what I'm talking about.

I keep a sharp eye on my stove. When the water is scalding but not boiling, I pour it into a bucket, drop in the bags, and push them (gently, very gently) straight down with rubber-gloved hands. Every ten minutes, I check the temperature with a candy thermometer, until it drops to about 120 degrees, cool enough that I can hold the bags but not so cold that the melted lanolin re-congeals and makes the entire enterprise a bust. I squeeze out the excess liquid by flattening the bags between my palms (again, gently, very gently)—wringing or twisting will also cause the dreaded felting—and dump the water onto some thirsty plants in my garden. Swarf makes excellent "compost tea."

Round two: I glug something into the water called Unicorn Power Scour, a super-mild, super-natural, super-concentrated detergent that promises to further cut the grease, then, once again, submerge the fleece. For rounds three and four I immerse the bags in clear water to rinse out the soap. I imagine that in olden days, women scoured fleece as a side task, while busy doing something else, but I'm too preoccupied with temperatures and timing, so I sit on the deck and watch and wait and haul water back and forth. It takes a couple of long days, but in the end, Martha's clean, damp, sweet-smelling fleece is spread across every surface in my office, drying.

I need to use carding brushes to remove any final debris that didn't wash out; they will also align the fiber in one direction, making it easier to pull out and spin. In preindustrial times, carding was often relegated to children, so I figure it's got to be relatively simple. I could've bought a hand-cranked carding machine, invented in the

mid-eighteenth century, to speed the task along, but that felt like cheating, plus the cheapest machines are three hundred dollars and I didn't want the price of my sweater to balloon. Instead, I got a pair of rectangular paddles covered with bent wires, like oversized dog brushes, and began watching infinite YouTube videos on how to use them (because there are infinite YouTube videos on everything).

I regretted my penny-pinching almost immediately. The thing about hand carding is that you can only do a couple of grams of fleece at once. If you get impatient, overloading the carder, it simply won't work and you'll have to do it again. I fluff out a few tufts and lay them lightly on a paddle so the teeth just barely show through. I set that on my knee and with the other paddle brush the fiber once, twice, thrice. The key is to stroke *ever* so lightly; although it seems counterintuitive, the teeth of the two paddles should never mesh. When no more strands come off, I transfer what remains to the new paddle, switch hands, and start the whole process again.

After three or four rounds of this, I carefully peel the now-airy fleece away from the carder and roll it into a cigar-shaped puff—or rolag—that is ready for spinning. I read somewhere that you need 579 rolags to create enough yarn for a sweater. It took me about ten minutes to make this first one. If I multiply that out, this phase should last approximately . . . forever. I card for hours, until my hands cramp, my shoulders twinge, and my clothes become covered with loose fibers and barnyard grit, yet I barely make a dent in Martha's fleece.

The next day, despairing, I FaceTime my dad in Minneapolis while I work. I imagined this project would bring me closer to my mom, flood me with memories of going to yarn stores together, plunge me into new grief over her loss. And it does. A profound loneliness pierced me when my mother died. No one else could be so invested

in the minutiae of my life, so eager to hear every trivial detail. No one else could provoke in me that volatile mix of irritation and adoration. It felt like a layer of protection from this callous world had been ripped away, like I would never be fully warm again. So, I was prepared for that, for the waves of poignance and reflection. But the carding? That lets me connect with my dad.

Our relationship has not always been easy. He was a traditional guy who expected his daughter to stay close to home, marry a solid breadwinner like himself (Jewish lawyer or Jewish doctor, my choice), and raise children as my mom did. There's nothing wrong with that dream, but it wasn't mine. I came of age in the wake of second-wave feminism, a time when girls like me (white, educated, financially comfortable) measured our worth through personal ambition and professional achievement. It was not something he could understand. When I was a teenager, he viewed me as argumentative and unloving, even unlovable, and sometimes he told me so. I recall his looking at me after one particularly bruising fight, sighing, and remarking, "I guess you're just going to be like this, aren't you?" Later, at twenty-one, when I graduated college and announced that I was moving to New York City to become a writer, he was, to say the least, unsupportive.

"That's a pipe dream, Peggy," he said. "You can't do that."

"Oh no?" I responded. "Just watch me."

I left home behind without a qualm and didn't come back much, not for more than a few days at a stretch, anyway. But I also never felt all that far away; I took for granted that I could hop on a plane whenever I wanted to for a visit. The pandemic changed that, retexturing my sense of distance. Now I feel cut off, like someone who left their birthplace in a covered wagon to push west, not knowing if they'd

ever see their loved ones again: it seems almost impossible now to get there from here.

Unlike those early settlers, I have the advantage of modern technology. Gearing up for a conversation with my dad can be rough: at ninety-four, he has encroaching dementia, plus he doesn't hear very well. Often he's nonresponsive or lost to some alternate reality. Sometimes I put off calling for hours, until, I tell myself, it is too late in his time zone and I should wait until the next day. When we do talk, I struggle to connect, to get his attention. I make an excuse to hang up, then scold myself for my impatience; I should try harder, I should be a better daughter, especially now. His independent living facility, where he has an apartment with revolving full-time aides, is locked down. No one, including my two brothers, can visit him in person, and although his caregivers are remarkably devoted, they are not his kin.

While I'm doing the slow, methodical work of carding, though, I have little else to do but stay with him on-screen while he watches baseball on TV, narrating parts of the game to no one in particular. There are Twins reruns every day during the pandemic, a fantasy season in which the home team always wins. My dad doesn't get that the games aren't live; he attributes their streak to something he does with his walker.

I ask what, precisely, that is.

He smiles slyly. "It's a trade secret," he says, nodding, and I laugh.

Periodically, he asks me to hand him his glass of water; I realize that he doesn't distinguish between my virtual presence and my real one. That is oddly comforting, like when he thinks every blond, bearded young man on TV is my oldest nephew, who lives in Los Angeles. It feels like we are with him, after a fashion.

"Sorry, Dad," I respond. "I can't reach it. You'll have to get it yourself."

I try to avoid the word "remember" when we talk, because he can't, but it keeps escaping my lips anyway. "Remember when we were kids and . . . ," "Remember when you and Mom . . . ," "Remember that you said as a child you . . ." No, he does not, and it only frustrates him. Instead, we sing the tunes he sang to me as a toddler when he'd rock me to sleep—most of which were emphatically not lullabies: "Bill Bailey, Won't You Please Come Home" or "Praise the Lord and Pass the Ammunition." But also the one that goes,

> You are my sunshine, my only sunshine,
> You make me happy when skies are gray.
> You'll never know, dear, how much I love you,
> Please don't take my sunshine away.

The lyrics choke me up every time. People with dementia or Alzheimer's often recall music after all else fades. My dad no longer knows that he won a Supreme Court case—his greatest professional accomplishment—or that he earned a master's degree in the history of science at the age of eighty-two, the oldest person at the University of Minnesota, at that time, ever to do so. He can spend hours staring at nothing, shredding a paper napkin into ever-tinier fragments. Yet, he knows every single word to "Anchors Aweigh" and "Lida Rose." And he can sing them on key. Our daily visits start to feel to me like a spiritual practice, another form of meditation, another attempt at breathing and finding my center. I try to conceptualize them as an opportunity to express unconditional love (something, honestly, I never previously felt toward him) even through pain, to let my heart

grow even as it breaks, or grow *because* it breaks. And really, the anguish here is mine, not his. Despite the slip-slide of time and reality in his mind, my dad is happy, content, in many ways much more so than when he was "himself." In his second infancy, he seems to have been stripped down to his core, and the essence that remains is one of kindness, appreciation, and love.

"I'm so glad you're here, Peg," he tells me one afternoon. "It brightens my day."

I inhale. Deeply. "I love you, Dad," I say.

"I love you more," he replies, before lapsing into incoherence. That is not a phrase he has ever previously said to me, and as a daughter, I don't believe that it could possibly be true. Yet as a parent, I know it is; whatever love our children feel for us is dwarfed by ours toward them. No one wants to live the way my dad is now—I am quite sure he would not have wanted it for himself—but if it should be my fate, if Atropos waits too long to sever my thread, I hope I can muster his optimist's spirit. As the days crawl by, I feel increasingly privileged to have the time with him, time to weave our relationship more tightly together. I move the carding paddles back and forth, back and forth, piling up the rolags in a basket at my feet. I am almost sorry when I am finally done.

4

spinning my wheels

I KNOW WHAT YOU ENVISION WHEN you hear the words "spinning wheel" because it's what I used to picture, too: the one from fairy tales or Disney movies or endless paintings of young girls and grizzled grandmas in white bonnets (who were probably at *least* thirty-five). That's not wrong, but there are many kinds of wheels. The first to become widespread in the West was the great wheel, which, true to its name, is quite large—about five feet in diameter. The spinner works standing, turning the wheel with one hand, building tension

to create twist, while evenly drafting out the raw fiber with the other. When the spun thread becomes too long to continue (roughly six feet), she revolves the wheel backward a smidge to wind it onto a spindle, then starts again. The great wheel is also known as the Walking Wheel because the spinner has to move continually while using it, stepping back and forward. The typical distance they traveled is hotly disputed (if you're a spinner, anyway). I have read that women might walk thirty miles a day using a great wheel, or thirty miles a week or thirty miles a month. Regardless, it appears to have been the original spin workout.

The smaller Saxony wheel on its characteristic three-legged platform emerged during the sixteenth century in Germany; it's sometimes referred to as "the Cinderella wheel," which seems a misnomer since that particular fairy tale does not feature spinning while so many others do. If it were my call, I'd rebrand it as the Rumpelstiltskin Wheel, or maybe the Aurora, after Sleeping Beauty, even though that fairy tale was probably set a couple hundred years earlier. One notable thing about those early wheels: the spindle was a protruding metal quill, which, while it doesn't look especially sharp, could, I suppose, in theory, prick the finger of a medieval princess, causing her to fall into a hundred-year swoon.

Certainly, no wheel I've ever seen has involved anything so hazardous. Instead, for the past three or four centuries, wheels have been equipped with a flyer: a U-shaped piece of wood lined with wire guide hooks that fits, cuplike, around a bobbin. In a miracle of engineering, the flyer whirls at a different rate than the bobbin, automatically winding the thread as it goes, so spinners no longer have to stop to do it themselves; as a bonus, it foils the plans of evil fairies. Foot treadles were added shortly after, allowing European women to

have a seat as they worked (somehow I think that if men spun they would've figured that one out long before). There hasn't been much innovation in functionality since then, but design-wise, some of today's models are strikingly abstract, almost like the suggestion of a spinning wheel, the modern art version. Since most of us no longer need wheels for basic cloth production, they are also generally made to spin the thicker yarn favored by knitters and artisan weavers.

I can't spare the space in my house for a great wheel, or even a Saxony, not if my husband and daughter have a say in it; anyway, neither wheel is portable and today's crafters need to be able to toss our equipment into the backseat of our Priuses to go to our spin classes. If it were any other year but 2020, I would visit a shop and give a range of wheels a test whirl, but that is not to be. After tumbling down a research rabbit hole, I take a leap of faith with a Ladybug, partly because I like the name. It's also one of the most highly recommended wheels for the new spinner: uncomplicated, easy to treadle, and compact. It's a vertical, or castle-style, model, meaning its bobbin and flyer are stacked on top of the wheel rather than out front, like on a Saxony, so it takes up almost no floor space. Its body is hand-polished maple and there are handles built into the legs for convenient transport. The only thing that gives me pause is the wheel mechanism itself, which is a relatively environmentally friendly polyurethane and red; Schacht, its manufacturer, calls the color a "statement," but I'm not sure it's one I care to make.

Schacht, by the way, started as another back-to-the-land offshoot founded right around the time that Hazel Flett was discovering Bodega Pastures. Like Hazel, Barry Schacht was a hippie idealist—living in his van, fired from his job as a groundskeeper at the University of Colorado for mowing a peace sign into the grass—who, in his spare

time, made a hand spindle for his brother's girlfriend. On a whim, the three of them day-tripped with some friends to an outta-sight sheep ranch that offered spinning lessons. The girlfriend brought the spindle; the Schacht brothers came home with a commission for two hundred more, and a business was born. A half century later, the company is furnishing a new generation of eco-conscious makers with sustainably sourced spindles, looms, and wheels. They hide a tiny ladybug emblem on all the ones in my wheel's line, an Easter egg for owners who read about it in the manual's fine print. It's in a different spot on every wheel, so there will never be another quite like mine. I turn the frame this way and that, looking underneath the treadles and behind the maidens, and find my bug about halfway up one of the legs. Although it's not a Saxony wheel, I am enchanted.

IN HER BOOK ON ancient women's work, Elizabeth Wayland Barber mentions that, in 10,000 BC, the precursor to the Estonian, Finnish, and Sami languages had "a verb for keeping warm." The notion so struck Kristine Vejar, a textile artist in Oakland, California, that when she decided to open her own store, that's what she named it: A Verb for Keeping Warm. "At one point in our history, and even today for some, people spent a good part of their day 'keeping warm,'" Kristine says, "trying to clothe themselves or protect themselves from the elements. When people ask what the store's name means, that can get them to think more actively about fiber and their clothing and their blankets, and how the way we keep warm is not just conceptual." Verb, as its customers call it, is, as far as I know, a singular

venture: a natural dye studio, a spinning salon, a fiber store (selling, among other things, their own line of naturally dyed yarn), two class-rooms, and, most important, a community rolled into one seventeen-hundred-square-foot space, with a sprawling garden of pigment flowers and plants out back.

Of course, none of that is happening now. The storefront is closed, and like everyone else, Kristine is trying to figure out how to pivot online, how to stay viable for the duration. She agrees to give me a spinning lesson outdoors, in front of the North Oakland house she shares with her wife and business partner, Adrienne Rodriguez. When I arrive, she has set up her wheel in the driveway. A tall, lanky woman in her early forties, Kristine is dressed in vintage denim over-alls, whose worn spots she's patched to extend their life; even behind a mask, she seems to have a gently amused expression, as if chuckling at her own private joke.

I'm learning to spin with combed top: fleece that has been machine-carded into a silky bat for easy spinning, the short fibers removed and the rest lying nicely in the same direction, kind of like when a parent has taken a wet hairbrush to a child's wayward curls. My top comes from Bluefaced Leicester sheep, a breed developed in England in the early 1900s in an attempt to increase the hardi-ness of local ewes; they do, indeed, have blue-tinged skin on their dignified, Romanesque noses (some of their progenitors were, like Martha's dad, blue-skinned Wensleydales), but their fleece is pearly white. Spinners will geek out about the micron count of wool—the diameter of an individual fiber—which determines a garment's ul-timate softness. Lower is better. Human hair is around seventy mi-crons, so even if you were inclined to collect whatever fell off your head—and I sincerely hope you are not—you wouldn't want to knit

with it. Cashmere (which is, of course, from goats, not sheep) tops out at sixteen microns. The softest and finest sheep's wool, merino, is typically under twenty-four microns, though it can dip as low as ten. Bluefaced Leicester clocks in at twenty-four to twenty-eight microns, fine enough to be cozy against bare skin. Its fiber (or "staple") length is three to six inches, considered the Goldilocks range, I'm told, for a beginning spinner.

Drafting your fiber—which, again, is pulling the strands apart so they become longer and thinner, ready to spin—has been compared to cooking a chicken: there are dozens of ways you could apply the heat, depending on what you're after. You wouldn't dunk a bird in boiling water if you were craving crispy skin or broil it if you were going for a comforting soup. Similarly, different women have developed different methods of drafting different fibers at different times to produce different results. You might make one decision if your material was meticulously combed (like my top), another if it was inexpertly jumbled (hello, Martha!). Do you want your yarn to be airy or smooth? Thick or fine? Warmer or lighter? All that factors into your drafting. Even the direction you turn the wheel matters: one way twists the yarn into an S curve, the other a Z, and that will affect the look of it.

There is a dizzying number of such details, and sometimes I wish I were learning in the sixteenth century, or at least before the internet's bottomless pit of #helpfulnothelpful advice. Kristine encourages me to forget all that and focus on learning to "front draft"; that's the simplest method to start with, and, as it happens, makes the smoothest yarn, especially when using my impeccably combed top. She shows me how to prepare the fiber by pre-drafting—stretching it apart between my hands—before starting to spin. Pre-drafting gives

you one less thing to think about, like using training wheels on a bike until you develop better coordination. While I busy myself with that, Kristine starts to spin. She takes a length of fiber between the thumb and first finger of each hand, holding them a few inches apart. She moves her front hand forward, drafting the fiber while treadling with her feet, turning the wheel. As she slides that hand back to its original position, the tension built by the wheel's revolutions causes the strands to twist and lock together; the flyer pulls the yarn forward and it winds effortlessly onto the bobbin. She continues like this, working rhythmically, hands and feet in perfect sync.

I am itching to give it a try. Kristine starts me off, attaching some fiber to my bobbin. I grasp it between my fingers, just as she did (though with a death grip that will later, once more, leave my hands aching), and start to treadle with gusto. The wheel immediately lurches backward, like time unwinding, snarling the fiber. I give it an encouraging nudge in the proper direction with one hand, but as soon as I add my feet it happens again; maybe the bad fairies have gotten to it after all.

When I do manage to get things going for a minute, my yarn twists way too tight, turning in on itself in knots and coils known as pigtails. I try to adjust, treadling more slowly, and end up with slubs—thick, unspun chunks—that clog the flyer's orifice (a word that rivals "moist" as the grossest in the English language), causing the yarn to pull off the bobbin rather than winding onto it. The yarn breaks. I try again. It falls off the guide hooks of the flyer. I try again. It tangles impossibly. I try again. I sprint on the treadles when I should stroll (in my defense, treadling is the fun part!). After a half hour or so of this, I feel discouraged. Everything already feels so hard in the middle of a pandemic; why am I trying to do something even harder?

Kristine's street has a fair amount of foot traffic—spending time outdoors is one of the few things people can do these days. A mail carrier, dog walkers, joggers, all pause to ask what we're doing or just nod and say, "Cool," as they pass. Several people, again, crack grim jokes about skill-building for the apocalypse. Although I'm not ready to turn all Oregon prepper, I have found myself, during the pandemic, contemplating what I would do if we somehow lost the big assists of technology—electricity, modern medicine, grocery stores, agreed-upon borders and boundaries. My grandpa's frontier tales never indicated exactly *how* his dad, who grew up in urban Russia, learned to clear that rocky Dakota prairie, to build fences (let alone a house!), plow fields, cultivate wheat. I know their life was not without adversity: Great-Grandpa Abe not only lost entire harvests to hailstorms but, before he gave it up, buried two sons and his still-young wife.

I have become fixated on the reality TV show *Alone,* in which contestants are dropped solo into the wilderness and have to figure out how to survive: the person who guts it out the longest gets a half million dollars, which does not seem nearly enough, especially after taxes, for their level of suffering. They routinely lose 25 percent of their body weight; a few have been badly injured or have become perilously ill; there are grizzly bears. The toughest part, though, is always mental. Without human interaction, even the most hardened bushcrafter cracks, convincing themselves that their loved ones miss them so much that they have no choice but to go home (I imagine their families watching the show yelling, "NO! WE'RE FINE! STAY! GET THE MONEY!").

I don't know if I'd be as compelled by *Alone* if I didn't feel, to some degree, that we are all living an aspect of it now: the stress and isolation, if not the threat of our food supply's being eaten by a wol-

verine. Everyone seems to be in a survival-themed defensive crouch—gun ownership among first-time buyers skyrocketed in 2020, right alongside the sourdough starter. I recall during the height of the anti-nuke movement, my high school social studies teacher split our class into groups of eight, assigning each member a character to play. "The bombs have launched," he intoned, "and there is only room for four of you in the bunker. Make the case to your group as to why you ought to be one of them." I can't remember who I was supposed to be back then—not the doctor, is all I can tell you, because the doctor *always* got in—but I do know who I am now, and let's face it: a woman nonfiction writer in her late fifties is not going to make the cut. Not without some serious skills, anyway. So I admit, I google "how to build a spinning wheel from scratch" and print out the plans, since when, as Jay at Bodega Pastures said, "it all goes down," there may not be power for my computer. When I inform Steven that spinning will be my ticket to survival, he laughs. After the apocalypse, he says, there will be enough clothing to last for decades in the abandoned stores and empty houses. If I really want to be viable I should learn to butcher meat or study medicinal herbs.

We have been married nearly thirty years, so I decide to ignore him.

THERE ARE COMPETING THEORIES about when, or even where, spinning wheels first emerged. It could have been in ancient Egypt, but maybe it was in China. Unless it was in India. Or Baghdad. Probably it happened sometime between 500 and 1000 AD, which seems an awfully broad time span, but that's what happens when you're talking

about centuries. At any rate, if the recognition that the mouflon's hair could be spun into cord set off one revolution, the introduction of the spinning wheel sparked another. I'm no PhD, but for my money, the spinning wheel was among the most influential inventions in human history, up there with the printing press, the combustion engine, the electric light, anesthesia, and, oh, I don't know, Snapchat. The wheel sped up cloth production—it was as much as a hundred times faster than a hand spindle—and, in Europe, its rise in the fourteenth century has been credited with everything from establishing trade routes, to the creation of banking systems, to laying the groundwork for modern navies, to the development of affordable paper, to catalyzing the Renaissance.

If that weren't enough for one seemingly unassuming tool, the wheel provided greater financial and social independence for some women, especially the never-married (those "spinsters" again) and widows, who were allowed to own their own shops; the latter, uniquely, could also leave property to their daughters providing they had no male heirs. Also, women were forbidden from joining guilds, the trade unions of their day, which set prices for goods and gave members economic clout. Spinning guilds were an exception: they were *exclusively* female (women were also, for some reason, allowed to be beer brewers). For centuries, the wheel supplemented rural incomes through cottage industries, based in actual cottages. Children carded raw material from their family's own sheep or plants; women spun thread and men wove fabric to sell locally; later, home carders and spinners were subcontracted by merchants. I'm surprised I never learned in school about the transformational effect of the wheel—I would've liked history a whole lot better if I had—but I can only surmise it was because the hands behind it were female.

Yet another spin of history changed all that. In 1764, James Hargreaves, a carpenter and weaver in Lancashire, England, came up with the spinning jenny: a hand-powered machine with multiple vertical bobbins that allowed one spinner to do the work of eight. It's generally said that Hargreaves was inspired when his daughter, Jenny, knocked over her spinning wheel, which then continued to function despite its spindle being bent upright. That's a charming tale but untrue: Hargreaves didn't even have a daughter named Jenny, and the source of the machine's name has been long since lost to history. Still, people do like a good origin story. An earlier invention, the first mechanical stocking-knitting machine, was said to have come about because a sixteenth-century clergyman named William Lee thought a lass he was wooing was more focused on her knitting than she was on him (though it seems entirely plausible she was doing her best to politely ignore him and he was just a dude who couldn't take a hint). An alternative, and to me more appealing, version holds that Lee was already married and was trying to spare his long-suffering wife further manual labor. Either way, when he petitioned Queen Elizabeth to approve the contraption, she balked, saying that she loved her poorest subjects way too much: mechanization would deprive them of critical income from their subsistence hand knitting and turn them into "beggars." That seems an astonishing conclusion for a monarch, given the wealth and power such an innovation could have conferred on her.

It was also prescient. Four years after the invention of the spinning jenny, a mob of aggrieved spinners—precursors of the Luddites—whose livelihood it had threatened, stormed Hargreaves's home, where he was selling the machines, and smashed them all to bits. Again, as a person whose profession has been devastated by the digital

revolution, I can relate. But progress was inexorable, especially once England's parliament made the destruction of textile machines punishable by *death*. Within a few years automated spinning and weaving technologies proliferated; the earnings for hand spinning—which had until then been the most common and highest-paid work for women—plummeted, and the cottage industries disappeared.

It's easy, as a twenty-first-century crafter, to romanticize the pleasures, the artistry, even the transcendent nature of spinning, or else to marvel at the first rock's being lashed to the first stick to make the first spindle. I wouldn't want to do that, not entirely. Especially after the Industrial Revolution—which started in England and was both driven and financed largely by those new technologies for producing fabric—making cloth was menial, monotonous, and dangerous work. Those young, single women were now brought out of the home, along with, for a time, children as young as six, and put to work in the mills and garment factories: they were seen by employers as more easily controlled than men and could be paid less for the same work. Most of the women (girls, really) were teenagers, between fifteen and twenty. They were expected to leave their unskilled jobs once they married; those who did not, rather than being valued for their expertise, could see their earnings free-fall as they aged.

American mill workers considered their conditions to be more humane than those in England, but they still toiled through twelve- to fourteen-hour days for meager wages (and employers secretly slowed the clocks to further extend hours). The noise on the floor was ear-splitting; their lungs filled with lint dust; the belts and gears of the machinery could catch their hair, ripping off their scalps. Male supervisors beat and sexually harassed them, even as factory owners promoted the environment as "moral" and "orderly." They had no

power, no recourse, and it would be nearly a century until any of them got the vote. Yet in 1834, when their wages were abruptly cut by 15 percent, girls in Lowell, Massachusetts, became the first workers in the U.S. ever to go on strike. A group marched from mill to mill, urging other young women to join them, finally gathering in an outdoor rally.

Their bosses warned that "a spirit of evil omen had prevailed" in this "amizonian [sic] display." Within a week the walkout was crushed, as was another two years later. But the girls did not give up. They formed the first union of working women, organizing, petitioning, lobbying. Although they would see virtually no victories in their own time, their courageous efforts, out of what can only be described as whole cloth, formed the foundation of both the modern labor movement and the women's movement. Subsequent young, female textile workers followed their lead: in 1909 in New York City, twenty-three-year-old Clara Lemlich led an eleven-week strike that became known as "the Uprising of the 20,000." Manufacturers hired hooligans and sex workers to physically attack the protesting girls; a corrupt police force either watched or joined in the assaults.

Then, in 1911, in a matter of minutes, 146 immigrant workers, mostly Jewish girls, some as young as fourteen, either were incinerated or plunged to their deaths in a fire at the Triangle Shirtwaist Factory. They couldn't escape the blaze: the exits had been locked to prevent them from taking unauthorized breaks or stealing bits of fabric (there was no evidence anyone had done either one). The fire remains one of the deadliest industrial disasters in U.S. history. Senator Elizabeth Warren, who had announced her presidential candidacy outside a Massachusetts mill that had been the site of a nineteenth-century strike, invoked the Triangle Shirtwaist tragedy during a 2020 speech

in Washington Square Park, describing how onlookers watched in helpless silence as "a woman jumped, and then another, and then another. They hit the ground with a sickening thud. They died on impact. So many, so fast. The women's bodies piled up. Their blood ran into the gutters." Everyone at the time knew about the hellish conditions of the mills and factories. There had been plenty of media coverage. The government chose to do nothing, putting corporate profits before people. Is that really so different, the senator asked, from today's responses to gun violence, to health care, to climate change?

As a Jewish woman myself, I've always felt connected to those Lower East Side activists, those girls who could have been me, could have been my daughter. Their lives—and deaths—inspired reforms that are still in place in this country today, such as a shorter work-week, a minimum wage, safety protections, the abolishment of child labor. It occurs to me, too, that it is no coincidence that so many ardent spokespeople of today's social movements—including Parkland, Florida, gun control activist X González; education advocate Malala Yousafzai; and Swedish environmentalist Greta Thunberg—have been teenagers who grew up in biologically female bodies. They are the Lowell girls, the New York City garment workers, of our time.

KRISTINE, MY SPINNING TEACHER, learned to knit and sew in the living rooms and around the kitchen tables of her grandmother's friends in rural Illinois, basking in their chatter and laughter. She came to associate crafting with women's love and community, with memo-

ries invisibly stitched into handmade garments. It wasn't until much later, as a college student studying in India, that she started thinking about textiles more politically. It would have been hard not to, given how intertwined cloth was with colonialism. Industrialization had created a voracious need for cotton in England with no way, in its pea soup climate, to produce it. But India? That country had been growing the crop for thousands of years. When the Civil War disrupted imports from the United States, the Crown systematically destroyed India's robust, local industry and reshaped it to serve Brittania: sabotaging spinners and weavers and pressuring farmers into replacing food crops with cotton.

The impact was devastating. In the 1870s alone, as the mills of England thrived, between six and ten million Indians starved to death. In the 1890s, that number rose to nineteen million. No wonder rejecting British-made textiles in favor of *khadi* ("homespun cloth") became a cornerstone of Mahatma Gandhi's campaign for Indian self-rule. Gandhi himself spun for an hour every day (usually starting at four a.m.) and urged all Indians to do the same. On the day his country declared its independence, he was in Calcutta appealing for an end to the violence between India and Pakistan while fasting . . . and spinning.

On that first trip to India, Kristine walked by open-air workshops in urban areas, saw how hard and quickly people labored. She stepped around puddles of dye that ran into the roads. Were they toxic? She also began learning from the Rabari people, seminomadic herders whose boldly colored, spectacularly embroidered fabric communicates history and identity. She began to realize that clothing could tell a story, launch a conversation. "And," she says, "I started to ask how we can include the people who make our clothing in that

conversation." I tell her what I've discovered about the environmental cost of our wardrobes, how overwhelming it can feel to parse every purchase, to ensure it supports sustainability and fair working conditions.

"I get it," she says, nodding. "One of my strengths and weaknesses is that I'm an American girl. For better or worse, I was raised wearing the Gap. But rather than thinking about what you *can't* have, why not think about what you *can*—about abundance? It's like, if you're trying to eat less sugar you wouldn't want to just focus on vegetables, right? You'd want to imagine a range of delicious food. So, maybe you buy previously owned clothing. Or you find the people who are being thoughtful, or doing something that inspires you and you want to support their story and their work." Kristine has gone through phases where she's tried to hand-make as much of her clothing as she could—sometimes everything but her shoes. It's the opposite of fast fashion, encouraging you to cherish every piece. I may not go quite that far, but I appreciate her reframing of possibility.

An hour ticks by and I have managed to get a wee bit of yarn on the bobbin, mostly by stopping, untangling the rat's nest I've made, and winding it on by hand. The results are wildly uneven—some sections as skinny as sewing thread, others as plump as a cotton ball. Nonetheless, Kristine seems pleased. "You did it!" she exclaims—my new favorite phrase—calling my efforts "art yarn." "People pay lots of money for that," she adds. "Enjoy it, because you'll never be able to do it again without special training." I look at my bobbin skeptically. As a child, I was often told something similar about my curly hair— "People pay a lot of money for that!"—and I hated it. The comment seemed implicitly compensatory, since it wasn't like I had a choice: it just grows out of my head this way (thanks, Dad!).

It occurs to me that it is vanishingly rare to find (or allow) ourselves, as adults, to be in a position of being absolute rank amateurs. At least I tend to avoid it; I don't like doing what I'm not already good at. If nothing else, the enforced tedium of the pandemic gave those of us who were neither ill nor essential the opportunity to experiment, to find comfort, competence, and escape in developing fresh skills. Spinning demands that my hands grow accustomed to things they've never done, to shapes they've never made, to work in novel and unfamiliar concert with my feet. It calls for patience and persistence, neither of which is my long suit when starting something new. It's all a bit like the feeling you get when you try to pat your head with one hand while rubbing your stomach with the other. There are flashes, seconds, when it comes together—when left hand, right hand, and feet move in harmony—but most of the time my limbs are as tangled as my thread.

"It really is like riding a bike," Kristine comments. "It involves a lot of muscle memory." She encourages me to spin a little every day, promising it will click. "In the end, it's more about the miles you spin than the perfection of the yarn," she says. "Don't go back or try to mess with it. Just keep going forward and practicing. And I promise, you're going to have such fond memories of what you're making. It will have a special place in your yarn archive; you'll see it there someday and say, 'Oh my God! My first yarn! How cute!'"

5

the prick of the spindle

AFTER A WEEK OF DAILY SPINNING, I find myself settling into flow, at least for a minute or two: that feeling of complete immersion, total absorption in the task at hand. Pinching, pulling, smoothing back—I am suffused with well-being, a sense of peace, not dissimilar to the feeling of being lost in writing. Craft can mean so many things depending on the context. It can be exploitative or liberatory, subsistence or luxury, rote or creative, an act of conformity or rebellion, of belonging or individuality. Making can be a way to resist a disposable culture, to connect to basic processes in a world where we've lost such

awareness, a world that, too often, reduces us to either workers or consumers. For me, at bottom, it is simply a source of joy.

The yarn winds onto the bobbin, where I imagine it could someday make swaddling for a newborn, a dress for a bride, a shroud for a departed loved one. I think about how we enter, move through, and exit this world wrapped in cloth, how unconsciously it marks us. Seeing an infant enfolded in that classic flannel receiving blanket—you know the one I mean, white with pink and blue stripes—catapults me back to the delivery room, to the exhausted, ecstatic moment of meeting my daughter. My mom, on her death, was clothed in a tunic and pants of plain white linen. All Jews are traditionally buried in those same hand-stitched garments—made without buttons, zippers, or other fasteners—as an affirmation of our fundamental equality before God. They give the corpse a generic quality, which is appropriate: without the animating spirit, it was no longer her.

I do my spinning (both mental and physical) alone in my office, but in the past, women worked in community, whiling away time by gossiping and joking. They told stories, meant for adult ears, that involved the transformation of poor girls into princesses: girls who had lost their mothers' protection through the mundane tragedy of death and whose only hope was a good marriage; stories that would later be called "fairy tales" and gathered for print by men named Grimm and Perrault and Giambattista, who would pretend they were the authors and become rich and famous and even immortal. Along the way, those men, especially the Grimms, ratcheted up the grisliness, believing it would scare children out of bad behavior, but to spare those same children's tender sensitivities, they excised the considerable sex and bawdiness. Did you seriously think that the prince stopped at *kissing* the comatose Sleeping Beauty? That Rapunzel and her beau chastely held hands when he visited her in that phallic tower

where she was imprisoned? Before the Grimms got ahold of them, both ladies were preggers with twins well before the wedding bells chimed (it was, incidentally, the babies, not the guy, who woke Sleeping Beauty in the Giambattista variant, by suckling the splinter out of her finger—imagine her surprise!).

The women spun their stories along with their thread, so naturally spinning was part of the narratives. In "The Six Swans," a princess rescues her brothers, who had been turned into birds by their stepmother, by spinning and sewing shirts from painful stinging nettles while remaining silent for three years. In "The Three Spinning Women," a girl is saved from the dreary task of making thread by a trio of "ugly" matrons in exchange for inviting them to the feast when she marries the inevitable prince. In "The Golden Spinning Wheel," a dutiful young spinner's eyes are gouged out and her hands and feet cut off by her own mother and sister. Eww. But, never fear, she prevails in the end.

Then there is "Rumpelstiltskin," whose plot is universal in the West and beyond—there are iterations in, among other places, Iceland, Scotland, the Netherlands, Italy, Serbia, Turkey, Russia, the Arabian Peninsula, the West Indies, nearly anywhere that relied on spinning (which is to say, everywhere). A quick refresher, in case you've forgotten: It is the tale of a miller who brags to the king, falsely, that his daughter can spin straw into gold; the king promptly imprisons her with a bale and a wheel and threatens to chop off her head if she doesn't fill the room with riches by dawn. A magical imp completes the task for her, once, twice, then—after she marries the king—a third time, demanding her firstborn child for his trouble. Her only recourse is to guess his name, which, in a moment of high drama, she does (spoiler: it's Rumpelstiltskin); he howls in rage and tears himself in half. The end.

The tale has been traced back over four thousand years, before any

of those previously noted countries or their languages even existed. In the first rendition that the Grimm brothers gathered, a young girl could not *stop* spinning straw into gold. Rumpelstiltskin offered to restore her to normalcy, allowing her to attract that all-important prince. It would seem counterintuitive that the girl (or her potential husband) would value making yarn over making gold, but the folklorist Jack Zipes suggests that yarn *was* a spinner's gold, linked to "regeneration, narration and creation." Maybe. Or, it could have been a warning to women that conventionality was their greatest asset, sort of like the TV show *Bewitched,* in which—because: patriarchy—a woman needs to suppress (or at least obscure) her natural gifts in order to keep a man.

By the time the Grimms published the story, the never-named girl had become a pawn to male power. Now the bluster of her father sets the tale in motion; the little man creates gold; the servant who discovers the imp's name for the girl is also male, though in earlier tellings she was a woman. Zipes believes the Grimms' changes unconsciously reflect the movement of spinning from the home, where it was under female control, to the mills, where young women became cogs in male-owned concerns. Excellent theory, but to me the ability to make that case largely shows how flexible and open to interpretation fairy tales truly are.

I always found "Rumpelstiltskin" befuddling, frankly. Why does the girl want to marry a man, even a king, who has threatened to kill her? Besides which, the little man helps the young queen out of a jam and how does she thank him? By reneging on her bargain and forcing him to self-destruct! Who's the real villain here? On the other hand, "Sleeping Beauty" (or "Briar Rose"), another story that revolves around spinning, speaks to me more—and differently—with each rereading. Again, in case it's been a while, in the variation we

tend to know, a princess is cursed by a fairy (who is angry at being excluded from the girl's christening), destined to prick her finger on a spindle at age fifteen and die. Kinder fairies soften the curse, so she merely sleeps for a century, then is awakened by true love's kiss, and happily-ever-after ensues.

Once upon a time, I simply skimmed the surface of the story, absorbing the romance plot, dreaming of the handsome prince who would someday see how special I was—even if I was passed out—and choose me for his queen. That myth was still ascendant in the pre-feminist 1960s, when I was little; it was the wish my own mother had for me, and I don't think she ever really gave it up. Later, as I began writing about girls, I viewed the prick of the spindle and the spilling of blood as emblematic of puberty; Briar Rose's sleep became a reaction to too-early sexualization, the protected time she needed for her own internal metamorphosis to womanhood. I bridled at the idea that a prince should be the catalyst of her awakening. Why not another princess (or, these days, someone who identifies as both? Or neither)? Why couldn't Rose waken herself, on her own terms, in her own time?

Still later, as a new mother for whom sleep was a vague memory, I read "Briar Rose" as a warning: We can't protect our children from peril. The more we try, the more vulnerable they become to whatever it is that we fear. If the king had not destroyed all the spinning wheels in the realm, if he had taught his daughter instead how to face and defend against danger, she might not, in her naivete, have reached for the first deadly bobbin she saw. It was her ignorance, really, that was the true curse, that courted disaster.

That said, I empathize with the king—we all want to shield our children from pain and, maybe especially with girls, keep them young, keep them close, delay the risks that come in this culture

with their burgeoning sexuality. I have watched my own baby girl with pride and apprehension as she grows and changes, becomes entranced by her own image in the mirror or its reflection in the magic glass of social media. She chafes against my authority, pushes for more freedom. Can she watch *Euphoria*? Go to a party where no parents will be present? What about a mixed-gender sleepover? A trip with the girls to a house in Tahoe (and how did that empty beer bottle get into her backpack)?

She counts down the days until she'll leave for college, and I, I have to learn to let go, to allow her space to awaken, to hope she does so with power and wisdom and a minimum of hurt. In some ways, I am newly eager for her to leave. As much as I'll miss her, I worry the pandemic has become its own sharpened spindle, that trying to eliminate all physical risk by (to borrow from another story) keeping her locked in the tower of our home will result in other, unforeseen, psychic costs. All around us, teens we know are succumbing to depression, eating disorders, ideological rigidity, and worse.

Meanwhile, I find that I, too, am awakening from slumber, thick with the sleep of eighteen years during which my first priority was someone else's happiness, safety, and well-being. I have no road map for what comes next, when my time is once again my own. I feel groggy and disoriented, as if I've risen too early, even as, in this unnatural year, my child has been home with me more than any time since infancy. I wish I could ask my mom about it, turn to her for a "clew" to the next part of my life's thread, the path from Lachesis to Atropos, from matron to—*gasp*—crone. Would she have been able to advise me? It's impossible to know. At any rate, by the last few years, she was in no shape to have such a conversation, and that brings a whole new round of mourning her loss.

So I read "Sleeping Beauty" once more, and this time I think about

which parts of myself I have allowed to grow dormant—what passions, what sorrows, what desires, what furies have been lulled into quiet by more pressing concerns—and what it would mean to roust them. There is a reason that "wokeness" has become both imperative and punch line. We are all Briar Rose, asleep to something, whether individually or collectively: systemic racism, a dying planet, misogyny, our inner selves. We sleep until we are ripe and ready for knowledge, and we hope that sleep does not go on forever, robbing us of both our present and our future.

IF MY MILES OF spinning were walking, I feel, after a month, like I have hiked the Pacific Crest Trail. I've worked through multiple pounds of top, and my consistency is infinitely better. I continue to marvel at the wonder of this fuzz turning to thread between my fingers—I would happily stop this project right here and spin endlessly, though I don't know what I'd do with the result. Give it to a king, perhaps. I do find that when my hands spin, my mind does not: the task is meditative and soothing, an excellent distraction at a difficult time.

I work with three bobbins, filling the first two with spun "singles," then plying those strands together in the reverse direction (so they won't unravel) onto the third. I wind the plied yarn onto a thing named, delightfully, a niddy-noddy: a dowel with T-shaped crossbars on either end that lets you quickly create a skein of one-yard loops, making it easy to know exactly how much yarn you have. It's unclear where the word came from; it may describe the back-and-forth "nodding" motion your hands make as you wind.

The next step is to remove the skein and soak it in water for about

fifteen minutes, then roll it up in a towel to remove excess moisture, followed by the best part of all: thwacking. I hold one side of the skein, whirl it a few times like a lasso, and smack it as hard as I can against the edge of the bathtub. *Thwack!* I give the skein a quarter turn and *thwack!* Whee! This is somehow supposed to set the twist of the yarn. Whatever. I'm just happy to have something that both is easy to do and releases my pent-up aggression. *Zoom school?* I think. *THWACK! Anti-maskers? THWACK! Covid? THWACK!* Alternatively, you can "snap" your yarn, by placing your hands inside a damp skein and yanking them quickly apart, but that is less enjoyable. I hang my thwacked yarn from the shower rod, weighed down on the bottom with a clothes hanger to pull out any last bit of kink, and let it dry. Slowly, over weeks, my collection of practice skeins grows. They are starting to look almost professional, though I'm still fairly certain I could spin "art yarn" without special training.

People spin from all kinds of things. Fiber from sheep, obviously, as well as cotton, flax, hemp, and the cocoons of silkworms. Also the hair of llamas, alpacas, goats, possums, and camels. There are sites advising on how to spin yarn from your dog's fur, which makes a very warm garment. It works best with double-coated breeds like Samoyeds and collies; those with poodle DNA, like mine, are poor candidates, because that no-shedding hair-fur wants to felt. I'm a total dog person but still—not judging—the whole thing seems a little creepy. If you must, you can even spin from a cat. That princess from the "The Six Swans" who was forced to spin with stinging nettles? That may sound torturous, but she likely would've known that once you strip the plant's leaves and soak and dry the stalks, the stinging hairs disappear, leaving a soft, breathable fiber similar to linen. No wonder fairy tales associated that cloth with magic!

It is possible to spin angora straight from the bunny; lightweight and silky, the fiber gives sweaters that touchable, fuzzy "halo" favored by 1950s Hollywood bombshells like Lana Turner and Jane Russell, who wore them over bullet bras. But angora has a troubling past. Heinrich Himmler, leader of the Nazis' SS, spearheaded "Project Angora" to provide warm, stylish fur for soldiers' uniforms, especially the lining of elite air force pilots' jackets. The Third Reich raised 65,000 rabbits in all, housing them in the infamous death camps, in conditions far superior to those of the Jews and other prisoners. Snapshots found among Himmler's personal effects after the war by Sigrid Schultz, a pioneering American woman war correspondent, showed the rabbits—sometimes held by officers or pretty, young women—next to rows of immaculate, roomy hutches. Each photo was labeled with the site where it had been taken: Buchenwald. Dachau. Auschwitz. The contrast was stark. "Thus," Schulz wrote, "in the same compound where 800 human beings would be packed into barracks that were barely adequate for 200, the rabbits lived in luxury . . . In Buchenwald, where tens of thousands of human beings were starved to death, rabbits enjoyed scientifically prepared meals. The SS men who whipped, tortured, and killed prisoners saw to it that the rabbits enjoyed loving care."

If nothing else, the Nazis were forward-thinking on animal rights. They weren't the only ones. About seventy-five years later, a viral video shot by PETA showed Chinese workers ripping fistfuls of fur off of writhing, screaming, raw-skinned angora rabbits (you can still find the video online; be warned that watching takes a strong stomach). The market for the fiber in the West instantly collapsed, as well it should have. I don't want to compare companies like H&M and ASOS, both of whom vowed to stop carrying angora in the wake of the controversy,

to the Third Reich, but it would have been nice if the industry's moral outrage (and PETA's) had extended to reexamining its abhorrent labor practices. During the pandemic, treatment of the largely female workforce in Asia that toils for Western companies—already rife with underpayment, inhumane hours, and violence—deteriorated so badly that it is now referred to as the "garment industrial trauma complex." I guess human workers are just not as cute as bunnies.

Finally, I feel ready to take on Martha. I pick up one of my rolags and start to spin. It becomes immediately apparent that whoever sheared this sheep—we will not name names—did not do a professional job. Remember those second cuts? My rolags are full of them, which means the fibers are uneven, often too short to spin. Clumps slip through my hands or won't tease out. I try to shove in the odd bits but they hang off the edges of the yarn, and when I give them a light tug, they pull right out. Still, one way or another, I find I can spin much of what I've carded, and that feels like a win. There is not enough here for more than a two-ply yarn, but that's fine. I also realize belatedly that I have spun my singles too thick, as if they were themselves a final product rather than about to be doubled, so even my two-ply yarn is what's known as "super bulky." There is nothing I can do about that once I've started, not when I have so little fleece to work with.

I make my way through the rolags, spinning, plying, winding, soaking, and thwacking. And then, one day . . . the spinning is over (spinning always stops at some point, doesn't it?). I have just shy of twelve hundred yards of yarn, which ought to be enough for a medium-sized women's sweater, and it's time to move on to the next phase: the dye pot.

6

i would dye 4 u

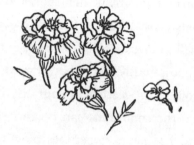

MY FRIEND HELEN KRAYENHOFF IS CO-OWNER of Kassenhoff Growers, an organic seedling nursery specializing in plants that thrive in Oakland and Berkeley. That is no small feat. The Bay Area is a mishmash of microclimates, a concept I'd never heard of, let alone experienced, before moving here thirty-two years ago. I had never aspired to living on the West Coast. I moved to San Francisco from New York for a boyfriend and, secondarily, for a magazine editing job. The boyfriend lasted four months, the job three years.

The weekend before I moved, a friend dragged me to a psychic deep in Brooklyn whose walls were covered with faux-wood-patterned contact paper. She predicted that I'd meet a man near a bridge who would change the course of my life. Although it has not upped my faith in clairvoyance (this was 1988; if she was really psychic, why wouldn't she have bought Apple stock and gotten out of that apartment?), it is true that on my first date with Steven, about two and a half years later, we ate dinner at a restaurant at the foot of the Bay Bridge—he lived on one side of it and I on the other. He was a brilliant, sexy filmmaker who made me laugh and made me think; also, he was a fabulous cook. I was on the verge of moving back to New York when we fell in love; despite some rocky times, we still are, so, more or less serendipitously, here I have stayed.

For most people, the weather in your city is the weather. Everywhere. But here, the conditions can be entirely different from one neighborhood to the next, sometimes blocks apart. During those early years, when I still lived in San Francisco, I would leave my office in the Mission District on a sunny late afternoon thinking I'd head to my apartment in Haight-Ashbury, about three miles away, and bike through Golden Gate Park before dinner. But halfway home, I would see the fog hanging in a low, damp wall ahead of me; the temperature would drop, and I'd decide to get a latte and read in a café instead. By now, when the radio announcer says, "The highs will be between sixty and eighty degrees," it is second nature to estimate what that means for my particular location and anywhere I might be visiting during the day. It's all about the layers: putting them on, taking them off, putting them on, again and again.

The microclimates also affect your garden, and, really, the key is to see what longtime residents of your block are growing and follow

their lead. During the hopeful warmth of May, I used to optimisti-
cally (or, one might say, stubbornly) plant tomatoes, peppers, and
cucumbers. Then—*bam!*—June gloom would roll in and settle over
the hills, often for weeks. The tomato blossoms would rot at the stem
and drop. The cucumbers became covered with powdery mildew. The
peppers never stood a chance. Sure, there were those tomato strains
recommended for foggy climes, but they never really got sweet. That
requires heat—which there was, plenty of it, about a five-minute
drive away. I watched enviously as my friends' produce flourished
under their days' longer, hotter sun.

Eventually, I gave up, though lately I've been tempted to try again.
The fog has been steadily declining in the Bay Area: it's dropped by
about a third during my lifetime and is noticeably less prevalent than
when I first moved here. Now on summer and autumn nights, the
temperatures rise with the altitude as I drive up the hill, sometimes
as much as nine or ten degrees. The weather at my house is becoming
more like that of the towns on the other side of the ridge, away from
the coast. I enjoy the newly warmer evenings, but it's disconcerting.

At any rate, Helen has the microclimates wired. She's also an avid
knitter (SLFHM) and learned to spin as a teenager in Canada be-
cause, like me, she thought it would be a handy skill to master in
the event of global cataclysm; in those innocent days—before pan-
demics and the recognition of climate change and the rise of Tucker
Carlson—the Big Bad of our collective anxiety was mere nuclear ho-
locaust. "You remember," she once said to me. "We all thought the
world was going to end. I learned how to winnow wheat, too. And I
perfected my baking and gardening." No question: I will definitely
be heading to Helen's when the bombs drop. She lives with her wife
and business partner, also named Peggy (a source of much hilarity

between us), in an urban oasis in Oakland, uncommonly thick with vegetation, both cultivated and natural. In addition to the nursery, Helen knits and sells hats that she dyes using color made from plants she grows or forages. They look, in the best of ways, like they should be worn by pixies. When I mention my project to her, she gifts me a cell pack of madder seedlings. Madder roots have been a source of natural red dye since antiquity. It's a hearty plant, easy to grow, that will take over your garden given half a chance, kind of like mint (which yields drab gray-green dye, not mint colored at all). But there's a catch: it generally takes three years for madder roots to mature enough to make color. So, although I take the plants, as I pat the soil around the seedlings, feed and water them, I feel uneasy, questioning how deep my own transient roots run.

It wasn't just the Bay Area or even my marriage that I came to accidentally; it was this house, too. I was thirty-five when we bought it, not young, but still restless, still the self-styled picaresque protag of my own life's story. I resisted any suggestion of material encumbrance—buying a couch had been a major concession. Furniture, I suspected, would lead to owning a home, which would lead to having children, which would lead, seemingly inexorably and inevitably, to giving up my writing, the thing that I believed made me me. It was a maxim of the era, after all, that women could not "have it all," and I knew, if it came down to it, what I would choose.

My rootlessness felt safe, free, if, in retrospect, after eighteen years of motherhood, misguided: my calculus of parenthood's sacrifices versus its joys, in particular, was badly skewed. "Don't plan on my having kids," I said breezily to my mom when visiting on my thirty-fourth birthday. It was almost a dare, that rejection of her life and values as a woman, that dagger to the heart. I watched the color drain

from her face, yet in a moment of preternatural maternal wisdom and restraint her only response was, "I'd be sorry not to meet your children." I can only imagine what she later said to her friends. And Steven? He hoped I'd change my mind, which, obviously, I did (though subsequent years of infertility meant we would have only one child), but he was a natural nonconformist himself, skeptical of convention in any form. He would never hold on too tightly, which was part of what drew me to him.

Still, by the mid-1990s, rents in the Bay Area were climbing steeply, as were home prices. Our landlord informed us he was selling the house we were renting; it had too many structural defects for us to take on—the floors tilted so precipitously that my wheeled desk chair would career into my office wall whenever I stood up—but since we would be forced to move, it seemed wise to take the plunge. We bought the smallest, least expensive house we could find (the latter a relative concept around here), one that wouldn't hold us hostage to a mortgage; but, while we love our neighbors, the neighborhood itself has never been a great fit. After the convenience of living in New York City and San Francisco, I rankle at having to drive ten minutes to the market when I run low on milk or forget the cilantro. As Daisy has gotten older, the house is too remote to be a hangout for her friends; they want, or did before Covid, to roam the thrift stores and cafés of central Berkeley with all the other teens. That has exponentially reduced my potential for the kind of casual eavesdropping that is so useful in knowing your kid, let alone the machinations of her friendships. Even so, the hills are beautiful—verdant in the spring, gold in the summer, with panoramic views at every turn—and through the accrual of memories (along with a good deal of remodeling) the house feels more or less like ours. But I have never fully lost

my ambivalence, nor the sense that I landed here by happenstance rather than choice.

I PLANT MY MADDER in October, when fire season is raging in earnest. On visits to Minnesota, I used to tell Steven that the state has just two seasons: winter and road work. *Ha ha.* But the idea of fire as a recognized "season" (one that keeps extending) is horrifying: in winter it rains, in spring it grows, in summer it dries, and in "fire season" . . . it burns? The arrow on the wooden danger-level sign at the top of our hill seems permanently pointed to red—highest risk. One day, the city sends out an email in which someone has hand-drawn a new, off-the-charts, more extreme alert, black with red stripes. They are calling it "catastrophic," and it was invented for a once in twenty-years event: parched and hot with winds forecast to hit seventy miles an hour. I would better label the category "terrifying." Or maybe just "exhausting."

Yet again, the three of us set out our go-bags in case of evacuation. In another, larger bag, to take assuming the burning roads are passable by car, I throw in a portfolio of my pre-internet magazine clips and, on a whim, my favorite jeans, because it's so hard to find pairs that fit. Steven adds his awards: an Oscar, an Emmy, and a Peabody for his documentaries along with a judo trophy he won in high school. Daisy grabs her tallis—her Jewish prayer shawl—which a friend of mine made for her Bat Mitzvah from a vintage wedding kimono, a blending of her Jewish and Japanese identities. We had tied its ritual knots as a family. I needlepointed the bag that holds

it, the pomegranates in the design representing the fruitfulness I hoped would ripen in her life. When she chooses it as one of her most precious possessions, I flash again on the ways textiles can evoke the sacred, the familial, the traditional, and the new all at once. Then I have to leave the room to cry.

I know the house will likely survive this event; it may very well be here indefinitely, never burn down, but I realize, in my bones, that I don't want to keep doing this. I stare out the window of my bedroom, my eyes resting on the gnarled old fig tree, dotted with lichen, that grows near the front fence. When we moved in, I was charmed by all the fruit trees in our yard—the Meyer lemon (a thin-skinned, sweeter variety that is popular with chefs like Alice Waters), the Santa Rosa plum, the Bartlett pear, the Fuji apple. The space is tiny but bountiful—prototypically Californian. That first year, the fig tree was heavy with sweet, juicy fruit. I don't know why, but it never yielded like that again and the squirrels invariably beat us to the few figs that did ripen.

Steven would like to cut the tree down, but it seems so stately that I have begged him not to. So, over the years, we have pruned off its dying branches, supported the remainder with two-by-fours jammed into the dirt. Whoever lives here next can do the final deed. The tree has those iconic, lobed leaves, huge and fibrous, the ones you see in paintings covering Adam and Eve's genitals to hide their nakedness: humanity's first underpants. I've always thought that was unlikely, because the cut stems of fig leaves ooze a white, milky substance that irritates human skin. In fact, any contact with the leaves gives most people a nasty rash, so if the first couple strapped them onto their nethers, they were in for some serious discomfort. Then again, if you're going to buy into the seven-day concept of creation and the

whole serpent-seducing-Eve-into-eating-the-apple thing (once more, hello, patriarchy!), the use of fig leaves as lingerie is hardly going to be a deal breaker.

Kristine had suggested that I start my dyeing by using plants from my own garden. In ancient times, people could only work with what was locally available; that meant most folks wore a lot of brown. More than the historical novelty, Kristine tells me that embracing a version of Dorothy's Kansas—looking no farther than my own back-yard for my heart's desire—will deepen my sense of home and place. "Before I knew how to natural dye, I didn't know the identity of any of the trees in my neighborhood," she says. "It's not that I didn't care, but why would I know? Then I started to learn about different plants and flowers and how they work and their attributes and where they come from. I love that history, it's another form of storytelling. And it connects you differently."

As with those three-year madder roots, that prospect rattles me a little. Is a stronger link to my environment really what I am after? Maybe what I want is the opposite: to loosen my ties, to prepare to go. Still, for now, I am stuck in this house, marinating in its memories and meaning. Of all the trees, the fig most represents our life here. Although the catastrophic-fire-warning means this is not a good day to dye—nor, I think grimly, its homophone—I decide that when the danger passes, when we get a stretch of cool temperatures, I'll give it a try.

The windstorm never does get as bad as predicted: the house does not burn and within a day or two we return to our lockdown routines. While I wait for the heat to break, I pore over guides to natural dyeing, each of which reflects the sensibilities of its era. A nineteenth-century recipe book often recommends "lead sugar" and

cautions that boiling vegetable matter too aggressively will turn it "dun colored." Hmm. A volume from the 1970s encourages me to dye my macramé projects, which I would, if I'd kept the knotted basket I started in fourth grade for my beloved spider plant (I never did finish it and threw the plant away when it became beset by icky red mites). Current manuals, by Kristine as well as master dyers Jenny Dean and Sasha Duerr, stress the links between natural dyeing, cultural diversity, and climate change ("My aim as a natural dyer has been to use only dyes from renewable sources," writes Dean).

One thing they all agree on is that it's imperative to keep precise records of your process: how much dyestuff was used, the weight and fiber content of the textile that was colored, how long everything was heated and soaked at every stage. A dyer's journal is like a chef's cookbook and the only hope for reliably replicating your outcomes. Ideally, you would include small samples as well—say, pieces of yarn tied to labeled index cards. I would like to say I listened to that sage advice, because it is clearly prudent. But I did not, because it seemed boring and time-consuming. This was not my most mature choice, and because of it, I doubt I would ever be able to make the same shades twice.

I thought my fiber was clean—I spent enough time scouring and carding the fleece—but apparently, it's not clean enough for proper dyeing. I fill the six-quart enamel pot I've purchased just for this purpose with water (don't use your regular cooking implements to make dye, even nontoxic dye, because you never know), add a dollop of dish soap, toss in a small skein of my spun Bluefaced Leicester, heat it all up, and let it soak yet again.

Next comes mordanting, which I've been told is the most important part of the entire dyeing process: immersing the yarn in a

solution of metallic salts and water. "Mordant" comes from a Latin verb meaning "to bite," the same root as for mordant wit; in this case it helps the color chomp down, binding to the fabric so it will last longer without washing out or fading in the light. People have used all kinds of things as mordants—rusty nails, tin cans, copper, soy milk, manure, human pee. Some old standbys, like chrome, are carcinogenic (for the dyer, not for those coming into contact with the finished product) so best avoided. Others, like iron or tin, can be irritating when inhaled and in 2020 I'm taking no chances with my lungs. Copper, when disposed of, can harm aquatic life, so that, too, is a nonstarter.

Most hobby dyers stick with aluminum sulfate, or alum, which, historically, was sometimes used as an ingredient in pickles to make them crunchy. That pleases me. My grandmother was an avid pickler, and I still have the recipe for kosher dills that she typed on her trusty Smith Corona (I also have her trusty Smith Corona, which I keep on a shelf near my desk). It is full of typos, the misspellings of a nonnative speaker, X'd out mistakes, and instructions such as "Shake each Jar down real good and fill up with pikls." My mom made pickles every summer, too, until a batch exploded in the basement, she suspected from botulism, and she became convinced she might poison us. So much for *that* mother-daughter tradition. Luckily, if I screw up on my current efforts, no one dies.

The mordant you choose not only ensures the yarn accepts the color, it can also affect its relative brightness and depth, as just about anything can: the minerals in your water; its temperature and pH; the ratio of textile weight to water to dyestuff; how and when that dyestuff was grown and harvested; the kind of metal your pot is made of; the fiber you are dyeing (silk, cotton, wool). Natural dyeing is se-

rious craft: a fusion of art, chemistry, received wisdom, instinct, and practice. It is the work of years to master it. Trying to learn it in a few months, even more so than my other developing skills, is pure folly.

Once my yarn is scoured, mordanted, and ready to go, I fill my pot—which I have begun to think of as a cauldron—with leaves I cut from the fig tree (wearing gardening gloves to avoid skin rash), then cover them with water. Once more, I heat the concoction to 180 degrees and try to hold it steady for an hour, to extract every scintilla of color. A sweet and spicy aroma fills the house—figgy. It straddles a line between the crisp scent of Christmas greenery and its decomposing aftermath: either pleasant or putrid, sweet or cloying. My family splits over which side of the divide it lands on. Daisy, passing through the kitchen, wrinkles her nose.

"Mom, that smell is *horrible!*" she says. From the den, Steven counters, "I kind of like it, it smells like nature," but an hour or so later, when the house still reeks, he changes his mind.

The liquid itself is muddy and brown—I'm not sure it should be— with the leaves lying in a sodden lump at the bottom like overboiled cabbage. I strain them out and drop in a skein, which instantly turns a deep, earthy gold. "Pee colored," Daisy declares. I think that it has more of a medieval, Middle-earth vibe.

Next, I pour half the liquid into a second pot so I can try adding an "assist," an ingredient whose chemical makeup will change the color: Something acidic, like a splash of vinegar, can shift it more toward yellow. An alkaline, like a smidge of washing soda, might bring out the pink. I sprinkle in a pinch of powdered iron that I bought at Kristine's store, and—*abracadabra*—the color of the liquid "saddens," turning a dark, greenish gray. I drop in a new skein of yarn and it turns a mossy green, like something you'd see in Sherwood Forest.

These are not exciting hues, but they are for me more wearable than a hot pink or a vivid turquoise.

More to the point, I just dyed two skeins of yarn—yarn that I spun myself, if not sheared. They may not be beautiful, but I don't care. The feeling of accomplishment, of excitement, of, again, *I did this!*, is exhilarating. Daisy and Steven, too, are unusually enthusiastic (though, even after the rinsing and drying, Daisy notes that the fig smell stays in the wool, where it will remain, permanently). I didn't dye enough yarn on this first foray to knit up more than a small swatch, but before the fig leaves turn brown and drop for the winter, I resolve to try again, and to make enough yarn for a hat. That way if and when we leave this house—whether due to fire, out of volition, because it's time, or because we must—I'll carry part of it with me.

COLOR IS, AT LEAST in part, a social construct. I know—sounds bananas, right? What could be more universal, more immutable, more *obvious* than the yellow of the sun, the green of the trees? But consider this: the ancient Greeks did not see blue. They just . . . didn't. Or, more accurately, they saw it, but they didn't *perceive* it. In *The Iliad* and *The Odyssey*, Homer characterizes the sea as "wine-dark"—a phrase he also uses to describe oxen. Or else he declares it to be purple, the same color he assigns to the sheep that Ulysses and his men hide beneath to escape the Cyclops's cave. Honey? Homer labels it green, just as he does a human face struck with fear.

The scholar who first noticed these peculiarities, a classicist and former British prime minister named William Gladstone, hypothe-

sized that the ancients' eyesight must have been physiologically less developed than ours—he believed they saw solely in black and white, with maybe a little red thrown in. Perhaps they had acyanoblepsia, a form of color blindness that renders a person unable to see blue. But that was untrue. The prism's hues were simply not an important descriptor in the Homeric age, according to Guy Deutscher, a linguist and author of *Through the Language Glass.* Nor were the Greeks alone in this quirk. Biblical Hebrew, classical Arabic, ancient Chinese, Tibetan, Vietnamese, Celtic, and Lakota are just a few of the languages that once had no separate concept for blue; many described the sky with a word for green. Both colors were called ao in ancient Japan. By the twelfth century, "midori" emerged to indicate green, but it wasn't until after World War II that it truly became a distinct color. Even today, the "go" light on traffic signals in Japan is, to Western eyes (including mine), plainly blue—the country's government claims it is just the bluest shade of green.

If it seems unfathomable that someone can look at green and believe it to be blue (or vice versa), Deutscher suggests you take a peek at what we call "white" wine. Or, more disconcertingly, "orange" juice, which is more often yellow. Go ahead and check, I'll wait. English speakers, by the way, did not have a word for the color "orange" until a couple of centuries after the fruit was introduced to Europe: before that, we said "yellow-red."

Russians consider it bizarre that anyone could think "light blue" and "dark blue" are shades of the same color; to them, the two are as dissimilar as grass and sky. Because of that, in lab experiments, Russians are able to distinguish those blues more rapidly than people whose language doesn't differentiate between them. It's so hard to absorb. I think about the endless hours I've spent staring at the ocean

trying to name all the gradations of blue I can see, contemplating the depth and breadth encompassed by that one color. Is it possible for someone not to recognize those variations at all? Is it possible there are colors out there that I am missing entirely? Steven and I have never been able to agree on whether the couch in our living room is blue (as I insist) or green (as he does). Now I wonder, could he perceive it differently because his grandparents were from Japan, where green and blue were both historically "ao"? Or am I more sensitive to blue because my ancestors were from Russia, where it is divided into multiple colors? Could such things be passed down familially, like pickle recipes? Or is he just, you know, *wrong*?

A popular theory developed by a pair of Berkeley-based anthropologists in the late 1960s claimed that words for color emerged in a prescribed order as societies developed, starting with basic ideas of "dark-cool" and "light-warm" (which include black and white but encompass anything else that might fit). Those were followed by red (perhaps because people need a word for the color of blood), green *or* yellow, green *and* yellow, blue, brown, and then either purple, pink, orange, or gray. While that order is common, it's not universal—even the fact that the anthropologists believed that it was, let alone that the chromatic spectrum was the only way to define color, is itself, arguably, cultural. For the Japanese, according to historian Michel Pastoureau, a color's shade may sometimes be less important than whether it is "dull" or "shiny," and who are we to disagree? In parts of Africa, he adds, "blue" or "brown" is less germane than whether a color is "dry or damp, soft or hard, smooth or rough, mute or sonorous, joyful or sad." Do not ask me what those things might mean, because I have no idea, which I'm sure would boggle anyone for whom the descriptions feel natural.

Then again, doesn't a color's material matter? Although they are all a similar hue, the blue of the chamois I use to clean my computer screen is not really the same as the one that illuminates the numbers of my LED clock, and both are different from the color of my eyes (fun fact: blue irises are actually brown; our perception has to do with their low levels of melanin and a trick of light). And all of those are qualitatively different from the wet, fathomless blue of ocean water. In Western culture, Pastoureau points out, we ignore those variables, the impact of light, sheen, luminosity, temperature, density—they simply aren't germane to us, don't enter our consciousness. So yes, color definitely exists, but it is we who imbue it with meaning: with relevance, poetry, pomp, hierarchy, holiness.

I don't need to broaden my rainbow to begin seeing my own surroundings differently. As I explore the possibilities of natural dye, my perception pulses with almost psychedelic wonder. I begin to understand what Kristine was talking about. Branches and leaves seem more articulated. Every leaf, every tree trunk, every plant, every seed, every bug, every lichen, every mushroom, every fruit, every vegetable seems new. The range of greens when the sun shines on the apple tree or camellia bush in my garden, the plethora of browns on the bark of their trunks, the myriad tans and beiges among the weeds that give the California hills their golden glow, all mesmerize me. What colors might be hiding within? What might be released if I submerge them in my cauldron, maybe adding a hippity hoppity of iron or vinegar?

Pear leaves, I discover, would make similar yellows to the fig, so I pass, although if I were a more advanced practitioner, I might attempt to make a pinkish hue from the tree's bark. Our lemon tree, disappointingly, would offer up only greige. Flowers from oxalis, a weed with which for years I have been locked in a Sisyphean battle,

make a neon yellow; interesting, but a little lurid and not lightfast. The redwood cones I collect on the playground down the street while throwing a ball for Ginger turn my dye water magenta, but the yarn I add comes out brown. Onion skins also make yellow, and carrot tops with a powdered-iron assist yield olive.

What about beets? you might ask. Don't they make a lovely red? Yes, but I do not mess with them, because beet dye, even when mordanted, fades with exposure to light or water. It's considered a "fugitive" dye, which makes me imagine the color stealing away in the night, like a thief evading justice. Avocado pits are supposed to make a blush pink that sets internet dyers aswoon, but I suspect these are the same people who are in paroxysms over the "unicorn" haircut (don't, I beg you). When I try it, I end up with a muddy pinky brown that Daisy, who does not mince words, glances at and pronounces "ugly." I try twice more, thinking I've used the wrong pot, or the wrong water, or too little (or too much) heat, or overdone the mordant, or not used enough, but my results are always the same.

There are so many things that could go wrong, yet a surprising number go right. Helen gives me another gift from her nursery: dyer's coreopsis, a daisylike annual with blooms that, on the same plant, range from entirely yellow to entirely red to yellow with red centers. Coreopsis grows quickly and prolifically so I harvest its flowers daily and set them to dry on a fine mesh net I've hung in my office. When I have a cupful—which takes weeks since they dry down to little more than a speck of dust—I simmer them and divide the liquid in half. A little vinegar in one makes a vivid yellow yarn, which is nice, but I hit the jackpot with the other by adding a half teaspoon of washing soda. The dye bath, and then the yarn I dunk into it, turns a rich, warm reddish orange. Bingo. This is Martha-worthy.

I also have great luck with marigolds; Lora gave me a trash bag full from her farm after our shearing lesson, and I dried those as well (though not before my office was overrun by the earwigs hiding among them). Steeped for an hour, they give me my favorite of all the yellows—less "pee colored" than the fig, less neon than the oxalis, and while I was also partial to the yellow from coreopsis, I preferred to save my stash for its redder shades. I throw a second skein into the marigolds to soak up any remaining dye and get a lighter, mellower color, a little like whipped egg yolks and sugar. This is the most fun I've had yet.

My wood-shingled office becomes a witch's lair, smelling of must and mildew. Desiccated flowers and leaves are strewn across my desk. The bookshelves overflow with old yogurt containers that are brimful of dried or rotting mushrooms (they were supposed to make yellow; they didn't, not for me, anyway) and mason jars of moldering extra liquid dye that I haven't had a chance to use but can't bear to throw out: more coreopsis, marigolds, and dahlias (yellow again) with a variety of assists. All that is missing is eye of newt, which is just sorcery-speak for mustard seed and, anyway, turns cloth an uninteresting beige. Daisy and Steven stay outside, calling to me from the deck rather than coming in to talk; I stop myself from cackling in reply (though I do once yell, "Poppies! Poppies will make you sleep!"). In Terry Pratchett's *Discworld* books, a comic fantasy series that Daisy and I dipped into when she was in elementary school, a witch's cackle was an indication that her mind was unspooling: "It meant loneliness and hard work and responsibility and other people's problems driving you crazy a little bit at a time, each bit so small that you'd hardly notice it, until you thought that it was normal to stop washing and wear a kettle on your head." Based on that description, most women

my age have, I think, earned the right to cackle a bit; maybe during the pandemic, we all did.

You might have noticed I mention yellow a lot. It is the easiest color to make, the most prevalent in nature. Orange is also relatively simple. Green is fairly common as well, at least the grayish tones—sage, basil, olive, moss. A true grass is tougher. Back when all fabric was locally dyed, you could tell where a person was from by the shade of their clothing. Someone who lived near the ocean had access to different plants, roots, fungi, moss, than someone who lived in the forest. Northerners and southerners might have different options, too. If we used only natural dye today, the colors I could access using persimmons, pomegranates, and loquats (all of which are widespread in, if not indigenous to, the Bay Area) would mark me as different from those whose options derived from the pine needles, coneflowers, and junipers of my native Upper Midwest. Color could indicate tribe, culture, social status. That makes sense: even in our era of infinite possibility, the hues and fabrics of our wardrobe continue to define us, don't they? When I defied my dad and stalked off to Manhattan after college, I brought with me tops and skirts in powder blue, emerald green, lemon yellow. I thought they looked mature, professional, but in the media world I was entering—imagine me as Anne Hathaway in the early scenes of *The Devil Wears Prada*—the only acceptable fashion choice was black on black.

Within a few months, I had expunged all color from my closet. My mom, who favored pastels and flower prints, lamented that I looked hard-edged. She meant that to dissuade me, but it did the opposite. I reveled in my new citified armor, all sinew and attitude. Six years in New York made such an intractable sartorial imprint on me that it would be decades before I risked branching out as far as

navy blue. While as a knitter, I adore vibrant yarns—I love to touch them, squeeze them, pet them, fantasize about them—I never buy them. The sweaters I make skew toward admittedly dull shades of gray, navy, brown (I draw the line at black; the stitches are too hard to see). I do generally use hand-dyed, high-end natural fiber bought exclusively at locally owned yarn stores, for which I pay a premium. All of those things—the hues, the cost, the craft and content of my materials—are statements, whether I mean them to be or not, about my values, politics, class; they mark me as elitist or environmentalist, depending on who's judging. Truth? It's probably a little of both.

I QUICKLY GROW BORED with my initial, hobbit-esque palette. I want to try something more exotic—say, purple. Purple was, basically, the black of the ancient world, the power color connoting wealth and privilege, or proximity to it. Cleopatra traveled on a barge festooned with purple sails to seduce Mark Antony. Things worked out less favorably for her grandson, whom Caligula (his first cousin) had executed for rocking an opulent purple cloak in the arena, detracting attention from the emperor himself. The amount of the color the ancients could wear was strictly regulated by something called sumptuary laws and meted out by rank. At various times, priests, generals, politicians, courtesans, and actors all had carefully delineated levels of access to it, but it was forbidden to most commoners on penalty of—yup—death. Centuries later, in England, Queen Elizabeth I restricted purple to close relatives of the royal family, though violation of the edict only incurred a fine.

Not that the hoi polloi could've afforded purple anyway: one pound of dye cost three pounds of gold. That's because the only source of the color was a milky mucus extracted from the butts of a particular sea snail (yeah, not so regal sounding, is it?). Snail-tush purple, known more formally as Tyrian purple after a city in today's Lebanon that mastered its production, was not only colorfast but became deeper and richer with wear. The most prized shades were described as resembling clotted human blood, a substance that, to be fair, was believed to have divine properties. The trouble was, each mollusk only produced a few drops of precious liquid (whose processing was redolent of the orifice it came from). It took up to 250,000 of them to produce a single ounce of dye; archaeologists in Europe have excavated billions of discarded snail shells, in some places mounded over 150 feet high.

These days, thankfully, there is an alternative for natural dyers: the bark of the Central American logwood tree. True, the color it produces is more on the fugitive side—it can fade with exposure to sunlight—but maybe we should start accepting such routine change and wear in all our colored garments, the way we do, for example, with denim. Anyway, I figure if I'm going to stray from my own yard I might as well go big and go royal. I'm still not ready to work with wood chips, so I order an ounce of sustainably produced powdered logwood extract on the internet. It costs thirty dollars and will turn a pound of yarn deep purple—a bargain, all things considered.

Spontaneously, I decide to risk going full-on Martha with it but, in case of disaster, stick to only a couple of ounces of her yarn. Aiming for a medium tone—I want to avoid the clotted-blood impression—I measure out 1 percent of the yarn's weight in powder, dissolve that in water, then heat it in my cauldron. Is it cheating to use store-bought

natural dye? Maybe, but the results are spectacular, a dark plum that I'm certain would get me murdered by Caligula. I throw in a second skein to sop up any remaining color and it turns a shade of periwinkle that I like even better. In an instant, my days of brown, green, yellow, and orange are over. Although in theory, I grew to appreciate the idea of using my color work to deepen my sense of home and place, in reality, I want to dye as I have lived: seeking adventure, novelty, unpredictability, refusing to be tied down.

Snail anuses may have been avoidable, but I can't get around the insects. Madder root (the one from my garden that won't be ready for years) makes a serviceable red, but it tends to run more toward brick. To make something pop, you gotta have bugs. Ancient Egyptians, Africans, and Europeans made crimson from the bodies of pregnant kermes, parasitic scale bugs (I don't know how they distinguished which were pregnant, though overall the females are larger than the males). In Asia the lac, also a scale bug, was used for millennia to make burgundies and pinks; the color was extracted from a resin exuded, once more, by the females, a substance that became known as shellac (yes, *that* shellac—it's bugs!).

Then, in the early sixteenth century, Hernán Cortés, the conquistador, noticed that the Aztecs were making a brilliant, durable carmine from cochineal, yet another scale insect. When squished, the females (again!) produce a single drop of pure color that is ten times more powerful than that of kermes. It still takes a heap of them to produce a viable amount of dye—seventy thousand for one pound. Call me species-ist, but given that they're bugs, that bothers me less than the wholesale slaughter of all those snails. Still, I do wish the insects didn't have to all be ladies.

Within a few decades, cochineal became the most coveted red dye

on the planet, and for two hundred years, only the Spanish knew its source. As with Tyrian purple, red became a signifier of wealth and status, so that monopoly was worth a fortune, as valuable to the Spanish empire as gold or silver. Pirates preyed on dye-carrying vessels: the Earl of Essex (whose crew included the poet John Donne) made off with more than twenty-seven tons of cochineal in one raid, worth, according to historian Amy Butler Greenfield, over eighty thousand pounds in British sterling. This at a time when Queen Elizabeth herself took in sixty thousand pounds a year, and the annual wages of a cloth dyer were six pounds.

I am not much of a red fan. I suspect I absorbed the aversion from my mom, along with my fondness for Doris Day and irrational hostility toward Debbie Reynolds. There are so many things, really, that a girl LFHM. My mom's antipathy toward the color extended beyond clothing, lipstick, and nail polish to hair; she'd become uncharacteristically outraged when anyone referred to her as a redhead (although, if you think about it, that is a misnomer, likely dating back to before the English word "orange"). She insisted she was blond, but based on photos from my childhood she did clearly, much of the time, lean distinctly ginger.

I recalled that idiosyncrasy when I first visited her grave, a little over a year after she died. It took me a while to find the marker: a pink granite rectangle, flush with the ground, her name etched in English and Hebrew next to a pair of tulips and above "Beloved wife, mother and grandma." In spring, the spot was pleasant, parklike: dotted with trees, near a pond, peaceful despite being squarely in the city. I stood for a while, lost in feeling, then, according to another Jewish custom, found a rock to place on the grave, something enduring to show that I'd been there. Returning to the car, my eyes blurred

with tears, I was startled by a large fox that trotted out from behind a tree; it paused next to my mom's headstone and looked directly at me. I couldn't imagine that she would come back as a fox—not only was she not big into wild animals but *it had red fur!* Then again, maybe apparitions don't get a choice, maybe it's any port in a storm. I later discovered foxes are associated with playfulness, protection, luck, and magic; she was always kind of sly like that. "Mom?" I said hesitantly. The fox swished its tail. Its *red* tail.

Despite my bias, I end up giving three different reds a turn in my cauldron: madder (using powdered extract since my plants are too young), lac, and cochineal—kermes is no longer widely available. A little ground chalk (or Tums) added to madder produces a tasteful maroon. I go light on the lac extract, hoping it will yield something closer to pink, and end up with a color that is, I'm sure, the one Prince had in mind when he wrote "Raspberry Beret." A second skein dropped in the same pot comes out a rosy lavender shade. I'm pleased with both. The cochineal turns the dye water the color of cherry Kool-Aid. *Pretty!* My first effort comes out a warm garnet, the next a cotton candy pink.

Naturally produced dyes were all there was for millennia. Until 1856, to be precise. That's when an eighteen-year-old chemistry student named William Perkin, home for Easter break, was conducting experiments in a makeshift lab, trying to impress his mentor by distilling quinine (a cure for malaria) from the sticky, stinky sludge left over when coal was burned for the gas that lit streetlamps. This was not as far-fetched as it sounds. Malaria was rampant in the nineteenth century, and quinine was scarce and pricey; coal tar had a similar chemical makeup and was newly plentiful as well as exceptionally difficult to dispose of (mostly it was dumped in rivers). There

definitely seemed a two-birds, one-stone potential there, but Perkin failed in attempt after attempt. Then he noticed something odd: a stubborn purple residue that wouldn't rinse out of the test tube. When he wiped it with alcohol, the color transferred to the cloth. He had inadvertently invented the first synthetic dye.

It's hard to overstate the impact of this. If you look around the room in which you are currently sitting, virtually every color in it likely owes a debt to his discovery, a hue that would be named Perkin purple, mauveine, and, finally, mauve. More than that, according to biographer Simon Garfield, Perkin's invention launched the modern chemical industry. The hundreds of components of coal tar would be spun off to become building blocks for products as diverse as detergent, laxatives, dandruff shampoo, sulfa drugs, photographic materials, Teflon, mercurochrome, synthetic fiber, perfumes, solvents, paint, fertilizers, weapons, roofing, analgesics, anesthetics, and more. Aniline (coal-tar derived) dye itself would be key to the understanding of chromosomes, the discovery of the bacteria responsible for tuberculosis, the research that led to chemotherapy. Only problem is, coal tar continues to be a significant water pollutant and likely carcinogen, so there's that.

The textile industry, you'll recall, was newly booming in the mid-nineteenth century, so Perkin's timing could not have been better. Mauve was a hit with fashion icons. When Queen Victoria wore it to her eldest daughter's wedding, she kicked off what the press of the time referred to as the "mauve measles." Purple lost its imperial status virtually overnight, becoming, in its easy access, positively plebeian. Other aniline colors soon followed: fuchsine (later renamed magenta), yellow, blue, violet, green. Resplendent and inexpensive to produce, each one caused a sensation. Ordinary people, freed from

dowdiness, went wild for the new hues, causing a backlash among the upper crust, who declared their brilliance "gaudy" and a sign of "inferior quality." It could also be toxic. The finishing process for some aniline dyes, particularly reds and pinks, left small amounts of arsenic on fabric. When it became damp—whether from perspiration while dancing or a walk in the rain—the poison could leach into the skin, causing an ugly rash, or worse (Napoleon is rumored to have died of arsenic poisoning, a result of exposure to the fashionable, arsenic-laced green wallpaper in his bathroom, where he loved indulging in long, steamy soaks). Although washing a garment would make it safer, laundering faded the colors; since they were the whole point, people avoided it.

How could the natural dye industry compete? It couldn't. It quickly collapsed, taking thousands of years of knowledge and expertise with it—kind of like my grandma's pickle recipe—never, for the most part, to be recovered. Perkin himself planted a patch of madder in a lot across from his home, humblebragging that it might otherwise become extinct. By 1870, just fourteen years after his eureka moment, cochineal dye, once worth more than its weight in gold, was barely produced at all. A century later, it did come around again as a natural coloring for food and makeup. If the ingredients of your favorite red comestibles or cosmetics include the words "carmine," "carminic acid," "cochineal" (obviously), "natural red number four," or "E-120"? Bugs. You'll find cochineal in lipstick, eye shadow, vitamins, strawberry yogurt, applesauce, juice, cake mix, gummy bears, raspberry jam, Popsicles, cheese, sausages, some Hot Pockets (!), and ketchup. Until 2006, it was in the liqueur Campari. (Side note: a number of candies with shiny surfaces, such as candy corn, Junior Mints, Jelly Bellys, and Whoppers, are coated with shellac from the lac bug.) Cochineals

are definitely not vegan, nor are they halal or kosher. They are also a little gross, but you know what's grosser? The most common alternative, red dye 40, which is made from petroleum.

Once more, I find myself marveling that although I have been so aware for so many years of what I put into my body—how my food is grown, where it is grown, with which pesticides, using whose labor—I was oblivious to the impact of what I put on it. Clothing production, especially dyeing and finishing, is, all by itself, responsible for a fifth of the world's industrial water pollution. A little arsenic is really the least of it. Dyeing cloth guzzles water (as I'd be the first to tell you, after the endless rinsing of my yarn)—the equivalent of thirty-seven million Olympic swimming pools a year. Factories in the countries where most of our garments are produced freely dump their wastewater—a toxic brew of color, chemicals, salts, and heavy metals—right back into local rivers and lakes.

China has recently begun tightening regulations, but in some regions you can still tell which colors manufacturers are using by looking at the shade of nearby waterways: they might be bright red, hot pink, orange, purple. There are rivers in Bangladeshi garment-manufacturing districts that run black. Dye impedes light, preventing photosynthesis, reducing oxygen levels, and killing whatever lives within. Even when effluent runs clear, carcinogens and endocrine disruptors may contaminate water that locals use for drinking, bathing, irrigating crops. I don't know that the answer would be returning to natural dyes (though that may be a piece of it) since they have their own environmental complexities, but blithely ignoring the problem because—in much the way we were long spared visions of the slaughterhouse—we are cut off from how our clothing is made? That is clearly not tenable.

AFTER WEEKS OF SCOURING and mordanting; brewing up leaves and bugs and bark; anxiously portioning out my Martha, I lay the best skeins in a ROY G. BIV row: the lightest cochineal pink, followed by two different lacs, a darker cochineal, the madder, a skein of orange coreopsis, two shades of yellow from marigolds, a green from the fig tree, both of the logwoods. I set a few lesser successes to one side, mostly workaday yellows or greens: from the oxalis, the dahlias, cosmos from a friend's garden, onion skins. But I don't quite have a full rainbow, not yet—I'm missing the "B" and the "I" of that old primary school acronym. Similar to Homer and the ancients, I seem to have produced every color except one: blue.

7

something blue

MUSIC IS A MADELEINE. WHEN I am ninety-four—if I am ninety-four—
and the details of my life grow hazy, I am certain I will still be able to
call up every lyric to Joni Mitchell's *Blue,* the way my dad, even when
otherwise incoherent during our wool-carding sessions, would rally
to "Give My Regards to Broadway." *Blue* was the first album that
grabbed me by the throat, the first vinyl record that I actually wore
out. A budding guitarist, I pored over Joni's open tunings and chord
shapes, trained my voice to sound like hers, or as close to it as I could

get. My vocal range has narrowed and dropped with age (as, to be fair, has Joni's), but I can still warble a creditable "Carey." Nor do I have to wait until senescence for the songs to hurtle me into the past. When *Blue* pops up on my Spotify, I am instantly transported to my chilly childhood bedroom, the lights shut off, cloaked in early winter twilight. Behind me, taped above my headboard, is Sylvia Plath's poem "Mad Girl's Love Song," scrupulously copied out in multicolored Flair pens—would I remember that detail without the prompting opening notes of "River"? The record changer arm is up so the disc plays on repeat. My sixteen-year-old self listens to Joni and cries, the sort of luxuriant tears only available to those who have not yet experienced real sorrow. "I'm so hard to handle," Joni croons, "I'm selfish and I'm sad." *Yes I am, Joni,* that younger me thinks, *yes I am.*

These days, I don't have time for a romantic wallow. No, that's not true. Of course I do—especially during quarantine: it's not like I'm going anywhere. There is plenty of opportunity to brood and languish. It's more that now, closer to life's end than its beginning, I have to be careful, parsing out my blue in small bits that won't over-whelm: the azure of paths not taken; the midnight of standing at my mother's grave; the cerulean of watching my daughter fill out college applications; the slate of days long past, and the cobalt of knowing how long past they are. That's what it is with blue. The color forces contemplation, wrapping you in an almost—but not quite—pleasant quilt of wistfulness, remorse, reverie, regret. It is not black—blue is gentler, less resigned—but it is close. Goethe wrote that blue's power is that it perpetually recedes, not meeting us, but forcing us to move toward it. Picasso, of course, had his blue period, Wallace Stevens his blue guitar, Leonard Cohen his famous blue raincoat. Jazz standards

assure us that blue skies smile and bluebirds bring happiness, yet that is at odds with the truth of the blues: of "Mood Indigo," of *Kind of Blue* (another album I wore out), of Billie Holiday and Howlin' Wolf. No one, by the way, knows for sure how the blues got its name. One theory holds that it comes from the indigo-dyed cloth some West African cultures traditionally wear when they're in mourning.

Indigo is endemic to India, so it may be no surprise that in Buddhist and Hindu traditions, the third-eye chakra, a portal to enlightenment, is also sometimes called the indigo chakra, or that meditating on blue is said to transform anger into wisdom. Just before lockdown, while trekking for a travel story in the mountains of China's Yunnan Province, I met a Tibetan lama who gifted me a Medicine Buddha amulet. Its lapis-colored skin is believed to bring balance and healing, protection from negative influence. When I got home, I hung the amulet on the doorknob of my office; I have looked at it every day since the pandemic began, and I am not ashamed to say that I have prayed to it, just a little.

All of this to say that blue is not just a color, not just a hue: blue is a spirit, a rhythm, a melody, a relationship, a *concept*. Blue is also a trick. I have already mentioned the illusion of blue eyes, but humans aren't the only ones whose blueness is a lie. The most brilliant blues in nature—the plume of a peacock's feather, the iridescence of a morpho butterfly, the luminescence of Nemo's friend Dory—are deception, a function of physics, of light scattering off of what is, on closer examination, gray, black, or muddy brown. In reality, among us vertebrates, only one species of frog and one butterfly produce authentic blue pigment. There are no blue foods (blueberries are purple) and only a tenth of flowers are blue, making it the rarest shade among blossoms.

Dyeing with blue or, more precisely, with indigo, is all of these things as well—blue and not blue; blue and more than blue. Even the word "dye" trips me up: indigo is in fact a pigment. Unlike the other plants I've used, it can neither be steeped to create a colorant "tea" nor can its powder be easily dissolved into a bath; indigo particles remain in suspension, like a handful of sand, and without help, they dye about as efficiently. Also, indigo doesn't fuse with cloth the way my other dyes did. It has to be built up slowly, in layers, and even then remains only on a fabric's surface. That's why your new, dark jeans will temporarily turn your legs blue—the indigo rubs right off. It's also why those jeans will fade so distinctively over time: indigo's limit is also its strength.

It's possible to dye with fresh indigo leaves by pulverizing them in a blender with ice—you'll get a turquoise or robin's-egg color. I tried that with some plants that Lora, my shearing teacher, gave me, but I forgot to strain the liquid, so, although the color was lovely, the skein became so embedded with leaf specks that I had to throw it out. Anyway, to get the full range of dazzling shades, you really have to make what's called a vat. And before you can do that, indigo's green leaves need to be transmogrified into usable blue: that is an arduous, specialized process, varying by geography and culture, involving some combination of soaking and fermenting the leaves, pounding them, heating them, creating a paste, shaping that paste into balls, drying the balls, and grinding them into powder.

Needless to say, I will be buying my indigo online.

To get that powdered indigo to dissolve and stick to the fabric, you have to make something called a vat: blending it in water with an alkaline base and a reduction agent that sucks the oxygen out of the liquid and transforms the pigment's molecular structure. If that sounds like a chemistry experiment, it is—chemistry or magic, potato, potahto. I prefer the latter, as usual. Whenever anyone tries

to explain to me the actual science behind it or why it is necessary, I develop an uncontrollable urge to check my text messages.

I do know that there are a variety of materials you can use to catalyze that reaction: Powdered iron, for one, but it is not recommended for wool, and anyway, it's toxic. Ditto, lye. You can also try henna, though it creates excessive sediment at the bottom of the vat, leaving you less room to work. Plain old fruit is a handy option—overripe bananas, mangos, dates, pears—except those vats can take a while to set up and are tricky for a beginner to maintain. Ida Grae, a doyenne of 1970s natural dyeing, cheerfully describes how to make a urine vat, traditional in some cultures, suggesting you ask your family to pitch in by peeing in a bucket in your backyard (helpfully, she recommends adding a lid). She also says you need ten gallons of the stuff. And it has to age six weeks. So, yeah, maybe that is a time-honored, respected method, and I'm not putting the knock on that, but still: maybe not.

The easiest chemical combo, and the one I gratefully go with, is a mixture of powdered indigo, pickling lime (which, like the alum mordant, is sometimes used to give dills their gratifying crunch), and fructose powder, a simple sugar. That seems reasonable. As a bonus, I can neutralize the liquid with vinegar when I'm done and pour it down the drain or possibly use the dregs for compost. Soil to soil: it's all very *Little Red Hen*.

Frankly, the accident of ingenuity that allowed anyone to figure all of this out is beyond my comprehension.

I HAVE ONCE AGAIN taken over my back deck, covering it with a plastic tarp and setting out all my supplies: elbow-length rubber gloves, a Dreyer's ice-cream apron that I got as a freebie and don't mind

wrecking, a mortar and pestle, a kitchen scale, a digital thermometer, PH-measuring papers, a variety of measuring cups and spoons, a broomstick, several rolls of paper towels. I have filled a five-gallon bucket with blisteringly hot water and put it on top of a seed starter mat, a heating pad for greenhouse plantings that I'm hoping will keep my water warm, or at least from cooling as quickly, because if a vat drops below a certain temperature, it won't dye properly. I have consulted myriad videos and websites about setting and using an indigo vat. I think I'm ready.

I had always believed indigo dyeing was an Asian art—in India and Japan, obviously, but also, some years back, while on another trek, this time through terraced rice fields in the far north of Vietnam, I passed rough-hewn houses with corrugated tin roofs, often with massive indigo vats in the yard, along with a plot of dye plants. The traditional costume of the Hmong minority that lives in that region is made of indigo-dyed hemp decorated with elaborate embroidery and appliqué, all produced, as you'd expect, by the women. Needless to say, I came home from that trip laden with indigo scarves, table runners, and pillow covers. But indigo is indigenous to a number of places, including parts of Central America, the Middle East, and, especially, Africa. Typical of all things blue, the plant in those regions is much more than a color. Indigo repels biting insects, guards against sunburn. It is a natural antiseptic, an anti-inflammatory, a sexual stimulant, and an abortifacient. In premodern Japan, samurai warriors wore indigo-dyed cloth beneath their armor to help heal wounds and used it to make flame-resistant uniforms for firefighters. Even today indigo extract is recommended in that country for eczema relief and hyped as a miracle ingredient in high-end skin care products.

A friend had introduced me to Catherine McKinley, a writer and

curator who spent four years traveling along the indigo trade routes through eleven countries in West Africa for her book *Indigo: In Search of a Color That Seduced the World*. She explained how, in that region, indigo makes the intangible tangible, entwining with birth, death, love, beauty, vanity, so many of life's vicissitudes. "When people were having a child they would have cloth woven and dyed in a specific shade and use it to wrap the baby when it was born," she said. The cloth would be used again when that child was married as well as for other special occasions and milestones. Eventually, at the time of death, the cloth would cover the person's body and accompany it to the grave. "The idea is that it carries you, protecting you, summoning and easing each life passage." I imagine, as a mother, the comfort, the joy I would feel in giving my infant something so precious, something that would safeguard her long after I was gone.

McKinley talked about West African indigo as an historically female story. Women dominated its production and trade, allowing a rare path to wealth as well as political and spiritual prominence. "Over the centuries, through time and the manipulation of religious power, men usurped that role," she said, "but some of the ancient methods have persevered." McKinley herself, though she has hand made two indigo quilts, was one of the few women I met who did not LFHM, at least not precisely. Growing up, she longed for a "Black maternal relationship," which was not possible with her adoptive white parents or the birth mother she hadn't known; indigo's magic brought her something akin to that, among the women she met in Africa. So hers, she said, "turns into a mothering narrative anyway. The art of dyeing, the communities of women who do it, and the largely domestic spaces where it is done—plus the trust necessary to be let in—meant that I was part of a warmth and intimacy I'd always

yearned for." West African indigo dyeing, she added, was historically dominated by women.

As with other rarefied dyes I've mentioned—the red from bugs, the purple from snails—it takes a huge amount of raw material to make the smallest amount of usable product: twenty-five pounds of leaves for a single ounce. And as with those other colors, most of today's blues are produced synthetically, using petroleum and heavy metals: quick and cheap, as long as you ignore the staggering environmental and cultural costs. "This idea that the end product is more important than anything," McKinley said, "it's an erosion of something fundamental, of that intense combining of the spiritual with all the other aspects of our lives. So yes, you can buy your inexpensive blue pants, but you've lost so many other things."

I need seven grams of indigo for every liter of liquid in my vat, so I weigh out 112 grams of powder and dump it into a mortar along with a little tepid water. I unintentionally smudge a thick blue streak across my face, which, try as I might, won't fully rub off for several days and leaves me looking bruised. The indigo isn't soluble, so I grind it and grind it and grind it with a pestle, aiming for a fine, smooth paste. My mortar, which is made of stone, is not quite right for the job: it's way too porous and keeps soaking up the liquid, drying out my pigment. I do my best, pausing frequently to scrape the sides with a spatula to keep the loss to a minimum.

I pour the results into a bowl, rinsing off the mortar and pestle, to capture the last bit of color that clings to them. I weigh out 224 grams of the pickling lime and dissolve that in more water, then, in a third container, do the same with 336 grams of the fructose. I pour the indigo into the five-gallon bucket of hot water, stirring it well with my broomstick, then add the lime and finally the sugar. So far, so good.

Next, I stir the vat in one direction for three minutes—which is far longer than it sounds—to create a vortex, being careful not to splash: that could add oxygen and spoil the reduction, the indigo version of felting yarn. I stop and quickly stir the other way, then *slowly* pull out the broomstick, breathing in the earthy, vegetable smell rising from within. The bubbles on the surface coalesce into a glossy cluster, called the indigo flower. Now, I wait for the contents to settle, to see if the magic has happened.

After a half hour or so, the depths of the vat have a kind of muddy brown, sedimentary quality, but the surface, beneath the floating flower, gleams with a coppery sheen. Nervously, I dip in a spoon and ladle up some liquid; I am delighted to find it is a translucent gold: "leuco," or white indigo. It's not blue, not yet, but it's ready. I could dye with it right now, but the vat's temperature is 180 degrees and it's getting late, so I decide to wait until tomorrow.

The downside is that, while the vat can't be too hot, I also can't let it get too cold. Tendrils of afternoon fog are already creeping across my deck. I have been piling on my Bay Area layers: a down vest over a waffle top over a wool T-shirt. And I'm chilly. The idea of trying to nurse a vat so it stays above the recommended one-hundred-degree minimum is daunting. If worse comes to worst, I can warm it in a larger vessel filled with boiling water. But what do I have that would be larger than a five-gallon bucket? The only possibility I can think of is the bathtub, and there is no way I can heat enough water for that. I put a lid on my vat, turn up the seed mat, and wrap it in old quilts and towels. All night, worry jolts me awake as I imagine those tiny, shivering molecules calling my name.

IN EUROPE, BLUE'S TOP influencer was Jesus's mom, Mary. The twelfth-century Cult of the Virgin sent her cloak's color viral; after centuries of indifference blue became all the rage in painting, stained glass, textiles. When King Louis IX of France embraced it, blue, like purple and red in their turns, was elevated to a sign of nobility, wealth, prestige, and power. At the time, Europeans produced most blue dye from woad, a mustard plant (which would seem like it should produce yellow but doesn't). Extracting the color (or "pastel") from it was no less complicated than it was from indigo, but since it could be grown regionally, the expense was far less.

The woad economy exploded across England, Italy, Germany, and, especially, France, where what is now the region of Occitanie became overrun with the medieval version of McMansions. Compressed balls of pastel were referred to as "blue gold," a term that would later be applied to indigo, and were traded as currency. Woad farming was so profitable that by the sixteenth century, the plant's cultivation had to be restricted because it was endangering food supplies across the Continent. I would have liked to have tried growing and processing woad myself—I live in the right climate for it—but while certain plants (*ahem!*) are now perfectly legal to grow in California, woad is not one of them. It is highly invasive, classified as a "noxious weed," and banned across much of the western United States, though if you live elsewhere you could give it a whirl.

When big money is at stake, things can get ugly. That was just as true in the Middle Ages as it is today. Artisans of the era were limited to working with a single color—it might have been blue, red, or something else—and they never mixed two to create a third, such as combining blue and yellow to make green, or blue and red to make purple. As blue gained ground, its popularity came at the direct ex-

pense of red, digging into the profits of that color's purveyors. According to historian Michel Pastoureau, some on team red went so far as to convince stained glass and fresco artists to make images of blue devils and hellfire in order to create negative associations in the minds of potential consumers—sort of an early fake-news-style gambit.

It didn't work. By the eighteenth century, blue had overwhelmingly become the favorite color in the West, and today it holds that title globally, regardless of geography, race, gender, political affiliation: Republicans are as partial to blue as Democrats. There is no defensible reason, by the way, for the particular coding of the American political system, which dates to the advent of color TV. For decades, the assignment was random, depending on the network, the election cycle, the region; according to *Smithsonian Magazine,* both parties initially tried to lay claim to blue because, in an echo of that bygone controversy over hell, red held connotations of communism. It wasn't until 2000, when *USA Today* and the *New York Times* ran their first color election maps, that our current understanding was cemented; the *Times* graphics editor has said he based his decision on the fact that "Republican" and "red" both begin with the letter "R." History is sometimes woven from slender threads.

The popularity of blue may have endured over the centuries, but not so the woad plant. The blue from indigo is ten times darker than woad's and doesn't fade as readily in sunlight or with laundering. Importing indigo balls from Asia had been exorbitant—the unscrupulous would try to make a killing by selling counterfeits made from pigeon dung—but once it could be grown in the "New World," using enslaved labor (more about that in a minute), the price plummeted, even after factoring in shipping across an ocean. To protect European

woad farmers' livelihoods from the threat of what they referred to as "the devil's dye," the French and German governments tried to ban the importation of indigo, but that only staved off the inevitable. By the mid-1700s, the woad economy had imploded, and its growers went broke or moved on. Indigo's reign lasted about a century, until 1897, when a German chemist, the Perkin of blue, developed a synthetic alternative for which he would win the Nobel Prize; within a decade, commercial production of natural indigo had all but disappeared.

Maybe there's a kind of nothing-lasts-forever lesson in all of this: culturally, historically, financially, technologically, environmentally. The spinning jenny destroyed the livelihoods of hand spinners and was, in its turn, made obsolete by new machinery. Woad succumbed to indigo, which was later, like cochineal, decimated by synthetics. Colors change in perception and meaning. In our own time, the tech industry has bulldozed newspapers; books; taxicabs; movie theaters; brick-and-mortar stores; and, oh yes, democracy. But surely something, someday, will dissipate the Cloud. In the meantime, our parents die. Our children grow and leave. Our spouses age. Places that were once desirable to live in become less so. Fires and floods alter our landscapes. Pandemics strip us of the illusion of control. These days, when I glance down at the hands holding my knitting needles I'm surprised to see they are not my own, but my mom's. Change, some old Greek dude said, is the only constant; learning to accept that, I find, is the work of a lifetime.

I SPEND TWO HOURS struggling to reheat my vat. Despite those best efforts at insulation, its temperature dropped overnight to seventy

degrees. So I cranked up my house's hot water tank to scalding, partially filled the bathtub, then poured pots of boiling water on top of that. I overdid it: my vat is now steaming, too hot for my hands, so now it's back to waiting some more.

Modern chemistry has brought us at least 270 variants of blue, from Absolute Zero, a bright cyan, to Your Shadow, which has a grayish-purple—dare I say mauve?—tinge, to the most recent, the vibrant YInMn Blue, discovered in 2009, again, as an accidental by-product when chemists in Oregon were studying something else. It may be possible, as well, to make myriad shades of natural blue, but I'd be happy with ten: that's how many were displayed in a tutorial by an L.A. instructor in natural dye techniques. It would be too risky to leap right in with my hard-won yarn, so before setting my vat, I had cut squares from a piece of cotton fabric that I'd scoured and soaked in not-quite-simmering water spiked with soda ash. At least cotton doesn't felt, so the task, while tedious, was less fraught than with wool. Also, indigo doesn't require a mordant, so I could happily skip that step.

First up, I tried making an icy hue, one that would be barely visible, a whisper on the fabric. I'd always thought of indigo as hovering exclusively around blue-black, but it turns out to have its own tonal rainbow, one that, McKinley found, can extend beyond blue. When she asked for "indigo" cloth in a Ghanaian market she was presented with green, gray, violet, anything approximating the range indigo produces during oxidation, as dyed cloth is exposed to air. Again, the spectrum's divisions can prove arbitrary. "Color," she wrote, "can be a *space*, and that space, however narrow, can hold one name or many."

I scoop off the foamy indigo flower and set it in a bowl (I'll return it to the vat when I'm done so as not to waste pigment), pick up my

first piece of cotton, dip it into the bucket, and immediately pull it out. The fabric emerges a weak yellowish green. Then comes the moment of alchemy: it begins to turn the color of snow in early twilight. I drop the square into a bucket of clear, cool water and pick up the next one. Again, I dip my cloth, this time for a tad longer, massaging the liquid into it on both sides. Carefully, I remove it, wringing it out beneath the surface to avoid introducing deadly oxygen. This time, the green is brighter; within seconds it morphs into a milky, living color so pure that tears spring to my eyes.

THE PRICE OF INDIGO in Europe was, as I said, prohibitive for millennia, because it had to be brought overland from Asia or, later, via sea trade routes. But by the eighteenth century, with colonialism in full ascent, the British (as well as the Dutch) began compelling farmers in India to grow the plants, with no possibility of profit and often, as with cotton, in lieu of food: Gandhi led his first civil action among indigo farmers. Europeans also established indigo plantations, operated by enslaved people, in Central America and the West Indies. They tried to cultivate the plant in North America, too—the British in Jamestown and the Dutch in New Amsterdam—but the climate refused to cooperate. Success came, improbably, to seventeen-year-old Eliza Lucas in South Carolina, whose father, a lieutenant colonel in the British army, had left her in charge of the family's plantations while he worked abroad. An amateur botanist, Eliza was eager to find profitable use for land where rice, the region's main cash crop, wouldn't grow. Locals who had already rejected indigo as too delicate for the Carolina winters ridiculed her experiments (along with

the gender of the person performing them), but after three years she triumphed, handing out seeds to those same neighbors. Within two more years, cultivation of indigo in the region shot up from 5,000 to 130,000 pounds annually.

Ultimately indigo accounted for more than a third of exports from the prewar colonies, second only to rice itself. When American dollars were worthless, cubes of indigo, as with woad, were used as currency. Indigo dyed the coats of the revolutionary soldiers and the cantons on the first American flags. Eliza (whose married name was Pinckney) became famous; when she died at age seventy-one, George Washington was a pallbearer at her funeral. So, on one hand, hers seems the inspirational story of a girl who was resourceful, brave in exactly the way we encourage among today's young women, uncowed by the sexism of her time, and a scientist to boot! On the other hand, in a foreshadowing of today's critique of "white feminism" as dependent on marginalized women's labor, Eliza's accomplishment relied on the ancient knowledge, traditions, and labor of captive Black people: the ones who advised her on cultivation, the ones who worked in her fields, the ones who extracted the dye, and on and on. She directly contributed to slavery's expansion in her own colony as well as others: the British governors of Georgia legalized it there, in part so that they, too, could reap the benefits of blue.

I asked McKinley how to hold all of this, to respect it, while working with indigo, but the question was too big for an easy response. Later, though, she sent me an article about Nike Davies-Okundaye, or "Mama Nike," a seventy-one-year-old Nigerian textile artist and activist. In its accompanying photo Davies-Okundaye wears a spectacular headpiece, over twelve inches high, crafted from adire, an indigo-dyed cloth traditionally made by Yoruba women. Mama Nike

grew up in a town renowned for its traditional arts—she initially learned weaving from her great grandmother—but was married off by her father at age fourteen to a man with multiple wives. Through fifteen years and four children, she nonetheless pursued her craft, opening a gallery of her work in her bedroom. After being "liberated" from that union, she went on to build an international reputation. That would have been inspiring enough, but Mama Nike also committed to bringing other women with her: she has trained thousands in adire textile arts, providing the autonomy and possibilities that come with earning their own living. Maybe that was the answer I sought, yet another lesson in alchemy: a reminder that from green to blue, through the beauty and the blood, the fundamental power of indigo is that it transforms.

THAT NIGHT IN BED, I do the *New York Times* Spelling Bee on my phone, poking at my keyboard to make as many words as possible from a "hive" of seven letters. When I hit the number needed to reach the "genius" designation, I flip the screen around to show Steven.

"The thing is," I tell him, "I'm not really enjoying the game. I feel kind of anxious until (and unless) I make 'genius,' and then instead of feeling happy, I'm just relieved not to have failed. So, it's never really *fun*."

He glances up from his book. "That sounds about right with your personality."

"Yeah," I agree abstractedly, then turn to him. "Wait, what do you mean?"

"You're always trying to prove something unnecessary that no one cares about to nobody in particular."

It's true. I am an incessant seeker of validation, perpetually worried, despite my age and relative success, about missing the mark, about not meeting unspoken expectations, about getting an A in whatever there is to get an A in: about how my work will be judged rather than what engaging in it means to me. Deep down I know that's a trap, one that sabotages creative thinking. Maybe that is part of what draws me to this eccentric project—the relief, the excuse, the *joy* of incompetence. For years I've had a dog-eared copy of an old Lynda Barry cartoon thumbtacked to the bulletin board in my office. Postcards, family photographs, pithy quotes come and go, but that comic has survived the writing of multiple books and dozens of articles. The first panel shows the artist hunched over her desk with a cup of coffee, pencil poised midstroke. Two thought bubbles hover over her head: "Is this good?" and "Does this suck?" "I'm not sure when these two questions became the only two questions I had about my work," she writes beneath the image. "I just know I'd stopped enjoying it and instead began to dread it."

"Is this good?"

"Does this suck?"

As the strip unfolds, Barry recalls the easy pleasure she took as a child in drawing and storytelling ("Look out! It's Dracula! What's that smell? He's pooping! And the mummy is pooping back! But it's lava!"). It didn't seem special, she recalls: "Every kid I knew could do it." I remember that loopy freedom as well. But somewhere along the line, usually in elementary school, something changes. Someone tells you what you are doing is "good." Someone tells you what you are doing is "bad." Likely, you experience some moment of what

educational psychologist Ronald Beghetto calls "creative mortifica-tion," a phrase so evocative I will carry it to my grave: it's when you are shamed or just too harshly critiqued for your efforts, so you put down the pencil or the paintbrush or the baseball bat or the test tube or the violin or whatever it is, and you never do that thing you loved again.

The time my kindergarten teacher, Mrs. Eckholdt, relegated my drawing of the solar system to the "bad" pile (just because I'd used black crayon to scrub out the part where I'd mixed up Jupiter and Sat-urn)? Maybe that's the reason I can't even doodle without hyperven-tilating. And were the inevitable negative comparisons of my piano playing to that of my exceptionally gifted older brother's the reason why, despite eleven agonizing years of lessons, I rarely touch a key-board? I must've somehow learned to protect myself: in college, I didn't take a single writing course because I was so afraid that a professor would tell me I wasn't good enough to go pro—and I'd believe him.

Mortification. It means, literally, "to put to death."

The alternative, and the best defense against those potentially psy-chologically lethal blows, is to focus more on experience than evalua-tion: to resist "good" and "bad" altogether and instead ask questions, identify what works, wonder what can be improved. It's recognizing that the gift of creativity is in the way it challenges you, allows you to make meaning, enriches your life. You don't have to shoot for im-mortality or even celebrity to achieve that. Of course, a true mas-ter strives for excellence, but I think what I am taking from all this grinding and stirring and dipping and tending to my vat is an under-standing of blue as a *process,* valuable in itself. After all, as a writer I never feel I have arrived, never claim expertise: over three decades in, I am still learning, still growing. Reminding myself of that, while it doesn't make the work easier, is, somehow, liberating.

I wake up early the next morning, before it's light, and reheat my vat once more. I don't even consider using my rubber gloves; I instinctively want to be able to feel the color, for my sense of touch, smell, and sight to merge with all that blue. The key to an enduring, saturated shade, I've learned, is not to leave the cloth in longer, but to build the color through multiple short dips, allowing the dye to oxidize in between. I decide to count to an arbitrary sixty-Mississippi with each one. I work forward and back among my shades, sometimes redipping a piece that I thought was done because the color of a later one changed the rhythm, the flow, the jazz of the rest. I dip once, twice, ten times. Bit by bit, my blues are born. As I relax into a state of receptivity, reciprocity, *communion,* with my vat, the relationship not only to my work but to time changes, slowing and stretching like denim-tinted taffy. My hands and nails turn deep navy, a color that will linger for weeks.

My completed efforts, rinsed and hung on the clothesline, seem clumsy and inept. But when the two questions begin dogging me again—"Is it good?" "Does this suck?"—I take a breath. I recall my teacher Kristine's prediction that one day I'll wish I could recapture my first "art yarn." I realize that what she meant is that I will long to be that free: to be able to make yarn that is thick and thin and tight and loose and gloriously uncontrolled, all without self-judgment. I will miss the lightness of a beginner, the freedom from expectation, my sense that *any* result is "good." "These are mine," I say, smiling to myself, and I know that is all that matters.

I SPEND MUCH OF the morning rinsing, soaping, re-rinsing, and scouring my cloth, to remove all remaining excess dye. I also soak the

pieces for an hour in yet another solution of boiling water and soda ash. Meanwhile, I watch more videos, demonstrations of how to use the vat to dye woolen yarn, which is what I ultimately planned to do. My vat still contains plenty of pigment, and I'm so enamored of indigo that I decide to dye all of my remaining Martha blue. When working with wool, a vat can be a little cooler than for cotton, but still, I struggle to keep mine hot enough to turn multiple skeins of yarn a medium shade. I have a little heart-to-heart with it, asking it to hang on, to be a little patient with me as a neophyte; maybe I'm imagining it, but the bucket seems to warm a little in response.

You can't simply dump the fiber into the liquid—if it hits the sediment on the bottom you'll end up with uneven speckles and embedded grit. So I loop a skein on a broomstick, and slowly submerge it partway into the vat, moving it up and down several times. I rotate it a quarter turn and do it again, ever mindful of the sediment at the bottom. I think about my relationship to the vat, to remind myself that I have all the time I need. I breathe. After five dips through every rotation, about two minutes each, my yarn is the color of old blue jeans. I know it will dry two shades lighter, so I dip each section once more, and then once again. Then I move on to do more skeins in the same way. It takes hours to get through all my yarn, and my shoulders are stiff from hunching over the bucket. I hope I have enough to make this the base color of my sweater; since I haven't made a pattern yet, I can't say for sure. Still, if anything represents this experience, the lessons of process over outcome, the dawning recognition both of what it takes to make a garment from scratch as well as what it means to have relinquished that art, it is the challenge and reward of blue.

It is one thing to rinse the excess color from a little swatch of cotton, but quite another to remove it from multiple hanks of wool. For the

rest of the day, I fill bucket after bucket after five-gallon bucket with water, hauling them from the bathtub through the house and out to the backyard. Each one weighs over forty pounds, so it's exhausting work. At first, I dump the used liquid, rich with indigo's plant nutrients, onto my garden—since it's doing double duty, rinsing and fertilizing, I can justify using all this water during a "megadrought" (so many new climate vocab words in 2020: "megadrought," "gigafire," "firenado"). But long after my plants are sodden, each new infusion is still turning deep blue. Five gallons. Ten. Twenty. Forty.

In our family, the three of us have grown accustomed to "drought showers," turning off the faucet while we soap, limiting our time under the spray to less than two minutes. We keep buckets in the tub to catch extra water as we wait for it to warm, which we later use to flush the toilet (something we do only when strictly necessary). So, this kind of waste makes my stomach clench. But it, too, is part of the story of indigo. A single pair of conventional denim jeans takes as much as fifteen hundred gallons of water to produce (along with another fourteen hundred to grow the genetically engineered cotton used for the fabric); globally about two billion pairs are sold each year. Most of those jeans are colored with synthetic indigo whose toxic waste may include formaldehyde, bleach, and lye; like other dyes, it kills wildlife in rivers and renders groundwater undrinkable. Natural pigment is safer, but using it is still a water-intensive process. Since I probably stop rinsing sooner than I should, I imagine that my yarn will turn not only my hands blue as I knit my garment (such "crocking" is fairly common with natural indigo yarn, seen as a form of personal customization) but my torso when I wear it; I'll also need to avoid leaning back against any light-colored upholstered chairs.

I give the vat a stir with the broomstick, replace the indigo flower,

pop the lid onto the bucket, and store it in a corner of my office. A vat will last for about six months in storage like this, in stasis, waiting to be reheated. I probably won't use this one again within that time frame—and, much as I'd like to, unless the drought ends for good, I doubt I'll feel comfortable dyeing yarn with indigo ever again. Still, I like the idea of myriad tiny blue molecules watching me for a while, keeping me company from behind their plastic wall—my teachers, my guardians—as I take my next steps with the yarn I've made and the lessons I've learned, thanks, in part, to their grace.

8

crafty women

THE FIRST THING ANYONE ASKS WHEN I mention I am writing this book is some variation on "Who invented knitting, anyway?" That now seems a pretty late-in-the-game question—as opposed to "String? *How?*" or, as I always wonder, while recognizing that it's entirely un-related, "Who figured out you could eat an artichoke?" The fact that our curiosity doesn't pique until so deep into textiles' production has broader implications: concerns about the impact of our clothing, if we have them at all, tend to center on the final stages of how a gar-ment is made rather than starting with how its fiber was produced,

spun, woven, and dyed; which chemicals were used in those processes; where the buttons and zippers came from; the treatment of workers at each of those stages. During this year of making my own fabric, I've learned that each of those steps matters.

Maybe, having read this far, though, you are still waiting breathlessly for the answer to that first-line inquiry. I wish I could provide it, but, again, wool degrades (hurrah!), so the origin of the craft is hard to pinpoint. There are, however, a few clues, such as a lone, child-sized wool sock, excavated from a third-or-fourth-century Egyptian trash heap, that is now on display at the British Museum along with all the other priceless plunder. Just one sock. Although its mate likely decomposed, I prefer to imagine it vanishing during laundering into the Nile equivalent of the Bermuda sock triangle, which makes me feel a sisterly kinship with those ancient Egyptian mothers.

That sock wasn't knit, not exactly. It was made by nålbindning: a technique that uses a single, blunt needle—similar to one you'd use for darning, if you darned, but carved from bone or animal horn—to connect short pieces of yarn into interlocking loops. It's like a cross between knitting and sewing with a little crochet tossed in. Nålbindning (the word is Danish, though the skill did not necessarily originate in Denmark) was practiced across the globe as far back as 6500 BC—in the Middle East, Asia, South America, Europe, Oceania—and it's still common among some Indigenous people in Peru. Like every other lost art, the craft has made a comeback in the internet era, with some going so far as to fashion needles out of ham bones for authenticity—but, really, as with the paleo diet, I think there was a good reason that humanity evolved beyond it. Nålbindning is laborious, and apologies to those who are into it, but

the results do vibe toward the primitive. It's an aesthetic, I guess, just not mine.

Speaking of aesthetics, that Egyptian nålbinded sock resembles a mitten for the foot, with a separate compartment for the big toe, because it's meant to be worn with those papyrus flip-flops that were stylin' back then. Bold statement. Also, just like us, Egyptian mamas wanted their babies to look cute: although it's lost a bit of its vibrancy over the centuries, you can still see whimsical stripes of seven colors in the tiny sock—shades of red, yellow, blue, green, and purple—that were created using a combo of madder roots, weld flowers (for yellow), and woad. Another pair of early Egyptian socks in the Victoria and Albert Museum, made for an adult who seems to have had freakishly long metatarsals, remains an impressively bright red after all this time. Anyway, by the ninth century, give or take four hundred years, crafting had advanced significantly; a pair of socks (it's always socks!) dug up from that era were knit the conventional way out of white cotton, banded in indigo with intricate geometric Islamic motifs. Like a vintage Chanel suit, they are still stunning, even after a millennium.

My own early yarn experiments began in second grade, when my parents gave me a Knitting Nancy for Chanukah: a wooden spool with a vertical hole drilled through it, painted to look like a smiling, limbless doll and topped by metal spokes that resembled a crown. A Knitting Nancy (also called French knitting, spool knitting, or, my favorite, tomboy knitting) is often a child's first exposure to fiber craft, other than maybe those plastic potholder looms. To use it, you wind your yarn twice around the spokes, then flip the lower strand over the upper one with a hook, making stitches; after a while a tube of cord emerges from the bottom. There isn't much you can do with it, other than applaud your own cleverness, so I quickly became bored

(I would later learn that if you work with a giant one of these knitters you can close the top of the tube and make a hat).

I progressed to hooking tiny shag rugs, which were also pretty useless, then flirted with embroidery, crocheted a yarmulke (it came out square), and went through a hard-core needlepoint phase before, in sixth grade, asking my mom to teach me how to "really" knit. At first I didn't take to it, I didn't have the patience, but a year later my rudimentary knowledge came in handy: all the girls at my junior high had to knit scarves as part of our compulsory home ec training. (We also, in those pre–Title IX days, learned to cook Tuna Surprise—the "surprise" being that the dish was inedible; the boys, meantime, were in metal shop making dustpans for their future wives when the teacher was watching and bongs when he wasn't.)

The girl sitting next to me, whose name was Barb, could not get the hang of her needles; no matter how she tried, her scarf came out shaped like a rhombus. When I finished my own work, I unraveled hers and redid it so she wouldn't flunk. That was forty-seven years ago. We are still the closest of friends, sharing a bond that can only be forged with someone who remembers the high-water, elephant-bottom pants you wore to her Bat Mitzvah party at age thirteen (and loves you anyway). Even if I'd never touched another ball of yarn, that would've made knitting worth it.

Since then, I've knit my share of scarves, hats, mittens, blankets, and sweaters, but I always stick to a pattern: I've never attempted to design anything. It might have been wiser to ease in with a shawl or a cowl, but in addition to never, under any circumstances, wearing either of those garments (I envy those who can make them look fashionable rather than fusty), I was impatient to see how my yarn would knit up and didn't want to get thrown off course. So I contacted Frenchie Danoy, an internationally known pattern designer and

coach based in Texas, who describes herself online as a Franco-Māori American-Australian takataapui (the Māori term for "gender fluid") "yarn alchemist." Frenchie, whose real name is Françoise, is in her late twenties, with an accent that, in a single sentence, can slide through all four of her nationalities (most endearingly, she pronounces "knitting" with a soft "T," rather than the "D" sound that most Americans use). At our first Zoom meeting, she wears a hoodie and rectangular glasses, her straight, dark hair pulled back in a clip. A neon-bright 3D crochet sculpture, inspired by traditional Māori wooden masks, hangs on the wall behind her, next to her own first weaving project, fashioned of macramé yarn and feathers.

I'm surprised to see that her face is unmarked. When modeling designs for her social media posts, Frenchie has a moko kauae inked onto her lips and chin—a sacred facial tattoo that can indicate such things as tribe, occupation, and social status (men's tattoos cover the entire face). She tells me that hers is a temporary version, though she is considering making it permanent. "The stencil has been a way to get used to the idea of having such a visible symbol on my face," she explains. "I wear it as a form of reclamation of my culture. And also to be front-and-center in my work about not conforming to white standards."

Frenchie has always identified as Indigenous (her mom is Māori, her dad French), but growing up in what she calls "the diaspora," she didn't know much about what that meant; it was knitting, which she took up about six years ago (SLFHM, although her mom had only just learned herself), that brought her back to her roots. She says she "fell in love at first stitch" and immediately began to experiment with designing. Almost unconsciously, she incorporated Māori motifs into that early work: classic geometric patterns; lace and cables that referenced ancestral legends and myths; twisting stitches

reminiscent of archetypal carvings. She says that fully formed, detailed "visions" of these ideas would pop into her head, which was weird, since she knew almost nothing about Māori art. "It was like my ancestors were calling to me, like they were saying, 'It's time for you to learn about where you come from and this is how you can do it.'"

Once she decided to launch her design business, in 2014, she traveled to New Zealand (or Aotearoa, as many Māori prefer to call it), attending a conference for Indigenous entrepreneurs and visiting her grandfather to hear more about her own family history. Back home—she was living in Osaka, Japan, where her then-husband taught English—she joined a local group studying her culture's stories, songs, and language. She called her business Aroha, her middle name. The word translates roughly to "love," "compassion," or "empathy," but, like the Hawaiian "aloha," means so much more: a spirit, a life force, a fount of creativity. Aroha is how we care for one another and for ourselves, the generosity we extend. "It reflects my core values," Frenchie says. Knitting, she adds, can encompass all of that as well. "I believe knitting is powerful. It can be a catalyst for transformation. It isn't just a bunch of little old ladies."

FRENCHIE IS RIGHT, YET I think it is precisely knitting's benign reputation that allows its practitioners to subvert the very conventions we appear to uphold. After all, that proverbial "little old lady" could well be an unrepentant cackler, a fearsome crone. Her innocuousness could be her superpower, allowing her to slip the bonds of feminine

constraint. "Craft" also evokes the witch in us: the secret lore passed from mother to daughter; ancient sources of authority, of authenticity, so dangerous they could get women burned at the stake. Maybe that is why our relationship to fiber is so often twisted to abuse or exploit us, to wrap us tight in fabrications that tell us our strength lies only in our youth; only in perpetual consumerism; only in embracing the distortions of a patriarchal mirror, then calling such self-binding a personal choice.

Given all that, it should be no surprise that women have long used handicraft as a conduit to public voice—a way to express patriotism or fight injustice—especially when it was otherwise forbidden. One of my favorite historical words is "tricoteuses." It's French for "women knitters" (they have a word for that there!), particularly those who, during the Reign of Terror, sat in front of the guillotines bearing grim witness to public executions. You may recall Madame Defarge, the formidable tricoteuse in Dickens's *A Tale of Two Cities* who stitched the names of the condemned into her work.

In real life, tricoteuses, mostly working-class market women, were no less bloodthirsty and also no less complex—an equal mix of feminist hero and vengeful villain. Initially celebrated as "Mothers of the Nation" for their marches against Versailles, they were later deemed uncontrollable by male leaders and barred from political assembly. But who could fault the ladies for knitting in a public space? It's kind of awful, kind of great. They watched as the heads rolled in the Place de la Révolution, many (presumably savoring the irony) stitching liberty caps: those red, conical hats with the point folded forward that represented freedom from tyranny. Marianne, the national symbol of France, is often depicted in a liberty cap. So, for reasons I cannot determine, is Papa Smurf.

During our own country's revolution, women were likewise excluded from "the room where it happened." Their signatures do not grace the Declaration of Independence and their gender did not guarantee them equality under the law, let alone the "unalienable Rights" of liberty, the pursuit of happiness, or, gosh, even life. Still, notably through their use of textiles, they were instrumental in the fight for freedom. You likely learned in school about the Boston Tea Party, but what about the significance of colonial women's boycott of exorbitantly taxed British cloth or the defiant public "spinning bees" they held in town squares? Later, despite the scarcity of time and resources, those same women made uniforms, blankets, and over thirteen thousand wool coats for Continental soldiers, who were so undersupplied that some were going into battle naked.

Then there was Molly "Old Mom" Rinker. One of the war's most fabled spies, she reputedly eavesdropped on the Redcoats who commandeered her Philadelphia home, tucking bits of information about troop movements into balls of yarn. Who would suspect an aging matron, placidly knitting socks at a scenic overlook, of tossing message-laced skeins to the patriots? The rock where she allegedly perched still bears her name, though a competing legend has risen casting the crafty lady as an evil witch who would launch her broomstick there (and the statue marking the spot, which has the word "TOLERATION" on its pedestal, is of a Quaker man).

Decades later, during the Civil War, women on both sides of the conflict wielded their needles to knit millions of stockings to supplement soldiers' shoddy, machine-made footwear, sometimes unraveling their own garments to repurpose the precious yarn. Photographs of Sojourner Truth taken at that time often show her holding yarn and needles, a conscious nod to her patriotism, her "Ain't I a Woman?" femininity, and her firm belief that engagement in industry—for one-

self or for pay, *not* as forced labor—was vital to personal agency and happiness.

Women knitters, still unable to vote, played possibly their most pivotal role during World War I. The muddy, frosty conditions of the European battlefields created an epidemic of trench foot, a fungus, essentially caused by continuously wet toes, that could lead to gangrene, amputation, even death. This was serious stuff: trench foot killed an estimated two thousand American and seventy-five thousand British troops. The only defense was to change your socks—a lot—to keep your feet warm and dry. But factories of the time couldn't ramp up fast enough to handle the load, leaving soldiers wearing one pair of government-issued socks while stuffing their only other pair into their armpits in an attempt to dry it faster.

Enter hand knitters. Red Cross posters illustrated by a basket of yarn admonished, "Our Boys Need SOX, Knit Your Bit." Women—and everyone else on the home front who could—took up their needles, crafting over twenty-three million articles of clothing. Across the pond, some female knitters, in a blending of Old Mom Rinker and Madame Defarge, became spies for the Allies, passing information by encoding it into their deceptively ladylike stitches. I'm not saying we won that war *because* of women's knitting, but I'm not sure we would've won without it.

Those "Wool Brigades" were no longer strictly necessary by World War II, but the U.S. government continued to promote "knitting for the troops" as a way to boost soldiers' morale and to offer women a role-appropriate sense of inclusion in the war effort. In 1941, Eleanor Roosevelt, First Lady and "knitter in chief," whose hands were never idle, held a tea to inaugurate the "Knit for Defense" campaign. That was soon followed by "How to Knit," a story in *Life* magazine illustrated by a cover photo of a young woman intently chewing her lower

lip while focusing on her wartime handiwork. Who knows? Maybe the guys at the front would have appreciated her lumpy, misshapen scarf! The Glenn Miller Orchestra had a hit with "Knit One, Purl Two" (though I prefer the tongue-twisting title "Since Kitten's Knittin' Mittens"); a popular propaganda poster of the era featured two knitting needles brandished in a "V" for "victory" above the words *Remember Pearl Harbor—Purl Harder!*

You could argue those efforts were more feminine than feminist, a reinforcement of women's domesticity, except that, if anything, knitting has become more radical in recent years. Maybe that's, in part, because making something with your own hands is now almost by definition political—knitting pushes back against the dehumanization of technology and consumer culture—and that may affect who is drawn to the craft. Today's knitters (as well as those who crochet) have mobilized against nuclear proliferation, the decimation of coral reefs, campus sexual assault, and more.

In 2006, a "yarn bomber" in Denmark covered an M24 Chaffee tank with a "cozy" made of four thousand pink squares, contributed by knitters throughout the world, to protest the country's involvement in the Iraqi war (American knitters, for their part, sent every senator a hand-knit helmet liner). A year later, to raise awareness of the over one billion people without access to clean water, global knitters joined with a UK-based NGO to create the first "knitted petition": a "river" of nearly a hundred thousand blue squares—that's over nine miles of textile—part of which, at one point, cascaded "like a waterfall" from the roof of the National Theatre in London down four stories to "flow" across the grass below. In Russia, the feminist guerilla punk collective Pussy Riot hid their identities beneath brightly colored, hand-knit balaclavas while performing songs such

as "Putin Pissed Himself" and "Kill the Sexist" (two of the collective's members were eventually unmasked and arrested, imprisoned for two years on charges of "hooliganism").

Knitters have made blankets for refugees; crafted penguin-sized sweaters to draw attention to oil spills; knit "temperature scarves" whose rows and colors document climate change; heaped handcrafted uteri on the steps of the U.S. Supreme Court in support of abortion rights (an especially pertinent statement, since knitting needles are notoriously used, to women's peril, in back-alley abortions). After the murder of Michael Brown by police in Ferguson, Missouri, activists in St. Louis formed the Yarn Mission, a collective to support Black creators and promote community organizing. The comfort of a knitting circle, founder Taylor Payne told *PBS NewsHour*, eased tough conversations: "It's the only way I'm able to talk about a lot of the things that have happened in Ferguson and continue to happen in St. Louis," she said.

Although most knitters are still female, men have always crafted as well—witness British diver Tom Daley, who proudly knit his way through the (delayed) 2020 Summer Olympics, including stitching a gold-medal-sized pouch emblazoned with a Union Jack. One of my favorite groups is the Chilean collective Hombres Tejedores, who knit together in public as a way to skewer gender stereotypes, favoring pink yarn and sometimes dressing in dark suits and ties.

Then there was the 2016 election of President Donald Trump, a man who, in addition to spewing misogynist, sexist bile, has a documented history of sexual harassment and assault. How did women express their outrage? They marched, yes, but first . . . they knit, some taking up needles for the very first time. They made millions of "pussy hats," those rectangular (typically) pink caps with their

suggestion of feline ears. A play on the word "pussy*cat*," the name was a reference to Trump's boast, secretly videotaped by *Access Hollywood,* that as a famous man he had license to grab women "by the pussy." Whatever your take on the Women's March of 2017—or the choice or color of its symbol—that sea of headgear streaming through streets around the world was, like the liberty caps of the French Revolution, an extraordinary visual statement of unity and resistance.

Do such acts of "craftivism" ultimately have impact? I can't say, but I do believe that change starts with personal reflection, followed by connection to like-minded others, and, finally, engagement in repeated, targeted collective action. The conversations craftivism inspires can jump-start that process, one stitch at a time.

I don't want to give the impression that political knitting is solely the province of progressives (though, these days, it does seem to lean that way). The craft was, as I said, used to rally both sides during the Civil War and was later leveraged by opponents as well as supporters of women's suffrage. More recently, when Ravelry.com, which at nine million registered users is the world's largest fiber arts networking site, banned all support of Donald Trump on its platform as inherently white supremacist—including the posting of MAGA-themed patterns or the adoption of Trump-y usernames—conservative knitters struck back, forming their own online communities, with exponentially less success. Freedom Knits boasts a logo of a half-stitched American flag on its front page, along with a photo of Lady Liberty (though, really, don't you think the Green Goddess would have sported a pussy hat?). A podcaster who goes by the handle Deplorable Knitter sells patterns on Etsy for hats that spell out slogans such as "Build the Wall," "Pro Life," "Blue Lives Matter," and "Let's Go Brandon." An indie yarn dyer made news with a "Polarized Knits" line that featured such jeeringly named

colorways as "gaslight" and "micro-aggression." A guy who calls him-
self "Neil of Uknitted Kingdom" (okay, that's funny) started *Blocked*, a
short-lived online magazine; his personal Instagram bio includes the
hashtags #itsoktobewhite and #thereareonly2genders.

If it seems that knitters are needling one another, well, so is ev-
eryone else. And as with everyone else, both the anomie and the ac-
tivism play out across social media, sometimes in disturbing pile-ons
of "cancellation," other times by accelerating needed change. Me, I
have pored over posts by small sheep ranchers, natural dyers, envi-
ronmentalists, and others who use their accounts to educate on sus-
tainable, regenerative textile production. I've cheered on proponents
of body positivity who have pushed pattern designers, yarn makers,
and knitting publications to showcase larger models or include a
broader array of sizes—labeled with actual measurements rather than
the potentially stigmatizing "small," "medium," and "XXXL." And I
was heartened when, in 2019, well before George Floyd's murder and
the renewed upsurge of the Black Lives Matter movement, knitters
began their own racial reckoning: a community-wide discussion that
ricocheted across Instagram and other platforms after a blog post by
a prominent white influencer compared her upcoming trip to India
to "being offered a seat on a flight to Mars."

Knitters of color responded with stories of discrimination, of be-
ing told by white crafters, "I didn't know [Black or Asian or Latina]
women knit!" Black American crafters, in particular, posted about
being followed around (or simply ignored) by employees in yarn
stores, of being told that if they need to ask what a skein costs, they
"probably can't afford it." They pointed out that those models on
store websites, in patterns, and in publications were not only thin,
they were almost exclusively white (that has started to change,

dramatically). They debated how the conventions of social media pics—showing projects but not people, or a ball of yarn with a cup of coffee—effectively "whitewashed" the craft's participants.

In the wake of that outpouring, knitters, designers, and dyers of color saw their number of social media followers skyrocket, along with support for their businesses. Gaye Glasspie, my own favorite knitting celeb, said her audience more than doubled in a matter of weeks, which was both gratifying and unnerving. "That first Black wave almost knocked me down," she told me. "I felt like I had to stand at my proverbial Instagram door and say, 'Back up! I don't deserve for you guys to come here just because I'm Black. If that's what you want, I need you to go away, because there are so many other things about me *besides* the fact that I'm Black.'"

I HAVE TO ADMIT, I am one of those white knitters who initially followed Gaye, better known online as "GG the Iconic Orange Lady," as part of a conscious attempt to mess with the algorithm and diversify my feed. But I stayed (and slid into her DMs to fangirl her) because I admired how she'd mastered the secret sauce of Instagram: GG has a rare gift for being real, vulnerable, motivational, intimate, and relevant all at once. She also sees knitting as I do, as a crucible, a prism through which to view the larger world. Her fear over making her first sweater, then, became an occasion to question her "imposter syndrome"; a discussion about fitting garments an opportunity to confront negative body image; her love of all things orange a statement against the "colorism" that pervades the Black community, dictating women with darker skin (like her) shouldn't wear anything

bright. GG also recognizes that sometimes, like when George Floyd and Breonna Taylor were murdered by police, knitting doesn't cut it. In those moments, she calls on her followers, many of whom, like me, veer toward the white and middle-aged, to put down their needles (and their social media feeds): to find meaningful, real-life ways to "stand in the gap," speaking out against racism not only in the aftermath of violence, but always.

Personally, I have spent a lot of time in that gap. During 2020, especially, I watched in horror as, along with the heightened visibility of brutality against Black Americans, hate crimes spiked against people who look like my husband and daughter. Asian Americans, among them people we know, were knocked to the ground in Oakland, spit on and cursed at in San Francisco. Others were punched in the face in New York, shot and killed in Atlanta. The aggression is not new—possibly the largest mass lynching in U.S. history was of Chinese Americans in nineteenth-century Los Angeles—but its intensity and frequency have become frightening. Steven, a big, imposing guy, began wondering aloud whether, despite that judo trophy from his teens, he should carry a walking stick for self-defense. The majority of the attacks, however—two-thirds—have been against women, the young as well as the elderly. They seem like easy targets, the media reports, presumed to be docile, unlikely to fight back (spending ten minutes in my house would disabuse them of that stereotype).

I struggle to help my daughter make sense of her pain and anger, to feel safe in her skin; the difference between us that others would feel compelled to comment on when she was little—"Where did you get your baby?" "Is she from China or Korea?" "She's so big—do you know whether her birth mother was tall?" (yes, I am)—has never seemed greater. Although, to a degree, I can draw on my own physical vulnerability as a woman or my experience as a Jew to guide me,

those things are not the same, as she—who is both of them as well—is quick to point out. At the end of the day, I am still white, and while I will not enumerate the litany of slights, slurs, and threats I have witnessed leveled at my daughter and my husband over the years, I have seen, starkly, how, even in our progressive community, my freedom contrasts with their constraints as we each move through the world. At times, I feel like a version of Eddie Murphy in the old *SNL* sketch, the one where he goes undercover in whiteface and is offered free money at a bank, cocktails on a city bus. I know, in a way my family never will, how group dynamics shift—both subtly and overtly—when people of color aren't around.

As a younger woman, I imagined I would be the mother my own could not be, the one who truly understood her daughter's quandaries and could provide the clear, wise guidance she needed to ease her way, the guidance I never had. Nope. As with my mom, my own limits have left me ill-equipped, unprepared—a painful realization for which I hope Daisy can, someday, forgive me. Yet, as a biracial person, her experience is unlike Steven's as well, putting him, too, at a loss: he grew up firmly rooted in one culture, as did I. Daisy inhabits the in-between, needing to create a unique, hybrid sense of self. She is really more like Frenchie. "You do have to figure out who you are in a different way," Frenchie agrees. "Because you're different from either of your parents."

I doubt, however, that my child will find her truth through knitting. Although she knows the basics, she hasn't much interest in pursuing the craft: she's been working on the same hat since she was twelve. And, significantly, I was not the one to teach her. I refused. The method my mom showed me all those years ago is cumbersome and slow. If you are a knitter, you will know it as English style, which involves holding the yarn in your right hand and "throwing" it over

the needle to create a stitch. It became dominant in the U.S. during World War II (when, I'm assuming, based on her age, my mom learned) because Continental style, the quicker, more sensible way to knit, had originated in Germany. It feels too late to change for myself, but I wanted something better for Daisy. Isn't that always the way of it for mothers and daughters?

My meeting with Frenchie is veering perilously close to a therapy session. And why not? Knitting can represent and hold and express so much. Frenchie asks what I want to elicit with this project. "What do you want people to feel when they see your sweater?"

I consider this for a moment. As this undertaking has evolved, so has my answer. "I guess," I say in what is more of a question than a statement, "Curiosity? About how we might connect to time, to history, to nature, to ourselves, to making and process? About the effort that goes into our clothing and its impact on the planet?"

Frenchie nods sagely. She divides her students—and all knitters—into one of four overlapping categories that, with unapologetic woo-woo, she calls "Fibre Muses": the Dreamer (who knits primarily as a means of self-expression), the Mystic (for whom it is a form of escape and self-care), the Giver (who selflessly knits for others), or, in my case, the Seeker. Seekers, she explains, "feel that yearning for self-discovery, so the idea of exploring the world through knitting resonates with them. They like to find out how other cultures have contributed to fiber arts, and to know the roots of their yarn or design or pattern. The magic of knitting for them is part of a more ethical, sustainable life, and because they think about how their actions affect the environment, they tend to support small, local, indie businesses."

Okay, maybe it's a little astrological, but I have to say the woman totally has my number. "That is exactly how I think of myself!" I exclaim, delighted.

"So what images and words come to you when I say that?"

I close my eyes and wait. Unbidden, the turmoil of the last year rises within me: my concern about the fires, my anxiety about Covid, my apprehension about Daisy's leaving and our aging—but, then, I also feel my love for my family, the goofy fun and unexpected meaning of pursuing this project. "Maybe," I whisper, "sky? Water? Possibility? Definitely the life I've knit together, but also . . . the unknown?"

Frenchie pulls up Pinterest and starts a "mood board" for me, typing in notes as I speak. She pins pictures of the ocean, of outer space, of seashells—images that seem at once vast and tranquil, if maybe a little remote. Occasionally, as I've meditated over the past year, I've observed my body split apart in a boundless, twilit abyss, my arms and legs spinning around me like a Calder mobile. Whatever "me" was left—some metaphysical consciousness—has felt remarkably serene, clear, if . . . distant. I didn't mind, it felt right, but that remove, that slight loneliness, has stuck with me. It may simply be the occupational hazard of a writer, someone whose job it is to step outside herself to discern the cultural patterns of the world, or it may be the reason that job appealed. At any rate, Frenchie has inadvertently honed in on that quality, or led me to hone in on it myself. We gaze silently at the board. "For our next meeting," she says, "I want you to think about what you'd like your sweater to look like. Should it have ribbing at the bottom? A rolled neck? Where should it hit on your arms?" She suggests a raglan-sleeved design as an easy base and quickly sketches an example. "The shape of the sweater is like a canvas," she explains, "and then you can 'paint' the stitches and the story."

If I get overwhelmed, she says before signing off, I should go back and look at my mood board: focus on all the images of nature, the expanse, and, of course, all that blue.

9

knit one

OVER THE NEXT TWO WEEKS, I browse online, collecting pictures of sweaters with lavish cables or complicated color work: the platonic ideal of sweaters. I sketch and sketch and sketch—artlessly, with zero sense of scale or symmetry. I also knit up sample swatches to test concepts and needle sizes. Cabling, I quickly realize, will require far too much yarn. Instead, I try a ribbed pattern of two knit and two purl stitches, imagining something huge and flouffy that swallows me up, maybe with cool-girl sleeves that graze my knuckles. The stitches are

supposed to form lovely vertical lines, but because my yarn is so un-even, they come out wavy, accentuating the fiber's flaws. If this were a painting, it would be one made by a five-year-old. With her fingers. I try experimenting with color work instead, using a mosaic stitch to knit geometric patterns in bright, contrasting colors. If anything, that looks worse. I sketch a series of multihued dragonflies on graph paper, thinking they could run across a yoke, but in practice, they, too, come out distorted, completely unrecognizable. It turns out that a badly shorn sheep makes for badly spun yarn makes for a hideous sweater. Although I have insisted all along that I am more interested in process than product, this is shaping up to be a disaster.

In desperation, I call Frenchie. "If the yarn is saying, 'Don't turn me into a mosaic,'" she says, "then you shouldn't! You have to accept the constraints that it's communicating and work within them.

"Your yarn is more rustic," she continues—a nice way, I think, of saying "wildly inconsistent." "Trust that! And remember that for you *everything* is integral. It's not just the construction and the stitches, it's the way you spun the yarn and the dyeing that you want to highlight."

Listening to Frenchie, I recall an interview I once did with a psy-chologist named James Kaufman who defined creativity as something "that is both novel *and* appropriate." That second part was key. "Sup-pose the person you hired to repave your driveway covered it with salami," he said. "That would be novel, surely, but not appropriate." The limits inherent in any project, he added—whether financial, ma-terial, or logistical—are actually the springboard to innovation, not its obstacle: you can't color outside the lines until you know where the lines are. It occurs to me that I have been trying to design a sweater out of salami. So I begin to think more simply. Maybe a basic stockinette stitch—one row knit, one row purl—with colored stripes.

Not fancy, but it would minimize the worst of my yarn's weaknesses while emphasizing the dye work. I sketch more diagrams, eagerly filling them in with colored pencil. In what order shall I put the colors? Will I have enough indigo to pull through as a base? How close together should the stripes be? Should they be horizontal or vertical? Should they run throughout the sweater or only at the top or the bottom? Maybe just on the sleeves?

WHILE I'M WORKING, I again hang out on Zoom with my dad. The months of lockdown have been rough on him, and his contented attitude, the one I once found so reassuring, is starting to wear thin. First, while an aide was busy in the kitchen, he tried to stand up, toppled, and broke his pelvis in two places. Then he got Covid. We understandably feared the worst: that he would die alone in the hospital, confused about where he was and why, wondering where his children were. "Help me, Peg!" he would plead in our daily FaceTime calls, set up by a nurse in the isolation ward.

"We're trying, Dad," I'd say.

He would nod, then a moment later start in again: "Peg, help me!"

Miraculously, his symptoms remained mild and after two weeks, he was allowed to go back to his apartment. Still, he never fully recovered, his mind and body taking permanent hits. He's in a wheelchair full-time now, though his arms are impressively buff from lifting five-pound dumbbells daily with one of his caregivers. I want to fly to him, my own risks be damned, but there would be little point, given the ongoing ban on visitors to his building (even as plenty of workers,

none of them tested, stream in and out). Will I ever see him again? The question leaves me frantic.

Holding his attention online becomes nearly impossible. Some days I share my screen with him so we can watch old Laurel & Hardy shorts on YouTube. I do not enjoy this much—I hate slapstick humor. I console myself by thinking at least it's not the Three Stooges, whom I find unbearable. As a child, I would loll in the den on Sunday mornings watching either of those comedy teams on TV; in those days of six channels they were the only thing on that wasn't religious. I guess they were considered kids' fare, along with the reruns of old Little Rascals shorts, which I also despised. My dad, who generally regarded his children's TV habits with a dismay akin to that of today's parents toward social media—*Stop watching that boob tube! It's rotting your brain! Read a book, why don't you?*—would stand in the den in those moments jingling the change in his pocket and laughing uproariously. He loved nothing more than a good pratfall. The only time I ever saw my mom truly furious with him was when she fell down the cement stairs leading from the front door of our house to the driveway and he nearly busted a gut.

He still thinks Stan and Ollie are a hoot. I glance at the dates of the films and notice they were all released when he was a small child—six, seven, ten years old. I try to picture him in a theater, his eyes glowing with the magic of the screen, giggling during *The Music Box* when the piano the Boys are trying to deliver skitters down multiple flights of stairs. For the third time. What a Fine Mess! The first "talkie" came out a year—almost to the day—after my dad was born. Imagine that. I look past the broad "humor" of the films to the jalopies mingling on the streets with cart horses; the freshly built houses; the women's bobbed hair under head-hugging cloches. Maybe these

images don't seem like archaic, faded black and white to him. Maybe they look like the world he remembers, the world as it should be. I soften into tenderness, watching the movies with my little-boy dad.

Meanwhile, I begin to notice how often *I* am forgetting small things. The name of that actress who stars in *Mare of Easttown*. The name of the town in Minnesota where Carleton and St. Olaf colleges are. The title of the book I just read. The word "gazpacho." I test myself continually. *Do you remember do you remember do you remember do you remember.* I have read that younger people forget things all the time (where did I put my keys? Why did I walk into this room?) but they don't attribute those screwups to aging: it's just something that happens when your mind is elsewhere. The more, um, *mature* among us are not necessarily forgetting more than we ever did so much as worrying more when we do. I hope this is true. I've also read that knitting can slow the onset of dementia and reduce Alzheimer's risk (along with that previously mentioned alleviation of chronic pain, anxiety, and depression—it's a miracle cure!). I hope this is true as well.

My mom retained her faculties until the end, except that in her last few years she was subject to auditory hallucinations, voices, likely triggered by Parkinson's disease. Initially, they were friendly, but over time they grew ever more malevolent, describing in harrowing detail how they planned to torture and kill everyone in her family. I don't know much more about it than that: she refused to say anything else. Once she admitted she was afraid to tell us the extent of it, afraid we'd all see her differently, as less mentally competent. She may have been right. Still, I could always tell when she was struggling, or believed I could. Her face would stiffen; she'd get a faraway look in her eyes. "They're not real, Mom," I'd say to her softly in those moments. She'd smile thinly. She knew that, she did, but as the voices grew

louder, more insistent, and more frequent, that knowledge became harder for her to hang on to.

Sometimes I wondered if they had been there all along, a version of the anxious, intrusive fears we all have about loved ones—like that nagging thought that a teenager, out past curfew, has been in a fiery wreck. Healthy people dismiss such notions, but for her they had somehow shaken loose, spun out of control, manifested as separate, independent entities. Blessedly, in her final days, the voices seemed to leave her in peace. As I sat next to her bed, knitting a gray, marled cardigan that I could never bear to wear, I watched her lips move. I bent closer to hear that she was quietly repeating the names of her children and grandchildren like a prayer—*David, John, Peggy, Matthew, Ari, Julie Ann, Harry, Lucy, Daisy*—wrapping the fabric she had made of her life around her, even as she was letting it go.

FRENCHIE SKETCHES AN IMAGE of a sweater from above, the neck hole in the center, the shoulders and chest spreading around it. I find the perspective disorienting. She makes another sketch from the angle where the sleeve joins the armpit. Then she sketches the front and back necklines. I feel like I am looking at one of those M. C. Escher posters that people put on their dorm walls in college in the 1980s. I can't tell which way is up.

"Okay," she says cheerily. "Let's talk about math!"

Over the last months, I have willingly wrestled an ornery sheep, sorted through dung-studded fleece, tangled myself in half-spun yarn, filled my home with foul-smelling dye fumes, but *math*? I did not sign up for this. Although I believe, passionately, in the importance of nu-

merical literacy for young women, that's partly because I was denied it myself. By the time Daisy was in fifth grade, her homework was beyond me. Knitting is chockablock with math; most of us who do it try to ignore that fact, especially if we don't create our own patterns. You have to calculate, for instance, the rate at which sleeves or waistlines need to increase or decrease to taper evenly, figure out how many yards of yarn you will need for a project based on the fiber's weight and bulk. You may need to determine how many stitches you will get from a given skein. If you expect to publish a pattern that includes multiple sizes, you need to compute the difference in proportions. There are *equations* to be done! Story problems! *Algebra!*

Elizabeth Zimmermann, a revolutionary twentieth-century knitter (SLFHM), earned the gratitude of crafters everywhere with Elizabeth's Percentage System (EPS), an elegant, flexible set of ratios for making a sweater based on the number of stitches you'd need in your chosen yarn and stitch pattern to fit your desired chest circumference. Honestly? Even writing the phrase "set of ratios" gives me a headache. Zimmermann believed that mastering knitting's math freed you to express your individuality through, as Frenchie suggested, your yarn, color, and stitchwork. It is how you establish those lines beyond which you can improvise.

Zimmermann's circular shawl formula, for example, based on the geometry of pi, can be made as large or small as you wish. For her Möebius-strip cowl you can use any yarn and any stitch and knit to whatever width and length you want. When you're done, you give your piece a half twist, graft the ends together, and presto! One surface, one side, one edge. Apparently, there are Euclidean spaces and parametric surfaces and Cartesian coordinates involved. Fine. What I know is, it looks fancy. I've thought a lot about Zimmermann during the pandemic. She died in 1999, but her personal motto—"Knit on

with confidence and hope, through all crises"—resonates more than ever.

Math-loving knitters make Klein bottle hats (based on another one-surfaced, non-orientable shape) or use Knitting Nancy tubes to explain abstract algebra. They whip up doughnut-shaped tori and pointy, sci-fi stellated dodecahedrons. Elisabetta Matsumoto, an applied mathematician, physicist, and knitter (SLFHM) at the Georgia Institute of Technology, studies knitting as a form of coding, with knits and purls replacing the standard binary 0s and 1s. The variations on those basic stitches are similarly infinite, and Matsumoto's scientist's eye recognized what mine did not: knitting takes something inelastic—yarn—and, depending on how its "code" is implemented, transforms it into variably stretchy, three-dimensional objects. I'm not sure how, but I believe it when she says that quality has implications for fields as wide-ranging as aerospace technology and the growth of human tissue for medical use.

There is even a mathematical hack for designing successful stripes: the Fibonacci sequence, named for a thirteenth-century Italian mathematician (the same guy who introduced the West to Arabic numerals and the decimal system). Each of its string of numbers is the sum of the two previous ones, so, starting from the beginning, it goes like this: 0, 1, 1, 2, 3, 5, 8, 13, 21. Get the idea? And on it goes forever. Fibonacci hit on the pattern while trying to work out how many rabbits would be born of a single pair in one year. His solution, clever as it is, was predicated on a few questionable assumptions, such as that the rabbits would all reproduce once a month, they would always give birth to one male and one female in each litter, and none of the kits would die.

Even so, when you divide a Fibonacci number by the one previous to it, you get something called "the divine proportion," which is

found everywhere in nature: the spiral of a nautilus shell; the radiating twists of sunflower seed heads and pinecones; galaxies; hurricanes; ocean waves; the human body. Each phalange of your fingers is larger than the previous one by the divine proportion; same is true of the ratio of your whole hand to your forearm. Dividing the number of female bees by the number of males in a hive will also result in the divine proportion. A flower's petals are generally a Fibonacci number, as is the arrangement of a plant's leaves.

The universe throws so much chaos our way—rabbits do die, they don't have perfectly gendered pairs of babies, they might be sterile, *there are pandemics!*—that I find it comforting to know there is order in it somewhere. In knitting, Fibonacci numbers produce patterns that are most pleasing to the eye. So my stripes can be of varying widths, but if I want to do it right, they should involve some combination of the numbers above. Unfortunately, I don't know how many rows each of my colors can make. Those creative constraints again. I will have no choice but to wing it, knitting until either a stripe seems right to my eye or the color runs out.

It turns out to be the simplest math that is for me the most bedeviling. Frenchie asks me to bring my body measurements to our next session. That makes sense. I need to know the size of my neck to determine the width of my sweater's opening; the depth from my shoulder to my armpit to make the sleeves; the length of my torso and arms (as well as the girth of the latter at both the widest point and the wrist); the circumferences of my bust, my waist, my hips. Yet, every place my measuring tape touches sparks a wince of disgust, the automatic reaction born of forty-five years of body image battles. I know the exact moment that punishing inner dialogue kicked in, at a weigh-in during gym class (*why* were we having "weigh-ins"

in the first place?). I had just turned thirteen, was five feet six inches tall, and tipped the scale at 118 pounds. Not a lot, but my mom was that height at age twenty, when she married my dad, and weighed 110. I know this because she told me many times. She was not a vain person—she barely wore makeup, didn't spend much on clothes, had a no-nonsense short haircut; it was more that she viewed thinness as virtue, an indication of morality and even intelligence.

When I was in junior high, she thought it was a fun bonding activity to try on my jeans to show how well they fit her. Two years later, when I'd put on another thirty pounds and had grown out of not only her dungarees and mine but my oldest brother's, I began, with her blessing, a series of ill-fated fad diets. (Remember "liquid protein"? No food, just three tablespoons of a viscous, vile-flavored goo mixed three times a day into a noncaffeinated, sugar-free soda. The product, which was derived largely from leftover slaughterhouse hooves and bones, was yanked from the market after some of its users died of heart failure).

I don't like making my mom look cruel or hurtful. I loved her—I still love her—and I no longer blame her for her shortcomings or for my own; there is a point where we need to forgive. But it is probably no surprise that, by sixteen, I'd become perilously anorexic. Although I've maintained a normal weight for decades, that unhappy, sorry girl still lurks inside me (and sometimes she can be so mean). The only upside of the experience is that it spurred me to spend a career writing about the social forces that shape women's views of our bodies, advocating for more freedom, agency, autonomy, and pleasure.

I never, under any circumstances, say anything negative about my body in front of my own daughter, though it sometimes takes all my willpower to refrain. And I definitely never comment on hers. I have made sure that she's seen me not only eat a healthy diet, but also, oc-

casionally, indulge with relish (hiding my own internal ambivalence) in a bowl of Ben & Jerry's, a slice of double chocolate cake, or an order of curly fries. Steven is the primary cook in our home, partly because, as I said, he's great at it, but also because I didn't trust myself around food management. I worried I'd screw her up. As with that unfortunate style of knitting, I didn't want her to "learn from her mom" in the way I had. It makes me a little sad not to be able to communicate love through nourishment as Steven does so easily, but I hope to offer a different gift: an end to the cycle of feminine self-loathing that equates food with shame.

ONCE FRENCHIE AND I (mostly Frenchie) plug in all the numbers and compute the stitches per inch in my yarn, I cast on my first row and start to knit. Finally, something I know how to do! Because I'm unsure about whether I've dyed enough blue for my base, I have designed the sweater to be made from the top down, starting at the collar, so I can adjust the length accordingly as I go. It adds an element of suspense; I'm hoping it won't end up as a crop top. At first, I meticulously line up the stripes on the torso with those on the sleeves, but in the end I give up. If it's not perfect, I'll call the differential a "design element." I'm only once forced to seriously undo my work (or "frog," as knitters say, because you have to *rip-it, rip-it, rip-it*), because whatever ratio we used to determine the circumference of my upper arms is incorrect. The sleeves, when I try on the work in progress, are far too tight—it likely isn't truly the fault of the ratio, but I have learned not to go where that line of thinking will inevitably lead.

I'm not too discouraged by the wasted effort—decades of knitting

have taught me that fixing mistakes is part of the process. I think of it as "unknitting." Besides, I can do stockinette stitch with my eyes closed (I mean that literally—I *can* do stockinette with my eyes closed), and the beauty of a bulky yarn like the one I've spun is that it knits up astonishingly fast; it doesn't take long to catch up. In two weeks, I'm finished! I have never made a sweater so quickly. And to my surprise, the results are . . . okay. At least not nearly as hideous as I imagined.

Frenchie asked several times whether I wanted to incorporate shaping into the torso, tapering it closer to the body. I knew from GG's Instagram posts that no one is fooled when you try to hide your insecurities under baggy clothes, that, in fact, a proper fit will be the most flattering. Still, each time she suggested it I took stock of my weirdly large rib cage, my absurdly short waist, my middle-aged meno-pot, my uneven hips, and replied, "*Noooo* . . ." Against my best interests, I conceived the final product to be boxy, straight and rect-angular, indifferent to the particulars of my particular physique. Just as I was warned, this turns out to be a mistake. The sweater hangs oddly far from my body, especially in the back, and I keep tugging to adjust it, to make it look a little sleeker.

I don't yet do the final work of weaving in the various hanging yarn ends; maybe someday I'll want to frog back to the armpits, try again and do it better. But probably I won't. Whether to rip and revise is a common knitter's dilemma. The way I look at it, impatience may be the enemy of perfection, but the perfect is the enemy of the good. I *wish* I were the kind of person who is willing to frog even when spying an error that is rows, inches, *weeks* earlier in my work. I'm not, yet those mistakes will nevertheless grate on me every single time I wear the sweater or cuddle in the blanket. In

that way, too, my knitting reflects who I am: too lazy to fix it, too neurotic to let it go.

I've also neglected to employ the technique that would keep each stripe from "jogging" while knitting in the round—not quite matching up at the top and bottom. Some people don't mind that, so, again, I'm going to call it "knitter's choice" rather than a flub. Beyond that, I adore the stripes, which are, starting at the neck, carnation pink, orange, daffodil, periwinkle, raspberry, olive, fuchsia, lemon, and, around the hem, a purple as noble as the mucus from a snail's bum. All in all, they are much more sumptuous than I imagined, and more colorful than anything I would ordinarily wear. As for the blue, it is all of those images on the mood board incarnate. I could not be prouder. Yet again, *I did it!*

The sweater is warm, which I expected given its bulk, but also surprisingly physically heavy—nearly three pounds, which is two more than the thickest sweaters in my closet. I'm not sure why that is, though I did use every speck of Martha's fleece. At best, I would wear it as an outer layer, in lieu of a jacket. When I visit Minnesota. In the dead of February. Because there is no way I would have cause to wear this thing in California. Maybe the weightiness is appropriate. It is, after all, carrying a lot: my hopes and fears for the future; my commitment to thinking more consciously about clothing (as well as other) consumption; the devastation of the pandemic; the grief over my mom's death, over the slow, dripping loss of my dad; my apprehension about the fires and the advancing climate crisis; the anticipatory loneliness of the empty nest. It's all knit in there. This whole damned year. No wonder the result feels like lead.

AT OUR LAST MEETING, Frenchie left me with a Māori invocation, something to lend spiritual guidance and help me reach a desirable outcome on my quest.

> Kia whakairia te tapu.
> Kia wātea ai te ara.
> Kia turuki whakataha ai.
> Kia turuki whakataha ai.
> Haumi ē!
> Hui ē!
> Tāiki ē!

Translation: "Restrictions are moved aside so the pathway is clear to return to everyday activities. Join! Gather! Unite!"

I don't know whether that's why, but suddenly everything seems to progress rapidly, not only in my knitting but in the world at large. Restrictions do move aside, pathways clear, and, for the moment, anyway, everyday life begins to return. Steven is the first of us eligible to be vaccinated; I follow a month later, and by summer, Daisy does as well. The first time I hug a friend after a year's separation, I cry, as does she. I want to make plans with everyone I know, everyone I have missed, but I also feel a bit like a zoo animal whose cage has been opened: so used to confinement that I can't imagine release. My social life does broaden a little, but not much and nowhere close to what it was Before. When the three of us take in *A Quiet Place Part II* at an actual theater, that, too, feels strange. We enjoy ourselves, but the seats are mostly empty and it will be months before we do it again. On the other hand, when, still masked, Steven and I go to a local club for a Wailin' Jennys show, the audience whoops as the house manager welcomes us back.

After a brief flirtation with the idea of heading east, Daisy decides that winter is a scam that she wants no part of. She commits instead to a school in Los Angeles, just six hours away. "I won't be so far from you and Dad," she tells me, clearly seeing that as a perk. She also claims, at least for now, that she'd like to come back after graduation, to make a life in the Bay Area. I recall how eager I was at her age to get as far from home as possible as fast as possible, for as long as possible, to shed my old skin and become someone new. Maybe it is an inevitable swing of the generational pendulum. As a girl of my demographic and era, I needed to prove that I could make my own way, as solitary and self-contained as a Marlboro man (who may now more readily evoke incels and lung cancer). Perhaps because I did that, my daughter doesn't have to. She's free to let interdependence support rather than undermine her dreams—I bet she'll even want to own a couch. Or it could be that Covid, wildfire, and the threat of environmental catastrophe have made Gen Z less individualistic than their elders were, shifting their priorities from personal achievement to cultivating friends, family, community: the things that will, one hopes, sustain them through whatever is to come.

As soon as I am fully vaxxed, I hop a plane to Minneapolis to see my dad. The reunion, after fifteen months, is joyous and painful—at least from my perspective. He doesn't realize that it's been over a year since we were in the same room, which is probably to the good. He looks so much older than he did on my laptop screen, stooped nearly double. His hair, untrimmed since lockdown, is as wild and wiry as Einstein's mane; he runs his hands through it obsessively, unconsciously. I take them in mine, giving them a gentle squeeze, and lay them in his lap. That stops him for a moment, but soon he is at it again.

The last time I was here, he could, with a little help, play a word search game on an iPad. He could tell stories about his days in the

navy (though he had begun to incorporate elements of action scenes from the World War II movies he watched on TCM). He still read the newspaper, at least the comics. Now, most of the time, he can't string five cogent words together. It's hard to talk to him, too, because he won't wear his hearing aids; when his caregiver puts them in, he immediately tugs them out and if not stopped will pull them apart, breaking them. My two older brothers and their wives, who do the heroic day-to-day work of managing his care, are often exhausted, disheartened, and although they don't begrudge it, I feel guilty about living so far away.

When I call to tell all of this to Steven, he encourages me to reframe, reminding me how lucky I am: it could be so much worse. I may well, he says, look back on these as "the good times." His own aunt, after her dementia diagnosis, quickly lost the ability to recognize her nieces and nephews, her siblings, her grandchildren, her kids, anyone she had ever known. Everything she'd ever been disappeared, and she lived that way for years. I know he's right, but I mourn each small loss.

One afternoon when I arrive at my dad's apartment, I am fairly sure he doesn't recognize me. He smiles politely and says, "Hi, honey!" "Honey" is what he calls his aides when he can't remember their names. After about ten minutes, he peers closely at me, smiles, and says, "Peg!" I relax. It was just a glitch and doesn't happen again. But it reminds me of the first time I noticed that his mind was slipping, more than ten years earlier, before my mom was sick. They used to rent a condo near San Diego every February to escape the Minnesota tundra. Steven, Daisy, and I would swing down to visit for a long weekend (and now, as with my daughter's childhood desire to engage me in incessant games of pretend, I wonder what I was so busy doing

that I couldn't stay for longer—I'd give anything to have that chance again). On a morning walk, my dad and I passed a playground.

He smiled. "Remember when we used to take you kids there?"

"Dad!" I responded, alarmed. "You didn't start coming here until I was thirty. You're thinking of the grandchildren!"

He laughed. "Senior moment!" he said lightly, but it unnerved me. I had the thought, *Is this how it starts?* His latest small hiccup gives me the same feeling: *Is this how it ends?* Truly? I don't know what to hope for. The idea of my dad's death is gut-wrenching. Even in this diminished state, I want him here, in this world, with us, with me. And yet: if he is going to not only lose most of the details of his life, his marriage, and his work but forget his family entirely? I think—I *think*—I would rather see him go.

His aide mentions that he has been seeing my mom lately, speaking to her. "He says, 'Beatsy! Where have you been? I've been searching everywhere for you! Beatsy, your shirt! It's so beautiful!'" I'm taken aback. When we buried her, my dad sobbed and keened as they lowered her coffin into the frozen ground, the sound echoing in January's thin air. But that was it. He hasn't so much as mentioned her for at least four years, and he's nonresponsive when I do. Maybe, his aide suggests, this means he is easing closer to the next world. That seems plausible. The gauzy veil separating the living and the dead may grow more permeable as we near life's end, becoming, as it were, immaterial. Or a less metaphysical interpretation could be that the distinction between dream and reality increasingly blurs. Either way, the thread of his life seems to be fraying, Atropos's scissors poised to close. It comforts me to think my mom is joining him for this transition, that he isn't alone; also that, after death, the Fates provide a well-stocked wardrobe.

ANOTHER MORNING HE IS back to moaning, "*Oy*, Peggy! *Oy*, Peggy!"

"What is it, Dad-o?" I say, taking his hand.

"*Oy*, Peggy! *Oy*, Peggy!" he repeats, ragged voiced. "Help me! *Help me!* I want to go home! I want to go *home!*"

He repeats this over and over, sometimes cursing: "God*damn* it!" "*Shit!*" "Son of a *bitch!*" (Though with that last one, he stops, turns to his aide, and says with full lucidity, "I didn't mean you!") It's excruciating; I don't know what to do for him and I just want him to stop. I also wonder, what does he mean by "home"? Where is home? *When* is home? I'd call it a metaphor for wanting to die—he sometimes settles when I sing "Swing Low, Sweet Chariot" (though it unsettles *me*)—but he was never poetic in that way.

So, I ask, "What do you mean, Dad? Where's home?" Sometimes he says, "St. Paul" or "Selby Avenue," where he lived as a child. Mostly, he doesn't reply. Then again, what would I say if someone asked me those same questions? Where is home? *When* is home? It's no longer here in Minneapolis, the place I left over forty years ago—my mom is gone, my father will soon follow; my siblings are here but their children are not, so who knows where they'll land in the coming years. My dearest friend—she of the rhombus scarf—plans to skedaddle someplace warmer as soon as she and her husband retire.

Nor is home any longer the place where I am raising my daughter—that time is nearly through, though I will hold "home" as an idea for her for as long as she needs, for as long as I can. Home is wherever Steven is, that's for sure, yet that, too, is not forever: he will age, I will

age, things will change. As a young woman I wanted so desperately to stay unencumbered. Now I know. Independence? That's easy. It's connection you have to protect, that ever-shifting balance between continuity and change.

As for the house, the one we've lived in for the past twenty-five years, the one we essentially stumbled into? That is not home anymore, either. By the time I return from Minneapolis, the sweet reprieve of the winter rains has ended and another summer of record drought looms. Steven and I decide that, once we settle Daisy at school, it will be time for us to cast off, too—a term that, aptly, means both to finish a project in knitting, and to start a journey in sailing.

I'm a little surprised to feel no tug of nostalgia at the prospect. Maybe memories, even the good ones, are the furniture of this next phase, something I don't want to live among, at least not to the extent that they trap me. Like Daisy, we first consider a more radical shift: maybe to Los Angeles to be near Steven's siblings, maybe to Minneapolis to be near mine (though only if they promise never to move). Maybe to New York, where we both have friends. Or to Honolulu, where we were married. Or Western Massachusetts, where everyone else seems to want to go. Or even San Francisco, out in the Avenues near the good Chinese restaurants. We consider them all and eliminate them, one by one.

For all its faults and all my fears—and despite the fact that, in what is surely some kind of omen, my madder root plants, which I've neglected to adequately water, have all died—the East Bay has become more than just where we live. It is the closest thing I have to home—the place, *my* place, where I have now spent over half my life. I'm not sure I understood that before the pandemic grounded me (literally and, in the end, figuratively), before my year of shearing, spinning,

and dyeing: before working with so many elements tied to this land. I know there will be new disasters ahead, natural and otherwise, that the California dream is on life support—housing prices soaring, fires burning, water disappearing, social services straining—but I've realized I just can't leave.

The rest is not dramatic. We put our house on the market and immediately, if unexpectedly, find a suitable swap at the bottom of the hill. Our "new" home is a hundred years old—ancient by California standards—with original built-ins, rattling windows, and, I'm happy to say, another Meyer lemon tree in the backyard. It is also a couple miles west of the overheated heart of the fire zone. That is far enough, for now—and if I've learned nothing else over the last year, it's that "for now" is all we have. Because life, like a sweater, can come together or unravel: slowly, arduously, then oh, so very fast.

Plus, there is a yarn store right down the street.

acknowledgments

THANK YOU FIRST TO MY AGENT, Suzanne Gluck, who took this loopy idea seriously; to my editors Sara Nelson and Jennifer Barth, whose wise insight guided it to fruition; and to Leslie Cohen, Katie O'Callaghan, and the team at Harper, an imprint that has supported and believed in my work and me these many years.

The silver lining of the pandemic has been recognizing how truly blessed I am with loving friends and family. Huge thanks to: Sylvia Brownrigg; Ina Park; Rachel Silvers; Shafia Zaloom; Peg-bo Edersheim Kalb; Dan Wilson and Diane Espaldon; Jay Martel; Neal Karlen; Ruth Halpern; Eva Eilenberg; Elly Eisenberg; Shari, Steve, and Etta Washburn; Caitlin Sweeny; Sadie Britton; Mexica Greco; Romilly and Sam Thomson; Lissa Soep; Judy Campbell; Judy Warner; Barb Swaiman (who still can't knit a scarf); Simone Marean; Natalie Compagni; Cornelia Lauf, Danny Sager, and Brian McCarthy; Laura Silver; Michael Pollan and Judith Belzer; Doug McGray; Jay Caspian Kang; Barry Tubb; Dawn Prestwich; Brian Shames and Patrice Rocher; Ken, Charlotte, and all the Grays; Anna Rabkin; Jessica Williams; Teresa Tauchi and Sam Boonin; Ann Packer; Brock Colyar; Maya Guzdar; Bonnie Tsui; Tracy Clark-Flory; Janet Ozzard; Sae, Alex, and Neo Wilmer; Tenli Yavneh; Alan Suemori and Eddie Lee (for the gochisou on my Honolulu writing retreats); Demi Rhine and the Monday night group; and, of course, Ayelet Waldman and the

ladies—and gentleman—of the Magnificent Seven (minutes). Special thanks and love to the Orenstein and Okazaki clans, particularly David, Leslie, and John Orenstein for all you do for Dad.

Thank you to my teachers and interview subjects—whether or not they are in these pages—for their generosity, wisdom, and patience: Lora Kinkade; Kristine Vejar and Adrienne Rodriguez of A Verb for Keeping Warm; Hazel Flett and Bodega Pastures; Valerie Yep; Helen Krayenhoff and Peggy Kass of Kassenhoff Growers; Catherine McKinley; Deepa Natarajan; Anthony Tassinello; Françoise Danoy of Aroha Knits; Gaye Glasspie of @ggmadeit; Alisha Bright of Fiber Circle Studios; Stephany Wilkes; Rebecca Burgess of Fibershed; and, especially, my sister-in-law and textile mentor, Debbie Orenstein. To my first teachers in life, my parents, Beatsy and Mel Orenstein, boundless gratitude: you are always and forever in my heart.

Steven and Daisy Okazaki just keep on being there for me, even when I am a huge pain or massively stink up the house with un-scoured fleece or various dye experiments. I love you more than I can ever say—if I had to be trapped for a year with someone, I'm sure glad it was the two of you (also, Ginger).

Finally, to all the mothers of all the daughters: pass it on!

notes

CHAPTER 1: YOU DO EWE

2 A much-ballyhooed effort: You can see a video. "Robot Sheep Shearing,"
 JamesTrevelyan, YouTube, November 5, 2008, https://tinyurl.com/5aum2dkr.

3 something called "biological wool harvesting": More video! Prue Adams,
 "BioClip," ABC-TV (Australia), March 28, 2015, https://tinyurl.com
 /2627xr6x.

3 in 2019, an Australian tech company: See it in action! "Robotic Assisted
 Shearing Scoping Study," Australian Wool Innovation Ltd, YouTube, May 8,
 2019, https://tinyurl.com/bdfsarua.

4 shearers are fond of saying: Rachel Mealy, "Study Shows Shearing Is
 Toughest Job," *The World Today*, ABC Local Radio (Australia), February 25,
 2000, https://tinyurl.com/hzpew9bd; "Sheep Shearing," *World's Toughest
 Jobs*, BBC3, March 4, 2016, https://tinyurl.com/bdh48czv.

6 a YouTube video of his work: "Sheep Shearing (1964)," British Pathé,
 YouTube, April 13, 2014, https://tinyurl.com/cjmrvh66.

6 Some ranches also engage in mulesing: Mulesing has been banned in
 New Zealand, the United Kingdom, and some other countries, but it's still
 prevalent in Australia. For more on mulesing and possible alternatives, see
 RSPCA, "Research Report: Prevention and Control of Blowfly Strike in
 Sheep," January 2019, https://tinyurl.com/mw61cctw.

7 "the String Revolution," a technological leap: Elizabeth Wayland Barber,
 *Women's Work: The First 20,000 Years; Women, Cloth, and Society in Early
 Times* (New York: W. W. Norton & Company, 1995).

8 which they did reputedly while rocking: Marie Hoff, "Shearing and
 Welfare: Why Are Sheep Sheared?," *Fibershed* (blog), July 11, 2019, https://
 tinyurl.com/4vxmw8au.

8 folded neatly atop the body: Check her out: "Bodies of the Bogs,"
 Archeology Archive, December 10, 1997, https://tinyurl.com/ca6be7us.

9 In February 2021, construction workers: Here's a vid. "Baarack the
 Sheep Shorn of 35kg Fleece After Being Found Roaming in Rural Australia,"
 Guardian News, YouTube, February 24, 2021, https://tinyurl.com/5xh8bsnm.

10 Lucky Brand clothing, meanwhile: "ASI Educates Brands on Benefits of American Wool," Northern AG Network, December 11, 2018, https://tinyurl.com/2m859fdx.

15 mismanagement of equipment by PG & E: Morgan McFall-Johnsen, "Over 1,500 California Fires in the Past 6 Years—Including the Deadliest Ever—Were Caused by One Company: PG & E. Here's What It Could Have Done but Didn't," Insider, November 3, 2019, https://tinyurl.com/yj5jj9au.

18 Local sanctuaries are flooded: Kathleen Coates, "Hard Choices: With Drought, Large Animals Harder to Sustain," *Press Democrat* (Santa Rosa, CA), July 29, 2021, https://tinyurl.com/yx832nnt.

CHAPTER 2: SHEAR MADNESS, SHEAR DELIGHT

21 which have been likened to: Dana Thomas, "Why Is Fashion Talking About Regenerative Farming?," *New York Times*, April 20, 2021, https://tinyurl.com/7ahf7462.

28 an annual, nationally televised Miss Wool of America pageant: See (you really *must*) "The Miss Wool of America Collection," Texas Archive of the Moving Image, https://tinyurl.com/225uhhdw.

30 just weeks after Lucky Brand's: See Kim Goodling, "The Future Is Wool," *Living with Gotlands* (blog), January 21, 2019, https://tinyurl.com/228nm2au.

30 Meanwhile, author Clara Parkes: Carrie Stadheim, "Duluth Trading Taken to Task Over Wool Comment," *Tri-State Livestock News*, November 30, 2018, https://tinyurl.com/2s43nct9.

31 Among the middle class, "wash-and-wear": Ellen Melinkoff, *What We Wore: An Offbeat Social History of Women's Clothing* (New York: William Morrow, 1984).

32 "the biggest environmental problem you've never heard of": Mary Catherine O'Connor, "Inside the Lonely Fight Against the Biggest Environmental Problem You've Never Heard Of," *Guardian*, October 27, 2014, https://tinyurl.com/bdek3evc.

32 France recently became the first: Environmental advocates in Britain, including the charmingly named Keep Britain Tidy, are pushing for the same. Jamie Hailstone, "Campaigners Call for Microfibre Filters to Be Mandatory in New Washing Machines," *Forbes*, May 30, 2022, https://tinyurl.com/bdta42x2.

36 So, whereas back in ancient times: For a great primer on ultrafast fashion, see Rachel Monroe, "Ultra-Fast Fashion Is Eating the World," *Atlantic*, March 2021, https://tinyurl.com/2sfbtx49.

36 Ultrafast youth brands, such as ASOS: Between January and April of

2022, Shein sold 314,877 new styles. By comparison, Zara sold 6,849 and H&M 4,414. Elizabeth Segren, "ThredUp Picks a Fight with Fast-Fashion Giant Shein," *Fast Company*, June 24, 2022, https://tinyurl.com/3ckarpjz.

37 the fashion industry is an ecological disaster: See the UN Alliance for Sustainable Fashion, https://unfashionalliance.org.

37 "dead white man's clothes": See, for example, Linton Besser, "Dead White Man's Clothes," ABC Australia, October 21, 2021, https://tinyurl .com/55xe789b.

37 By early 2021, #haul videos: By the time this book went to press in August 2022, #haul had 22.9 billion views.

37 preferring the online resale site Depop: Unfortunately, secondhand clothing sites and stores have been overrun by fast fashion discards. "The Golden Age of Thrifting Is Over," *New York Times*, July 6, 2022, https:// tinyurl.com/2j5hj9u7.

38 The Higg Index, for instance: See Hiroko Tabuchi, "How Fashion Giants Recast Plastic as Good for the Planet," *New York Times*, June 12, 2022, https://tinyurl.com/sc899bhr, and Vanessa Friedman, "New York Could Make History with a Fashion Sustainability Act," *New York Times*, January 7, 2022, https://tinyurl.com/4h5zyxdz.

38 what fashion industry critics have begun calling: For more on "degrowth," see Bella Webb, "Degrowth: The Future That Fashion Has Been Looking For?," *Vogue Business*, January 22, 2022, https://tinyurl.com/4h9d ym5b.

40 Bodega Pastures is a member of: For more on the excellence that is Fibershed, see https://fibershed.org/.

CHAPTER 3: THE STUFF OF US

51 you let it drop or otherwise set it spinning: In addition to the drop technique, there are methods that involve flicking a spindle while it is supported in a bowl or on a table. I have never tried this.

52 Elizabeth Wayland Barber, the archaeologist: Barber, *Women's Work*.

52 Journalist Kassia St. Clair has noted: Kassia St. Clair, *How Fabric Changed History* (New York: Liveright Publishing Corporation, 2018).

53 Before the Industrial Revolution, according to St. Clair: Ibid.

CHAPTER 4: SPINNING MY WHEELS

64 I have read that women might walk: A textile historian tested this out and concluded that it was entirely reasonable to walk thirty miles a week (assuming a six-day week and a ten-hour day) and that someone who was "younger and fresher" than she might well clock that distance in a day.

Penelope Hemingway, "Walking Wheel: How Many Miles a Month?" *Knitting Genie* (blog), July 3, 2017, https://tinyurl.com/3nscbfff.

65 Barry Schacht was a hippie idealist: See Schacht Spindle Company, "Our Story," https://tinyurl.com/29a9p943; and Eric Peterson, "Made in Colorado 2017: Schacht Spindle Nears 50 Years of Boulder-Made Looms," *ColoradoBiz*, March 6, 2017, https://tinyurl.com/2sd8ht6t.

66 In her book on ancient women's work: Barber, *Women's Work*.

68 has been compared to cooking a chicken: Or, in this case, cooking a potato. See Abby Franquemont, "Drafting, Predrafting, Prep, and Control," *Abby's Yarns Online* (blog), October 22, 2007, https://tinyurl.com/bdta42x2.

72 in Europe, its rise in the fourteenth century: See "The Spinning Wheel: The Beginning of the Medieval Textile Industry," Encyclopedia.com, https://tinyurl.com/ywkdv47u.

74 and employers secretly slowed: Glenn Adamson, *Craft: An American History* (New York: Bloomsbury Publishing, 2021).

74 promoted the environment as "moral": Ibid.

76 "a woman jumped, and then another": "Warren: 'We're Here Because of Some Hardworking Women,'" Elizabeth Warren, YouTube, September 22, 2019, https://tinyurl.com/6ryd9pbr.

77 given how intertwined cloth was: For an entertaining, thorough discussion of the role of textiles in both the colonization and the liberation of India, see Sofi Thanhauser, *Worn: A People's History of Clothing* (New York: Pantheon, 2022).

CHAPTER 5: THE PRICK OF THE SPINDLE

84 the folklorist Jack Zipes: Jack Zipes, "Spinning with Fate: 'Rumplestiltskin' and the Decline of Female Productivity," *Western Folklore* 52, no. 1 (1993): 43–60.

85 Later, as I began writing about: I was first inspired to consider the more impressionistic role fairy tales can play in our lives years ago when reading Bruno Bettelheim's *The Uses of Enchantment,* Joan Gould's *Straw into Gold,* and, basically, everything Maria Tatar and Jack Zipes ever wrote. Bruno Bettelheim, *The Uses of Enchantment: The Meaning and Importance of Fairy Tales* (1976; repr., New York: Vintage, 2010); Joan Gould, *Spinning Straw into Gold: What Fairy Tales Reveal About the Transformations in a Woman's Life* (New York: Random House, 2006).

89 But angora has a troubling past: See Stassa Edwards, "Nazis Secretly Bred Angora Rabbits at Concentration Camps," *Atlas Obscura*, December 2, 2015, https://tinyurl.com/2p94rdyk; "Angora: Pictorial Records of an SS Experiment," *Wisconsin Magazine of History* 50, no. 4 (1967): 392–413.

90 During the pandemic, treatment of the: Asia Floor Wage Alliance, *A*

Stitch in Time Saved None: How Fashion Brands Fueled Violence in the Factory and Beyond, December 2021, https://tinyurl.com/2p8z6hks. Factories supplying brands such as H&M, Amazon, Nike, and Target also laid off tens of thousands of workers without providing the severance pay to which they were legally entitled—approximately $40 million in withheld funds—leaving many unable to feed their families. Worker Rights Consortium, *Fired Then Robbed: Fashion Brands' Complicity in Wage Theft During Covid-19,* April 2021, https://tinyurl.com/4a26h3sp.

CHAPTER 6: I WOULD DYE 4 U

98 I pore over guides to natural dyeing: Anyone contemplating natural dye work should start with the following: Kristine Vejar, *Journeys in Natural Dyeing: Techniques for Creating Color at Home* (New York: Harry N. Abrams, 2020); Kristine Vejar, *The Modern Natural Dyer: A Comprehensive Guide to Dyeing Silk, Wool, Linen, and Cotton at Home* (New York: Harry N. Abrams, 2015); Sasha Duerr, *Natural Palettes: Inspiration from Plant-Based Color* (New York: Princeton Architectural Press, 2020); Jenny Dean, *Wild Color, Revised and Updated Edition: The Complete Guide to Making and Using Natural Dyes* (New York: Potter Craft, 2010). If you can find it, it's also fun to read Ida Grae, *Nature's Colors* (New York: Macmillan, 1979).

98 A nineteenth-century recipe book: William Partridge, *A Practical Treatise on Dying Woollen, Cotton and Silk* (London: Forgotten Books, 2018).

103 The prism's hues were simply not an important: Guy Deutscher, *Through the Language Glass: Why the World Looks Different in Other Languages* (New York: Picador, 2011).

103 Deutscher suggests you take a peek: Ibid.

103 Russians consider it bizarre: Ibid.

104 For the Japanese: Michel Pastoureau, *Blue: The History of a Color* (Princeton, NJ: Princeton University Press, 2001).

104 In parts of Africa, he adds: Ibid.

109 Cleopatra traveled on a barge: Purple was the queen's favorite color. Evan Andrews, "10 Little Known Facts About Cleopatra," History *Stories,* August 10, 2021, https://tinyurl.com/bdcy47vk.

109 Things worked out less favorably: That's what the Roman historian Suetonius said, anyway. There was probably more to it than that. Wendy Moonan, "An Ancient Bronze Bust with a Tragic Story of Jealousy," *New York Times,* December 3, 2004, https://tinyurl.com/dxps9t8n.

110 Not that the hoi polloi could've afforded purple: Mark Cartwright, "Tyrian Purple," *World History Encyclopedia,* July 21, 2016, https://tinyurl.com/2s3kxefh. For more on Tyrian purple, see Evan Andrews, "Why Is Purple Considered the Color of Royalty," History *Stories,* August 18, 2018,

https://tinyurl.com/3cmyddx8, and Kelly Grovier, "Tyrian Purple: The Disgusting Origins of the Colour Purple," BBC, August 1, 2018, https://tinyurl.com/yc2fu8yy.

110 Snail-tush purple: A Tunisian history buff has devoted himself to reviving the lost art of making purple from murex snails—unfortunately for the snails. Jihed Abidellaoui, "Tunisian Enthusiast Recreates Sea Snail Purple Dye That Defined Ancient Royals," Reuters, February 8, 2022, https://tinyurl.com/b5tktvt3.

111 Then, in the early sixteenth century: See Peter B. G. Shoemaker, "Red All Over: How a Tiny Bug Changed the Way We See the World," *Humanities* 36, no. 4 (July/August 2015), https://tinyurl.com/54nj5zv9; Devon Van Houten Maldonado, "The Insect That Painted Europe Red," BBC, February 1, 2018, https://tinyurl.com/5n86x7fu; Amy Butler Greenfield, *A Perfect Red: Empire, Espionage, and the Quest for the Color of Desire* (New York: Harper, 2005).

112 for two hundred years, only the Spanish: Shoemaker, "Red All Over"; Maldonado, "Insect That Painted Europe Red"; Butler Greenfield, *A Perfect Red*.

112 worth, according to historian Amy Butler Greenfield: Greenfield, *A Perfect Red*.

113 That's when an eighteen-year-old chemistry student: For more on Perkin and his discovery, see Simon Garfield, *Mauve: How One Man Invented a Color That Changed the World* (New York: W. W. Norton & Company, 2002).

114 according to biographer Simon Garfield: Ibid.

115 who declared their brilliance "gaudy": Sam Vettese Forster and Robert M. Christie, "The Significance of the Introduction of Synthetic Dyes in the Mid 19th Century on the Democratisation of Western Fashion," *Journal of the International Colour Association* 11 (2013): 1–17, https://tinyurl.com/2p8shnuj.

115 Perkin himself planted a patch: Garfield, *Mauve*.

116 Clothing production, especially dyeing and finishing: See Ellen MacArthur Foundation, *A New Textiles Economy: Redesigning Fashion's Future*, 2017, https://tinyurl.com/32szrs5e; Helen Rogan, "Asian Rivers Are Turning Black. And Our Colorful Closets Are to Blame," CNN Style, September 28, 2020, https://tinyurl.com/mu9tmd6c; and Kathleen Webber, "How Fast Fashion Is Killing Rivers Worldwide," EcoWatch, March 22, 2017, https://tinyurl.com/58pn78du.

CHAPTER 7: SOMETHING BLUE

121 No one, by the way, knows for sure: Laura KoAn, "Why Do We Call It 'the Blues'?," *Sitting at the Foot of the Blues* (blog), January 3, 2017, https://tinyurl.com/5dtwz57x. Many sources say "the blues" derives from the seventeenth-

century British expression "the blue devils," a term for the hallucinations that accompany alcohol withdrawal, but I wonder why people of African descent living in the southern United States would have chosen that reference. Others say it relates to a note played at a slightly different pitch than is standard.

124 Indigo repels biting insects: Catherine McKinley, *Indigo: In Search of the Color That Seduced the World* (New York: Bloomsbury Publishing, 2012).

124 A sexual stimulant: Ibid.

124 In premodern Japan: Nupur Singh, "7 Things You Should Know About Japanese Indigo Dye"; Anne Roselt Design, "The Incredible Story of Indigo"; Tatcha cosmetics, https://tinyurl.com/3nmcbkud.

128 In Europe, blue's top influencer: See Pastoureau, *Blue*, and Noor F. K. Iqbal, "Ambivalent Blues: Woad and Indigo in Tension in Early Modern Europe," *Constellations* 4, no. 1 (2013): 277–92.

128 Artisans of the era were limited to working: Pastoureau, *Blue*, and Iqbal, "Ambivalent Blues."

129 According to historian Michel Pastoureau: *Blue*. I do wonder whether calling seventeenth-century delirium tremens "blue devils," as mentioned in an earlier note to this chapter, was related to those efforts.

129 according to *Smithsonian Magazine*: Jodi Enda, "When Republicans Were Blue and Democrats Were Red," *Smithsonian Magazine*, October 31, 2012, https://tinyurl.com/ycxvnn4r.

131 that's how many were displayed: Graham Keegan, *More Than All You Need to Know to Make Your Own Indigo Dye Vat* (blog), June 25, 2020, https://tinyurl.com/mrv9cxhe.

133 Eliza's accomplishment relied on: McKinley, *Indigo: In Search of the Color That Seduced the World*. See also, Neil Caudle, "How Red and Black and White Made Blue," *Glimpse*, Fall 2013, https://tinyurl.com/ynca7zhy. Eliza was particularly indebted to an enslaved carpenter named Quash, who as a free man would later be called John Williams. Andrea Freeser, *Red, White and Black Make Blue: Indigo in the Fabric of Colonial South Carolina Life*, (Athens: University of Georgia Press, 2013); Natasha Boyd, *The Indigo Girl* (Ashland, OR: Blackstone Publishing, 2017).

133 the British governors of Georgia legalized it there: Jesslyn Shields, "The Dark History of Indigo, Slavery's Other Cash Crop," HowStuffWorks, February 7, 2020, https://tinyurl.com/2p8bsudk.

133 Later, though, she sent: Caroline Roux, "Artist Mama Nike: 'I Found a Way to Make Women Powerful by Being Able to Earn Money,'" *Financial Times*, October 6, 2022, https://tinyurl.com/4he8bm44. See also, Forbes Africa, "The Material of Life According to Textile Queen Nike Davies-Okundaye," *Forbes*, October 6, 2022, https://tinyurl.com/2b6vavv4; Christian Purefoy,

"Nigeria's 'Mama Nike' Empowers Women Through Art," CNN, April 12, 2011, https://tinyurl.com/ywvmx2rt.

135 you experience some moment of what educational psychologist: See Ronald A. Beghetto, "Creative Mortification: An Initial Exploration," *Psychology of Aesthetics, Creativity, and the Arts* 8, no. 3 (2014): 266–76.

136 The alternative, and the best defense against those: Peggy Orenstein, "How to Unleash Your Creativity," *O, The Oprah Magazine*, February 2011, https://tinyurl.com/musur73j.

CHAPTER 8: CRAFTY WOMEN

148 You likely learned in school: For more on spinning bees and the role of textiles in fomenting the Revolution, see Sofi Thanhauser, *Worn: A People's History of Clothing* (New York: Pantheon, 2022); Anne L. MacDonald, *No Idle Hands: The Social History of American Knitting* (New York: Ballantine Books), 1990; "Spinning Bees, Spinning Wheels," *Women & the American Story*, July 8, 2022, https://tinyurl.com/5md5s9fz.

148 Later, despite the scarcity: Macdonald, *No Idle Hands*.

148 Then there was Molly: See Barbara McCabe, "From the Archives: Toleration Statue Has Rich History," *Friends of Wissahickon* (blog), February 27, 2020, https://tinyurl.com/yet7ajnd. For more on Rinker and sister Philadelphia spy Lydia Darragh, see Dorothy Stanaitis, "Women's History Month: What's in a Name?," Philadelphia Corporation for Aging, March 10, 2021, https://tinyurl.com/2a34jua5.

148 Photographs of Sojourner Truth: For more on symbolism in Truth's photos, see University of California Berkeley Art Museum and Pacific Film Archive, *Sojourner Truth, Photography, and the Fight Against Slavery* (exhibition brochure), 2016, https://tinyurl.com/54az3je8.

149 But factories of the time: See Suzanne Fischer, "The Technology of Socks in a Time of War," *Atlantic*, November 7, 2011, https://tinyurl.com/mr32e4w5; Anika Burgess, "The Wool Brigades of World War I, When Knitting Was a Patriotic Duty," *Atlas Obscura*, July 26, 2017, https://tinyurl.com/3n8akjz5.

149 Across the pond: Women on the both sides of World War I and World War II acted as spies, passing encoded messages in their innocuous-seeming knitting. Because of this, the UK and the US banned the printing and mailing of knitting patterns during the wars. Nathan Chandler, "Crafty Wartime Spies Put Codes Right into Their Knitting," September 28, 2020, https://tinyurl.com/2p8ttrcv.

150 Today's knitters (as well as those who crochet): See "Nuclear Weapon Campaigners Knit Seven-Mile 'Peace Scarf' Protesting Trident Replacement," *International Business Times*, August 9, 2014, https://tinyurl

.com/yc3a6jk3; Sarah Derouin, "How to Crochet a Coral Reef—and Why," *Scientific American*, Janaury 11, 2017, https://tinyurl.com/mryuapaf; Stitch to Enrich, University of Texas at Dallas, https://tinyurl.com/27c68u43.

150 In 2006, a "yarn bomber": The artist's name is Marianne Jorgensen. Mandy Moore and Leanne Prain, *Yarn Bombing: The Art of Crochet and Knit Graffiti* (Vancouver, BC: Arsenal Pulp Press, 2009). For pictures of the American helmet liners, a project initiated by artist Cat Mazza, see Rose Miller, "Radical Knitters Stitch for the Senate to Bring Our Troops Home," *Mother Jones*, March 21, 2007, https://tinyurl.com/ycke57y9.

151 two of the collective's members were: After their release, they donned their face coverings again to perform at the 2014 Winter Olympics in Sochi, where they were set upon and beaten with whips by a uniformed Cossack militia. There's a video of this. "Pussy Riot Whipped by Cossack Militia in Sochi During Performance Attempt," Euronews, YouTube, February 19, 2014, https://tinyurl.com/2p9fdwbs.

151 Knitters have made blankets for refugees: Mark Tran, "Knitting for Refugees: The Londoners Keeping Refugees Warm Over the Winter," *UNHCR* (blog), December 15, 2107, https://tinyurl.com/2zjjrcxc; Katie Dupere, "Pussyhat Project Co-Founder Launches the Next Big Craftivism Effort of the Resistance," *Mashable*, June 5, 2017, https://tinyurl.com/5n7yrtkz; Heather McNab, "The 109-Year-Old Man Who Knits Sweaters for Penguins: Meet Alfie Date, Australia's Oldest Man Who Creates Tiny Clothes in His Spare Time," *Daily Mail*, February 11, 2015, https://tinyurl.com/2tmnjp3f; Nadine Daher, "How Knitting Enthusiasts Are Using Their Craft to Visualize Climate Change," *Smithsonian Magazine*, February 19, 2020, https://tinyurl.com/ypbs8afv; Michael Mechanic, "Knit Your Congressman a Vagina," *Mother Jones*, March 20, 2012, https://tinyurl.com/288xupjr.

151 The comfort of a knitting circle: Corinne Segal, "Stitch by Stitch, a Brief History of Activism and Knitting," *PBS NewsHour Weekend*, April 23, 2017, https://tinyurl.com/yxehk88c.

151 One of my favorite groups: See Read Sales, "Knitting Men: The Chilean Group that Challenges Prejudices with Needles and Thread," BBC New Mundo, December 13, 2016, https://tinyurl.com/4rfuxndw.

152 Do such acts of "craftivism": The word "craftivism" was coined in 2003 by knitter and activist Betsy Greer. See Besty Greer, *Craftivism: The Art and Craft of Activism* (Vancouver, BC: Arsenal Pulp Press, 2014).

153 A guy who calls himself: Emily Sugarman, "Conservative Knitters Try to Needle the 'Woke' with New Mag," *Daily Beast*, February 18, 2022, https://tinyurl.com/3jwdr3xv.

153 they "probably can't afford it": See Gaye Glasspie, "Stand in the Gap: A

Call to Action," *GG Made It* (blog), January 18, 2021, https://tinyurl.com/yckcrb7n, and "The Changing Face of the Yarn Industry," 21 Hats, YouTube, January 20, 2022, https://tinyurl.com/3dk7vfv5.

154 They debated how the conventions: For more on this, see Jaya Saxena, "The Knitting Community Is Reckoning with Racism," *Vox,* February 25, 2019, https://tinyurl.com/5yus8x6v.

155 GG also recognizes that: Gaye Glasspie, "Why I Can't Just Knit: The Story of a Black Knitter During Civil Unrest," *GG Made It* (blog), June 5, 2020, https://tinyurl.com/5cf59d4x.

155 They seem like easy targets: Harmeet Kaur, "Fetishized, Sexualized and Marginalized, Asian Women Are Uniquely Vulnerable to Violence," CNN, March 17, 2021, https://tinyurl.com/2p8kwbdp.

CHAPTER 9: KNIT ONE

160 something "that is both novel *and* appropriate": Orenstein, "How to Unleash Your Creativity."

163 I have read that younger people forget things: Daniel J. Levitin, "Everyone Knows Memory Fails as You Age. But Everyone Is Wrong," *New York Times,* January 10, 2020, https://tinyurl.com/yc3k3pnv.

163 I've also read that knitting: Yonas E. Geda, Hillary M. Topazian, Lewis A. Roberts, et al., "Engaging in Cognitive Activities, Aging, and Mild Cognitive Impairment: A Population-Based Study," *Journal of Neuropsychiatry and Clinical Neurosciences* 23, no. 2 (2011): 149–54; Jill Riley, Betsan Corkhill, and Clare Morris, "The Benefits of Knitting for Personal and Social Wellbeing in Adulthood: Findings from an International Survey," *British Journal of Occupational Therapy* 76, no. 2 (2013): 50–57.

165 Elizabeth Zimmermann, a revolutionary: See *Knitting Without Tears: Basic Techniques and Easy-to-Follow Directions for Garments to Fit All Sizes* (New York: Fireside Books, 1971).

165 Zimmermann's circular shawl formula: If you'd like to give Zimmermann's pi shawl or Moebius ring pattern a try, they are still available on Ravelry. Her daughter, Meg Swansen, and Swansen's children continue to operate Schoolhouse Press, a publisher, a knitting supply business, and the home of "Knitting Camp," which Zimmermann founded in the 1950s. See https://www.schoolhousepress.com/.

166 Math-loving knitters make: See Sarah-Marie Belcastro, "Adventures in Mathematical Knitting," *American Scientist,* March–April 2013, https://tinyurl.com/mryexcad, and Becky Stern, "Math Monday," *Make:,* June 20, 2011, https://tinyurl.com/2mtmumww.

166 Elisabetta Matsumoto, an applied: Lakshmi Chandrasekaran, "How One Physicist Is Unraveling the Mathematics of Knitting," *ScienceNews,* January

26, 2021, https://tinyurl.com/nyyzr9fj; Siobhan Roberts, "'Knitting Is Coding' and Yarn Is Programmable in This Physics Lab," *New York Times*, May 17, 2019, https://tinyurl.com/2fsju7ru.

168 Remember "liquid protein": See Nadine Brozan, "The Liquid Protein Diet Controversy," *New York Times*, May 18, 1977, 50; Ward Sinclair, "Percy Cites More Deaths, Urges Liquid Protein Ban," *Washington Post*, November 24, 1977, https://tinyurl.com/y9n7dwbr.

selected bibliography

Adamson, Glenn. *Craft: An American History.* New York: Bloomsbury Publishing, 2022.

Asia Floor Wage Alliance. *A Stitch in Time Saved None: How Fashion Brands Fueled Violence in the Factory and Beyond.* Report. Asia Floor Wage Alliance, 2021.

Austin, Mary Hunter. *The Flock.* Boston: Houghton Mifflin, 1906.

Barber, Elizabeth Wayland. *Women's Work: The First 20,000 Years Women, Cloth, and Society in Early Times.* New York: W. W. Norton & Company, 1996.

Bettelheim, Bruno. *The Uses of Enchantment: The Meaning and Importance of Fairy Tales.* New York: Vintage, 1977.

Burgess, Rebecca with Courtney White. *Fibershed: Growing a Movement of Farmers, Fashion Activists and Makers for a New Textile Economy.* Hartford, VT: Chelsea Green Publishing, 2019.

Dean Jenny. *Wild Color, Revised and Updated Edition: The Complete Guide to Making and Using Natural Dyes.* New York: Potter Craft, 2010.

Deutscher, Guy. *Through the Language Glass: Why the World Looks Different in Other Languages.* New York: Arrow Books, 2011.

Dickens, Charles. *A Tale of Two Cities.* Reprint. New York: W. W. Norton & Company, 2019. First published in 1859.

Duerr, Sasha. *Natural Palettes: Inspiration from Plant-Based Color.* Princeton, NJ: Princeton Architectural Press, 2020.

Ellen MacArthur Foundation. *A New Textiles Economy: Redesigning Fashion's Future.* Report. Ellen MacArthur Foundation, 2017.

Garfield, Simon. *Mauve: How One Man Invented a Color That Changed the World.* New York: W. W. Norton & Company, 2002.

Gould, Joan. *Spinning Straw into Gold: What Fairy Tales Reveal About the Transformations in a Woman's Life*. New York: Random House, 2006.

Grae, Ida. *Nature's Colors: Dyes from Plants*. New York: Macmillan, 1979.

Greenfield, Amy Butler. *A Perfect Red: Empire, Espionage, and the Quest for the Color of Desire*. New York: Harper Perennial, 2006.

MacDonald, Anne L. *No Idle Hands: The Social History of American Knitting*. New York: Ballantine Books, 1990.

Melinkoff, Ellen. *What We Wore: An Offbeat Social History of Women's Clothing, 1950 to 1980*. New York: William Morrow & Company, 1984.

Natarajan, Deepa Preeli and Helen Krayenhoff. *10 Plants for Color: A Simple Guide to Growing and Using Natural Dye Plants*. Self-published, Deepa Preeti Natarajan + Helen Krayenhoff, 2016.

Parker, Rozsika. *The Subversive Stitch: Embroidery and the Making of the Feminine*. New York: Bloomsbury Visual Arts, 2019.

Parkes, Clara. *Vanishing Fleece: Adventures in American Wool*. New York: Harry N. Abrams, 2019.

_____. *The Knitter's Book of Yarn: The Ultimate Guide to Choosing, Using, and Enjoying Yarn*. New York, Potter Craft, 2007.

Partridge, William. *A Practical Treatise on Dying Woollen, Cotton and Silk*. Reprint. London: Forgotten Books, 2018. First published in 1847.

Pastoureau, Michel. *Blue: The History of a Color*. Princeton, NJ: Princeton University Press, 2018.

St. Clair, Kassia. *The Golden Thread: How Fabric Changed History*. New York: Liveright, 2019.

Smith, Beth. *The Spinner's Book of Fleece: A Breed-by-Breed Guide to Choosing and Spinning the Perfect Fiber for Every Purpose*. North Adams, MA: Storey Publishing, 2014.

Stoller, Debbie. *Stitch 'n Bitch: The Knitter's Handbook*. New York: Workman Publishing, 2012.

Strawn, Susan M. *Knitting America: A Glorious Heritage from Warm Socks to High Art*. London: Voyageur Press, 2007.

Thanhauser, Sofi. *Worn: A People's History of Clothing*. New York: Pantheon Books, 2022.

Vejar, Kristine, and Adrienne Rodriguez. *Journeys in Natural Dyeing: Techniques for Creating Color at Home.* New York: Abrams, 2020.

Vejar, Kristine. *The Modern Natural Dyer: A Comprehensive Guide to Dyeing Silk, Wool, Linen and Cotton at Home.* New York: Harry N. Abrams, 2019.

Wilkes, Stephany. *Raw Material: Working Wool in the West.* Corvallis: Oregon University Press, 2018.

Zilboorg, Anna. *Knitting for Anarchists: The What, Why and How of Knitting.* Mineola, NY: Dover Publications, 2015.

Worker Rights Consortium. *Fired Then Robbed: Fashion Brands' Complicity in Wage Theft During Covid-19.* Report. Worker Rights Consortium, 2021.

Zimmermann, Elizabeth. *Knitting Without Tears: Basic Techniques and Easy-to-Follow Directions for Garments to Fit All Sizes.* New York: Fireside Books, 1971.

about the author

PEGGY ORENSTEIN is the *New York Times* bestselling author of *Boys &
Sex, Don't Call Me Princess, Girls & Sex, Cinderella Ate My Daughter,
Waiting for Daisy, Flux,* and *Schoolgirls*. A frequent contributor to the
New York Times, she has written for the *Washington Post,* the *Atlantic,
AFAR,* the *New Yorker,* and other publications, and has contributed
commentary to NPR's *All Things Considered* and the *PBS NewsHour*.
She lives in Northern California.